SHOUJO MANGA TECHNIQUES

Writing Stories

Written & Illustrated by
Mako Itsuki

CREEPY MOCH?

Manga
shing

A PUBLISHING
ngeles

Content Manga
MAKO ITSUKI

Cover Illustration
KAIMU TACHIBANA

English Translating
KUMIKO YUASA

Lettering
SNO CONE STUDIOS, LTD.

Editing
MARK FUJITA

Graphic Design
ERIC ROSENBERGER

Editor in Chief
FRED LUI

Japan Relations
JOHN WHALEN

Publisher
HIKARU SASAHARA

SHOUJO MANGA TECHNIQUES
Writing Stories

English Edition Published by
DIGITAL MANGA PUBLISHING
1123 Dominguez Street, Unit K
Carson, CA 90746
www.dmpbooks.com
tel: (310) 604-9701
fax: (310) 604-1134

Distributed Exclusively in North America by
WATSON-GUPTILL PUBLICATIONS
a division of VNU Business Media
770 Broadway, New York, NY 10003
www.watsonguptill.com

ISBN: 1-56970-970-X
Library of Congress Control Number: 2004105582
First Edition January 2005
1 2 3 4 5 6 7 8 9 10

Printed in China

WRITING STORIES

INTRODUCTION: CREATING A STORY IS SUPER EASY!

HEY YOU, THE ONE STRUGGLING TO WRITE MANGA STORIES! DON'T YOU THINK YOU'RE THINKING TOO HARD?!

◎ CAN'T FIGURE OUT HOW TO PUT YOUR IDEAS TOGETHER?

◎ DON'T KNOW WHAT EXACTLY YOU SHOULD DO EVEN THOUGH YOU'VE READ THE MANUAL?

◎ CAN'T COME UP WITH ANY IDEAS FOR STORIES?

◎ DO YOU ALREADY HAVE GREAT ILLUSTRATING SKILLS? WANT TO ADD MORE ORIGINALITY IN YOUR STORY?

AFTER READING THIS BOOK, YOU WILL HAVE THE ANSWERS TO THESE PROBLEMS.

THIS BOOK WILL GUIDE YOU STEP BY STEP THROUGH THE BASICS OF STORY CREATION ALL THE WAY TO THE ADVANCED TECHNIQUES THAT PROFESSIONAL MANGA ARTISTS USE TODAY. SPECIFIC CASES ARE EXPLAINED USING MANGA, SO IT'S EASY TO FOLLOW. JUST READING THE MANGA IN THIS BOOK WILL HELP YOU LEARN THE KNOW-HOW OF WRITING STORIES. OUR PASSWORD IS "WRITING STORIES IS SUPER EASY!" LET'S MASTER HOW TO WRITE STORIES TOGETHER!

SHOUJO MANGA TECHNIQUES:
WRITING STORIES

1. WHAT IS A STORYLINE? . 5
 (KYOKO'S ONE-POINT ADVICE) HOW TO EXPRESS THROUGH ILLUSTRATION . 19
 (KYOKO'S ONE-POINT ADVICE) HOW TO DRAW MANGA USING THE EPISODES YOU CAME UP WITH (1) 19
2. KEY POINTS TO WRITING A STORY . 21
 (KYOKO'S ONE-POINT ADVICE) HOW TO DRAW A MANGA USING THE EPISODES YOU CAME UP WITH (2) 29
3. HAKOGAKI TECHNIQUE: THE BASICS OF WRITING STORIES . 31
 (KYOKO'S ONE-POINT ADVICE) CREATING CHARACTERS USING THE HAKOGAKI TECHNIQUE 37
4. WRITING STORIES OUT OF A THEME . 39
 (KYOKO'S ONE-POINT ADVICE) EXPRESSINGING THE THEME THROUGH ILLUSTRATIONS . 49
5. WRITING STORIES FROM IDEAS . 51
 (KYOKO'S ONE-POINT ADVICE) EXPRESSING IDEAS USING ILLUSTRATIONS . 63
6. WRITING STORIES BY ESTABLISHING THE SETTING . 65
 (KYOKO'S ONE-POINT ADVICE) CREATING CHARACTERS FROM THE SETTINGS . 75
7. WRITING STORIES BY CHOOSING A GENRE . 77
 (KYOKO'S ONE-POINT ADVICE) CREATING CHARACTERS AFTER CHOOSING A GENRE . 85
8. CONSIDERING THE READERS' FEELINGS IN STORY-MAKING PROCESS . 87
 (KYOKO'S ONE-POINT ADVICE) CREATING CHARACTERS THAT APPEAL TO THE READERS 95
9. WRITING STORIES BY CREATING CHARACTERS FIRST . 97
 (KYOKO'S ONE-POINT ADVICE) HOW TO CREATE A CHARACTER . 109
10. THE INTRODUCTION, DEVELOPMENT, TURN AND CONCLUSION METHOD . 111
 (KYOKO'S ONE-POINT ADVICE) WHAT IS THE "INTRODUCTION, DEVELOPMENT, TURN AND CONCLUSION" METHOD? 121
11. WHAT ARE THE DEVELOPMENT AND THE INDUCTIVE METHOD? . 123
 (KYOKO'S ONE-POINT ADVICE) WHAT ARE THE DEVELOPMENT AND THE INDUCTIVE METHOD? 133
12. CREATING STORIES BY DETERMINING THE PAGE COUNT . 135
 (KYOKO'S ONE-POINT ADVICE) APPEALING TO THE READERS WITH A LIMITED PAGE COUNT 143
13. THUMBNAILS . 145
14. TACKLING PLAGIARISM . 153

CHARACTER INTRODUCTIONS

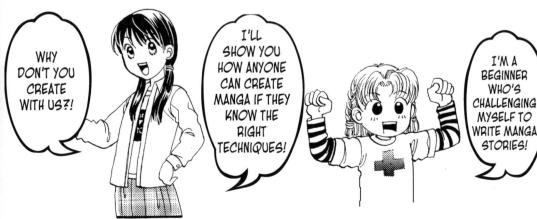

WHY DON'T YOU CREATE WITH US?!

I'LL SHOW YOU HOW ANYONE CAN CREATE MANGA IF THEY KNOW THE RIGHT TECHNIQUES!

I'M A BEGINNER WHO'S CHALLENGING MYSELF TO WRITE MANGA STORIES!

▲ KYOKO NAKASATO: ALISA'S TEACHER WHO'S SHOWING HER THE TECHNIQUES OF CREATING MANGA.

▲ ALISA MIZUKI: THIS IS HER FIRST ATTEMPT AT CREATING MANGA.

① WHAT IS A STORYLINE?

FIRST, YOU NEED TO LEARN THE BASICS ABOUT WRITING STORIES. IT'S IMPORTANT TO FULLY UNDERSTAND THE BASICS SUCH AS THE "5W1H RULE", "THE BASIC STRUCTURE OF A STORY", "HOW TO MAKE A SCRIPT" AND SO ON.

6

LOOK AT ALL THESE...

*SHF

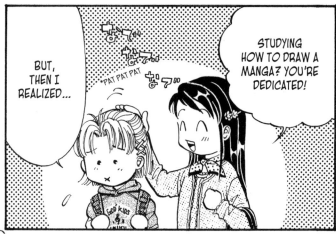

BUT, THEN I REALIZED...

*PAT PAT PAT

STUDYING HOW TO DRAW A MANGA? YOU'RE DEDICATED!

IT'S ALMOST IMPOSSIBLE TO WRITE A BRAND NEW STORY THAT'S COMPLETELY DIFFERENT FROM EVERYONE ELSE'S!

WITH SO MANY MANGA BOOKS LIKE THESE...

GOD'S KIDS BEAMS BOY

*FLIP FLIP

YOU'RE RIGHT. EVEN PROFESSIONAL MANGA ARTISTS HAVE TROUBLE WRITING A STORY THAT IS 100% ORIGINAL AND ISN'T SIMILAR TO ANY OTHER STORY OUT THERE.

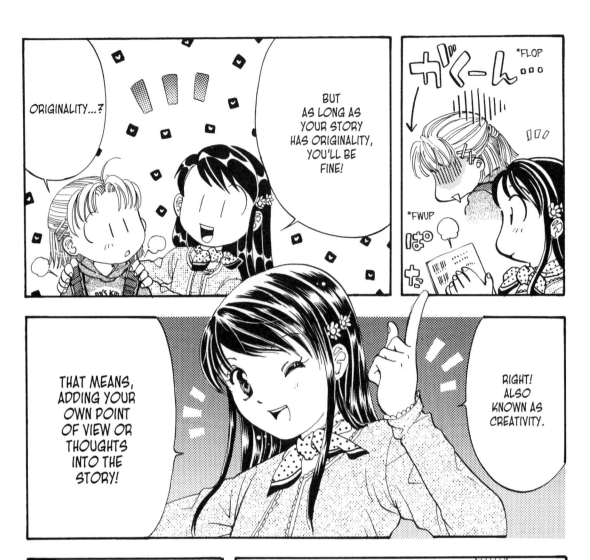

ORIGINALITY...?

BUT AS LONG AS YOUR STORY HAS ORIGINALITY, YOU'LL BE FINE!

*FLOP

*FWUP

THAT MEANS, ADDING YOUR OWN POINT OF VIEW OR THOUGHTS INTO THE STORY!

RIGHT! ALSO KNOWN AS CREATIVITY.

YOU'RE RIGHT! THE BASIC STORYLINE IS THE SAME, BUT HOW IS THAT POSSIBLE?

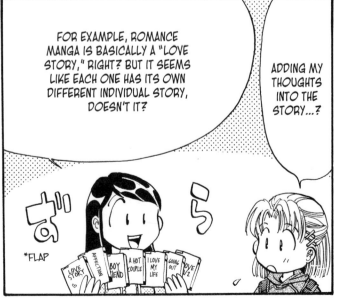

FOR EXAMPLE, ROMANCE MANGA IS BASICALLY A "LOVE STORY," RIGHT? BUT IT SEEMS LIKE EACH ONE HAS ITS OWN DIFFERENT INDIVIDUAL STORY, DOESN'T IT?

ADDING MY THOUGHTS INTO THE STORY...?

*FLAP

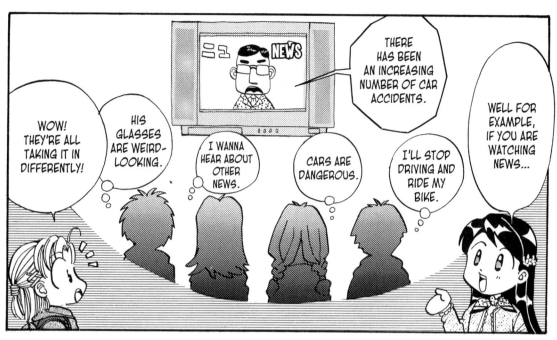

THERE HAS BEEN AN INCREASING NUMBER OF CAR ACCIDENTS.

NEWS

WOW! THEY'RE ALL TAKING IT IN DIFFERENTLY!

HIS GLASSES ARE WEIRD-LOOKING.

I WANNA HEAR ABOUT OTHER NEWS.

CARS ARE DANGEROUS.

I'LL STOP DRIVING AND RIDE MY BIKE.

WELL FOR EXAMPLE, IF YOU ARE WATCHING NEWS...

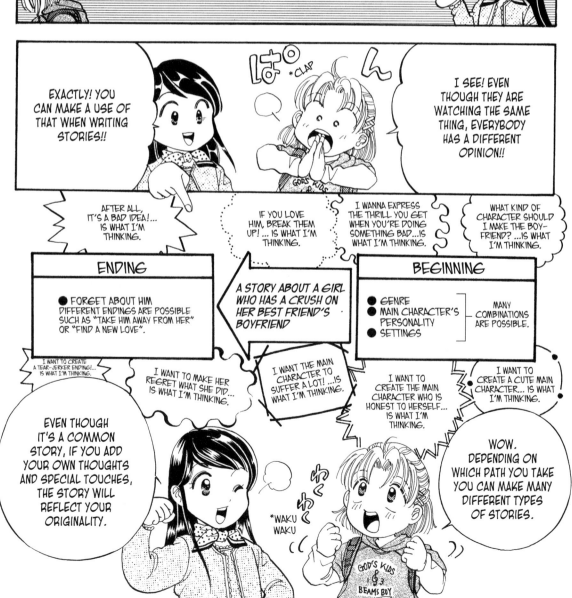

EXACTLY! YOU CAN MAKE A USE OF THAT WHEN WRITING STORIES!!

*CLAP

I SEE! EVEN THOUGH THEY ARE WATCHING THE SAME THING, EVERYBODY HAS A DIFFERENT OPINION!!

AFTER ALL, IT'S A BAD IDEA!... IS WHAT I'M THINKING.

IF YOU LOVE HIM, BREAK THEM UP! ... IS WHAT I'M THINKING.

I WANNA EXPRESS THE THRILL YOU GET WHEN YOU'RE DOING SOMETHING BAD...IS WHAT I'M THINKING.

WHAT KIND OF CHARACTER SHOULD I MAKE THE BOY-FRIEND? ...IS WHAT I'M THINKING.

ENDING

● FORGET ABOUT HIM DIFFERENT ENDINGS ARE POSSIBLE SUCH AS "TAKE HIM AWAY FROM HER" OR "FIND A NEW LOVE".

A STORY ABOUT A GIRL WHO HAS A CRUSH ON HER BEST FRIEND'S BOYFRIEND

BEGINNING

● GENRE
● MAIN CHARACTER'S PERSONALITY
● SETTINGS

MANY COMBINATIONS ARE POSSIBLE.

I WANT TO CREATE A TEAR-JERKER ENDING!... IS WHAT I'M THINKING.

I WANT TO MAKE HER REGRET WHAT SHE DID... IS WHAT I'M THINKING.

I WANT THE MAIN CHARACTER TO SUFFER A LOT! ...IS WHAT I'M THINKING.

I WANT TO CREATE THE MAIN CHARACTER WHO IS HONEST TO HERSELF... IS WHAT I'M THINKING.

I WANT TO CREATE A CUTE MAIN CHARACTER... IS WHAT I'M THINKING.

EVEN THOUGH IT'S A COMMON STORY, IF YOU ADD YOUR OWN THOUGHTS AND SPECIAL TOUCHES, THE STORY WILL REFLECT YOUR ORIGINALITY.

*WAKU WAKU

WOW. DEPENDING ON WHICH PATH YOU TAKE YOU CAN MAKE MANY DIFFERENT TYPES OF STORIES.

WHAT IS AN "IDEA"?	AN IDEA TELLS A CHAIN OF RELATED EVENTS IN DUE ORDER. IN MANGA, THIS REFERS TO BOTH A STORY AND EPISODES.
WHAT IS A "STORY"?	THE MANGA STORY IN ITS ENTIRETY FROM BEGINNING TO THE END.
WHAT IS AN "EPISODE"?	MULTIPLE SHORT STORIES THAT EXIST IN THE MANGA.

THE STRUCTURE OF A MANGA STORY

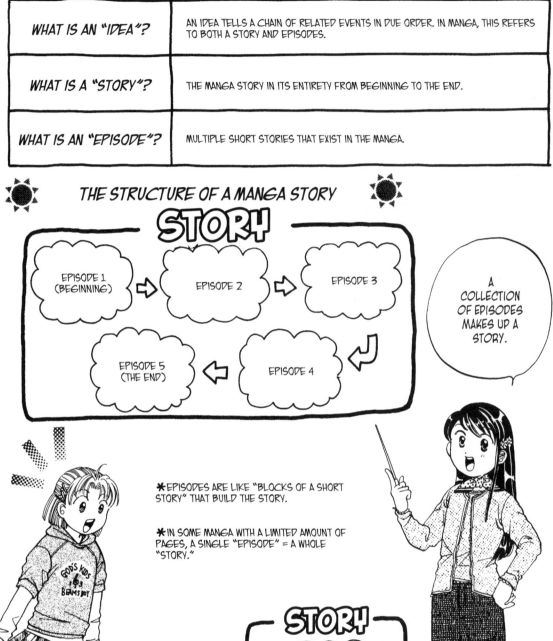

STORY

EPISODE 1 (BEGINNING) → EPISODE 2 → EPISODE 3

EPISODE 5 (THE END) ← EPISODE 4 ←

A COLLECTION OF EPISODES MAKES UP A STORY.

*EPISODES ARE LIKE "BLOCKS OF A SHORT STORY" THAT BUILD THE STORY.

*IN SOME MANGA WITH A LIMITED AMOUNT OF PAGES, A SINGLE "EPISODE" = A WHOLE "STORY."

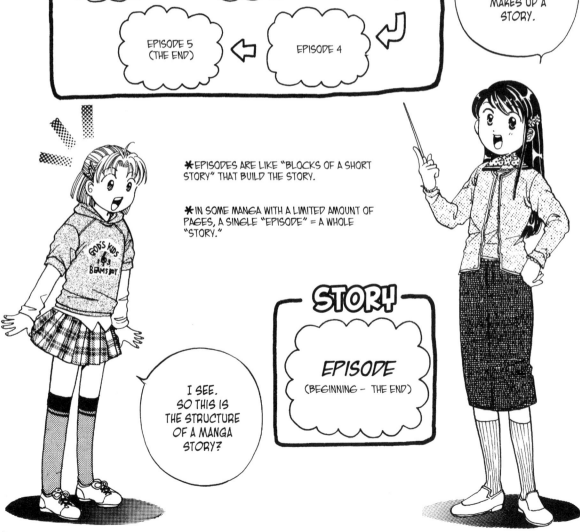

I SEE. SO THIS IS THE STRUCTURE OF A MANGA STORY?

STORY

EPISODE (BEGINNING – THE END)

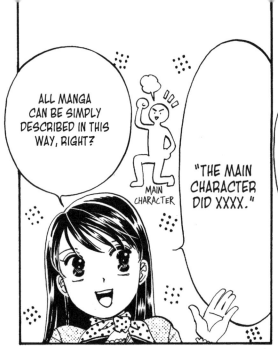

ALL MANGA CAN BE SIMPLY DESCRIBED IN THIS WAY, RIGHT?

MAIN CHARACTER

"THE MAIN CHARACTER DID XXXX."

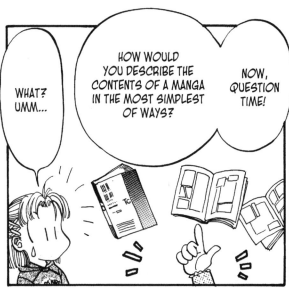

WHAT? UMM...

HOW WOULD YOU DESCRIBE THE CONTENTS OF A MANGA IN THE MOST SIMPLEST OF WAYS?

NOW, QUESTION TIME!

*SCRATCH SCRATCH

I UNDERSTAND THE STRUCTURE OF A STORY NOW, BUT I'M WORRIED THAT IT'S GOING TO BE HARDER WRITE ONE THAN IT LOOKS...

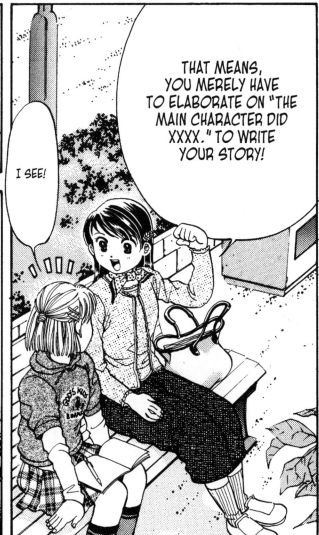

I SEE!

THAT MEANS, YOU MERELY HAVE TO ELABORATE ON "THE MAIN CHARACTER DID XXXX." TO WRITE YOUR STORY!

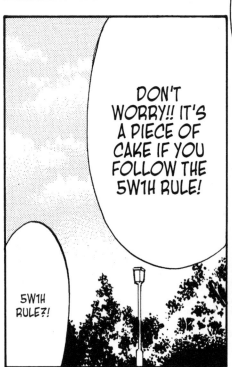

DON'T WORRY!! IT'S A PIECE OF CAKE IF YOU FOLLOW THE 5W1H RULE!

5W1H RULE?!

5W1H RULE FOR WRITING A BASE STORY

WHO?	EXPLAIN WHO THE CHARACTERS THAT MOVE THE STORY ARE. ESPECIALLY WHO THE MAIN CHARACTER IS.
WHEN?	EXPLAIN WHEN THE STORY IS HAPPENING. IS IT IN THE MORNING, AFTERNOON OR AT NIGHT? DID IT HAPPEN YESTERDAY, TODAY OR TOMORROW? DOES IT TAKE PLACE IN THE PAST, PRESENT OR FUTURE?
WHERE?	EXPLAIN WHERE THE STORY IS TAKING PLACE. IS IT INSIDE A BUILDING OR OUTSIDE? IS IT AT HOME, SCHOOL, PARK OR TRAIN STATION? DOES IT TAKE PLACE HERE OR OVERSEAS? IS IT IN THE REAL WORLD, FANTASY WORLD OR SCIENCE FICTION WORLD?
DO WHAT?	EXPLAIN WHAT THE CHARACTERS (MAIN CHARACTER) DO IN THE STORY.
WHY?	EXPLAIN WHY THE CHARACTERS (MAIN CHARACTER) DO SO.
HOW DID IT GO?	EXPLAIN WHAT HAPPENED DUE TO THE CHARACTERS' (MAIN CHARACTER'S) ACTIONS.

YOU CAN WRITE A BASE STORY BY SIMPLY FOLLOWING THIS RULE!

OK. NOW, WHY DON'T YOU MAKE A STORY BY FOLLOWING THE RULE?

OK!

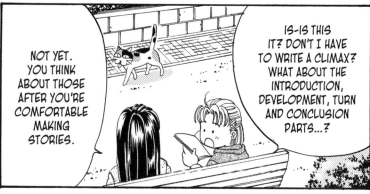

NOT YET. YOU THINK ABOUT THOSE AFTER YOU'RE COMFORTABLE MAKING STORIES.

IS-IS THIS IT? DON'T I HAVE TO WRITE A CLIMAX? WHAT ABOUT THE INTRODUCTION, DEVELOPMENT, TURN AND CONCLUSION PARTS...?

I SEE! I'M ALL CONFUSED BECAUSE I TRY TO DO SO MANY THINGS AT ONCE!!

*CLAP

IF YOU'RE NOT USED TO MAKING STORIES YET, YOU SHOULD FOCUS ON WORKING ON THE BASE STORYLINE.

BUT, THIS IS A BIT TOO SHORT TO DRAW A MANGA WITH.

*MMM...

IT'S SO SIMPLE...

IT IS! THIS IS AN EPISODE NOT A STORY.

↓ WHO
ALISA MIZUKI

↓ WHEN
THIS AFTERNOON

↓ WHERE
ON THE BENCH IN A PARK

↓ WHY
BECAUSE SHE COULDN'T WRITE A MANGA STORY

↓ DO WHAT
ASKED KYOKO NAKASATO HOW TO WRITE A STORY

↓ HOW DID IT GO
THEN SHE WAS ABLE TO WRITE A STORY.

I'M DONE!

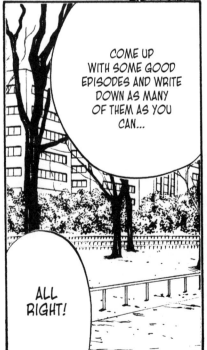

COME UP WITH SOME GOOD EPISODES AND WRITE DOWN AS MANY OF THEM AS YOU CAN...

ALL RIGHT!

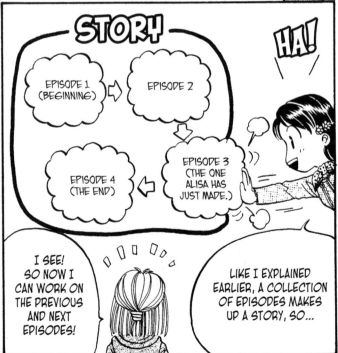

STORY

HA!

EPISODE 1 (BEGINNING)

EPISODE 2

EPISODE 3 (THE ONE ALISA HAS JUST MADE.)

EPISODE 4 (THE END)

I SEE! SO NOW I CAN WORK ON THE PREVIOUS AND NEXT EPISODES!

LIKE I EXPLAINED EARLIER, A COLLECTION OF EPISODES MAKES UP A STORY, SO...

SO I'LL CREATE THE FIRST EPISODE AND THE LAST EPISODE...

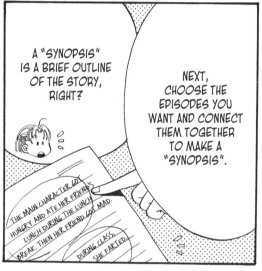

A "SYNOPSIS" IS A BRIEF OUTLINE OF THE STORY, RIGHT?

NEXT, CHOOSE THE EPISODES YOU WANT AND CONNECT THEM TOGETHER TO MAKE A "SYNOPSIS".

THE MAIN CHARACTER GOT HUNGRY AND ATE HER FRIEND'S LUNCH DURING THE LUNCH BREAK. THEN HER FRIEND GOT MAD.

DURING CLASS, SHE FARTED.

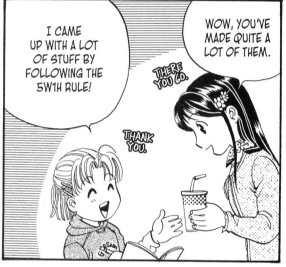

WOW, YOU'VE MADE QUITE A LOT OF THEM.

I CAME UP WITH A LOT OF STUFF BY FOLLOWING THE 5W1H RULE!

THERE YOU GO.

THANK YOU.

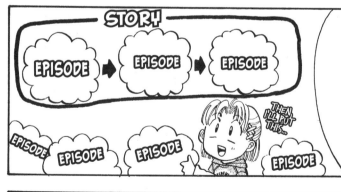

STORY

EPISODE → EPISODE → EPISODE

EPISODE EPISODE EPISODE EPISODE

THEN I'LL PUT THIS...

THAT'S RIGHT! AS YOU WRITE MANY EPISODES, YOU START TO SEE THE STORYLINE IN YOUR HEAD, DON'T YOU?! BASED ON THAT, YOU CONNECT THE EPISODES AND MAKE A SYNOPSIS.

HUUH?

SCRIPT...?

NEXT, WE'LL WRITE YOUR "SCRIPT!"

A SAMPLE SCRIPT WRITTEN ON A PIECE OF PAPER

PAGE	
1	COVER PAGE (A DOOR)
2	IN THE MORNING AT HOME (IN THE MAIN
3	CHARACTER'S ROOM) SHE HITS HER ALARM CLOCK.
4	SHE GOES BACK TO SLEEP THINKING ABOUT THE
	BOY SHE HAS A CRUSH ON, THEN SHE SLEEPS IN
	AND IS LATE FOR SCHOOL BIG TIME! (WHEN SHE
	THINKS ABOUT HIM, EXPRESS HOW COOL HE IS.)
5	THE SCARY TEACHER IS IN THE CLASSROOM,
6	HAVING A CLASS. HE YELLS AT HER WHEN SHE
7	SNEAKS IN, BUT THE BOY SHE HAS A CRUSH ON
	COMES IN LATE TOO.
8	THE TEACHER TELLS BOTH OF THEM TO STAND IN
	THE HALLWAY. SHE SEEMS HAPPY. THE BOY SEEMS
	SLEEPY...
9	SHE BUILDS UP THE COURAGE TO TALK TO HIM,
10	ONLY TO FIND OUT HE IS SLEEPING WHILE HE'S
	STANDING. (DISAPPOINTMENT!)

EPISODE ← ①

EPISODE ← ②

EPISODE ← ③

EPISODE ← ④

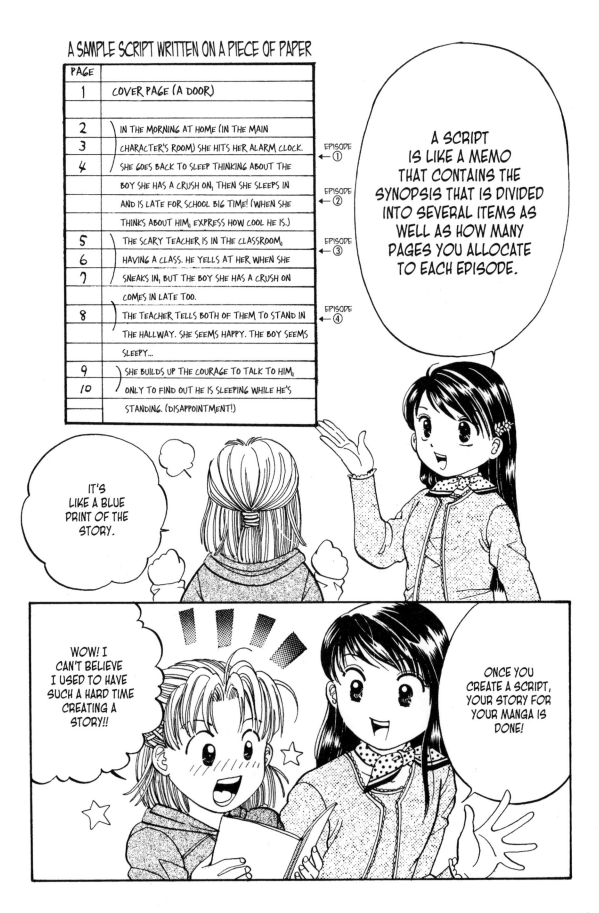

A SCRIPT IS LIKE A MEMO THAT CONTAINS THE SYNOPSIS THAT IS DIVIDED INTO SEVERAL ITEMS AS WELL AS HOW MANY PAGES YOU ALLOCATE TO EACH EPISODE.

IT'S LIKE A BLUE PRINT OF THE STORY.

WOW! I CAN'T BELIEVE I USED TO HAVE SUCH A HARD TIME CREATING A STORY!!

ONCE YOU CREATE A SCRIPT, YOUR STORY FOR YOUR MANGA IS DONE!

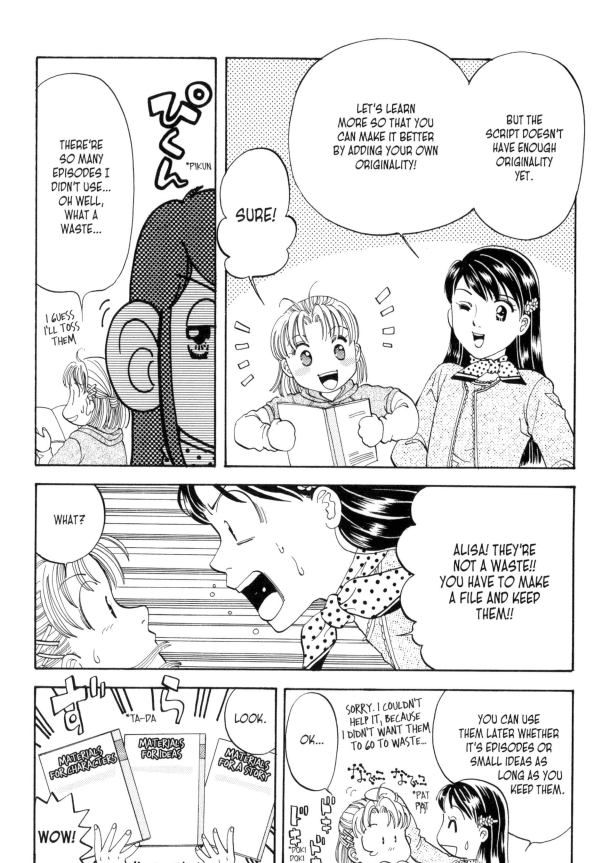

YOU NEVER WANT TO FORGET THE GOOD IDEAS YOU COME UP WITH. PLUS, THESE NOTEBOOKS HELP WHEN YOU'RE IN A SLUMP!

MAKE A HABIT OF WRITING DOWN THE IDEAS YOU COME UP WITH ALL THE TIME!

I'LL MAKE SOME NOTEBOOKS LIKE THESE RIGHT AWAY!!

MATERIALS FOR CHARACTERS

MATERIALS FOR IDEAS

MATERIALS FOR A STORYLINE

ALWAYS CARRY A NOTEBOOK AND PENCILS INSIDE YOUR BAG!!

COOL! I'LL TRY HARD TO BECOME A PROFESSIONAL MANGA ARTIST!!

WELL NOW, BASED ON THE 5W1H RULE, LET ME TEACH YOU A SUPER EASY STORY-MAKING METHOD. IT'LL ALSO TEACH YOU SOME INTERESTING TRICKS AND TOUCH ON HOW TO ADD YOUR OWN ORIGINALITY!!

● THE END ●

■ HOW TO EXPRESS THROUGH ILLUSTRATION ■

◎ HOW TO TRANSLATE THE DIFFERENT COMPONENTS OF MANGA INTO ILLUSTRATION

ILLUSTRATION IS CRUCIAL FOR A MANGA! BUT HOW DOES ONE REFLECT THE LITERAL FACTORS ONTO THE ILLUSTRATIONS? IN THIS SECTION, I'LL TEACH YOU SOME TIPS WHEN YOU DRAW THE ILLUSTRATIONS ON MANGA DRAFT PAPER.

■ HOW TO DRAW A MANGA USING THE EPISODES YOU CAME UP WITH (1) ■

◎ CLARITY IS THE FIRST STEP FOR A GOOD MANGA

EVEN IF YOU, AS THE AUTHOR, THINK "THIS EPISODE/STORYLINE WILL BE A MASSIVE HIT!" IF THE READERS DON'T UNDERSTAND THE CONTENTS CLEARLY, YOUR MANGA WILL BE MISUNDERSTOOD OR END UP BEING A BORING ONE. THEREFORE, IT IS IMPORTANT TO WORK ON THE STRUCTURE OF YOUR MANGA SO THAT THE READERS CAN UNDERSTAND THE CONTENTS CLEARLY.

▲ IT'S FUN TO WORK ON THE ILLUSTRATIONS WHEN DRAWING MANGA. HOWEVER, IF YOU COMPOSE YOUR MANGA STORY WITHOUT CONSIDERING THE READERS' POINT OF VIEW, THAT COULD MAKE THE CONTENT OF YOUR STORY UNCLEAR AND HARD TO UNDERSTAND.

KYOKO'S

ONE POINT ADVICE

KYOKO'S ONE-POINT ADVICE

◎IT'S IMPORTANT TO SHOW WHAT THE MAIN CHARACTER DOES, CLEARLY.

DRAWING MANGA CAN BE DIFFICULT SINCE THERE ARE MANY FACTORS TO CONSIDER, SUCH AS PANELING, DIALOG, THE LAYOUT OF THE PANELS, AND SPECIAL EFFECTS. WHAT CAN YOU DO TO MAKE THE READERS PROPERLY UNDERSTAND THE CONTENTS OF THE EPISODES AND THE STORYLINE?

LET'S MAKE IT SIMPLE BY SHOWING YOU THE KEY POINTS! DESCRIBE THE ACTIONS OF THE CHARACTERS, ESPECIALLY THE MAIN CHARACTER'S ACTIONS PRECISELY! APPLY THE "5W1H RULE" TO THE PANELING, ILLUSTRATIONS AND DIALOG!

PLEASE REFER TO "KYOKO'S ONE-POINT ADVICE" FROM PAGE 29 TO 30 FOR THE DETAILED DESCRIPTION OF HOW TO MAKE THE STORY BY FOLLOWING "5W1H RULE".

▲THIS MANGA WAS COMPOSED SO THE READERS COULD CLEARLY UNDERSTAND THAT "THE MAIN CHARACTER = ALISA MIZUKI" AND "HER ACTIONS = LEARNING HOW TO WRITE A MANGA STORY".

② KEY POINTS TO WRITING A STORY

BY NARROWING DOWN THE STORY-MAKING METHODS, YOU'LL BE ABLE TO CREATE A STORY-LINE EASILY AND EFFICIENTLY. FIND THE BEST METHOD FOR YOU FROM THE TEN "TIPS IN WRITING STORIES" THAT YOU'RE ABOUT TO LEARN.

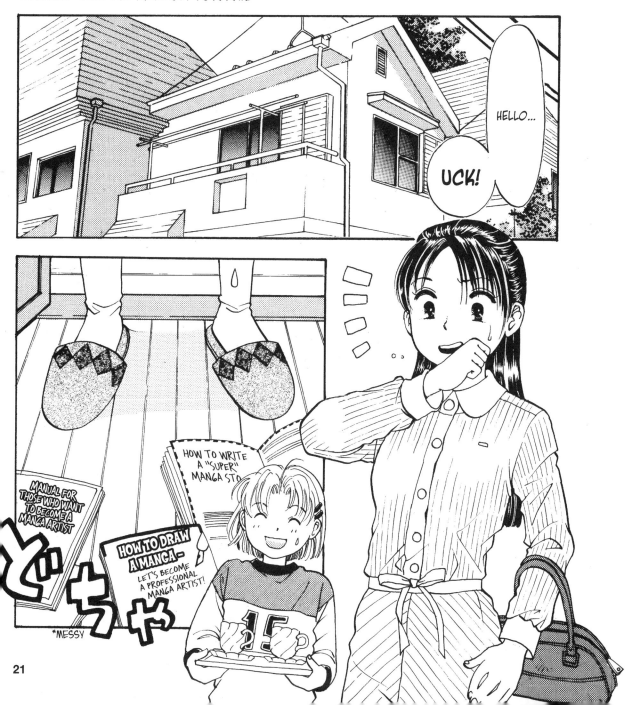

WOW... YOU'VE GOT SO MANY MANUALS...

PLEASE

I READ A LOT, BUT I DON'T QUITE GET IT.

EASY STORY-MAKING

THE 5W1H RULE YOU TAUGHT ME THE OTHER DAY WAS VERY EASY TO UNDERSTAND.

THANK YOU

EVERY PROFESSIONAL MANGA ARTIST HAS HIS/HER OWN WAY OF CREATING STORIES.

YOU CAN'T REALLY SAY WHICH METHOD IS THE RIGHT ONE SINCE THERE ARE SO MANY METHODS FOR MAKING STORIES.

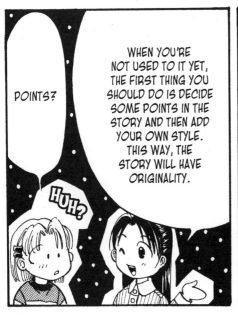

POINTS?

WHEN YOU'RE NOT USED TO IT YET, THE FIRST THING YOU SHOULD DO IS DECIDE SOME POINTS IN THE STORY AND THEN ADD YOUR OWN STYLE. THIS WAY, THE STORY WILL HAVE ORIGINALITY.

HUH?

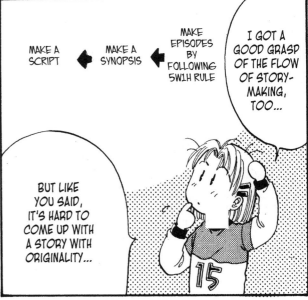

MAKE A SCRIPT ← MAKE A SYNOPSIS ← MAKE EPISODES BY FOLLOWING 5W1H RULE

I GOT A GOOD GRASP OF THE FLOW OF STORY-MAKING, TOO...

BUT LIKE YOU SAID, IT'S HARD TO COME UP WITH A STORY WITH ORIGINALITY...

 CLASSIFICATION OF POINTS IN STORY-MAKING

LEVEL	BASE POINT IN WRITING A STORY	DESCRIPTION
BEGINNER BASIC STORY-MAKING	**HAKOGAKI TECHNIQUE** (REFER TO PAGE 31 TO 38)	ONE METHOD OF STORY-MAKING IS TO CONNECT INDIVIDUAL EPISODES TOGETHER. THIS IS THE BASIC METHOD IN STORY-MAKING.
INTERMEDIATE STORY-MAKING USING KEYWORDS	**THEME** (REFER TO PAGE 39 TO 50)	THIS IS WHAT YOU (THE AUTHOR) WANTS TO EXPRESS IN A MANGA. IT COULD BE A MESSAGE TO THE READERS OR THE SCENES YOU ESPECIALLY WANT TO DRAW. YOU START WRITING A STORY BASED ON A THEME.
	IDEAS (REFER TO PAGE 51 TO 64)	IDEAS AND TRICKS THAT YOU COME UP WITH. YOU START WRITING A STORY BASED ON YOUR IDEAS THAT WILL ADD SPICE TO YOUR MANGA.
	SETTINGS (REFER TO PAGE 65 TO 76)	TO CREATE THE MOOD. YOU START WRITING A STORY BASED ON, 1) CHARACTER-RELATED SETTINGS SUCH AS RELATIONSHIPS, PERSONALITIES OR PAST EXPERIENCE; 2) WORLD-RELATED SETTINGS SUCH AS THE BACKGROUND, TIME, STATE OF SOCIETY OR SPECIAL TECHNIQUES.
	GENRE (REFER TO PAGE 77 TO 86)	CLASSIFICATIONS OF MANGA STORIES. THERE'RE SO MANY GENRES. YOU START WRITING A STORY BASED ON A STORY CLASSIFICATION SUCH AS LOVE, LOVE & COMEDY, SPORTS OR FANTASY.
	THE READERS' FEELINGS (REFER TO PAGE 87 TO 96)	THE IMPRESSIONS OR FEELINGS YOU HAVE AFTER YOU FINISH READING A MANGA. YOU START WRITING A STORY BASED UPON THE FEELINGS YOU WANT THE READERS TO HAVE, SUCH AS HAPPY, SAD OR TOUCHED.
	CHARACTERS (REFER TO PAGE 97 TO 110)	PEOPLE, ANIMALS OR THINGS THAT HAVE UNIQUE LOOKS OR PERSONALITY. YOU START WRITING A STORY BY CREATING A CHARACTER WITH A UNIQUE FEATURE.
ADVANCED STORY-MAKING WITH SPECIAL EFFECTS	**INTRODUCTION, DEVELOPMENT, TURN AND CONCLUSION** (REFER TO PAGE 111 TO 122)	A SPECIAL EFFECTS METHOD TO MAKE THE STORY MORE INTERESTING. YOU CAN TAKE ADVANTAGE OF THIS AND WRITE A STORY.
	DEVELOPMENT METHOD AND INDUCTIVE METHOD (REFER TO PAGE 123 TO 134)	A STORY-MAKING METHOD USING THE "FLOW OF A STORY"
	PAGE COUNT (REFER TO PAGE 135 TO 144)	THE NUMBER OF PAGES YOU PREPARE FOR YOUR MANGA WORK. YOU START WRITING A STORY BASED ON THE LENGTH SUCH AS SHORT STORIES, MEDIUM-LENGTH STORIES, LONG STORIES OR FOUR-PANEL CARTOONS.

LET ME CLASSIFY THE POINTS IN WRITING A STORY.

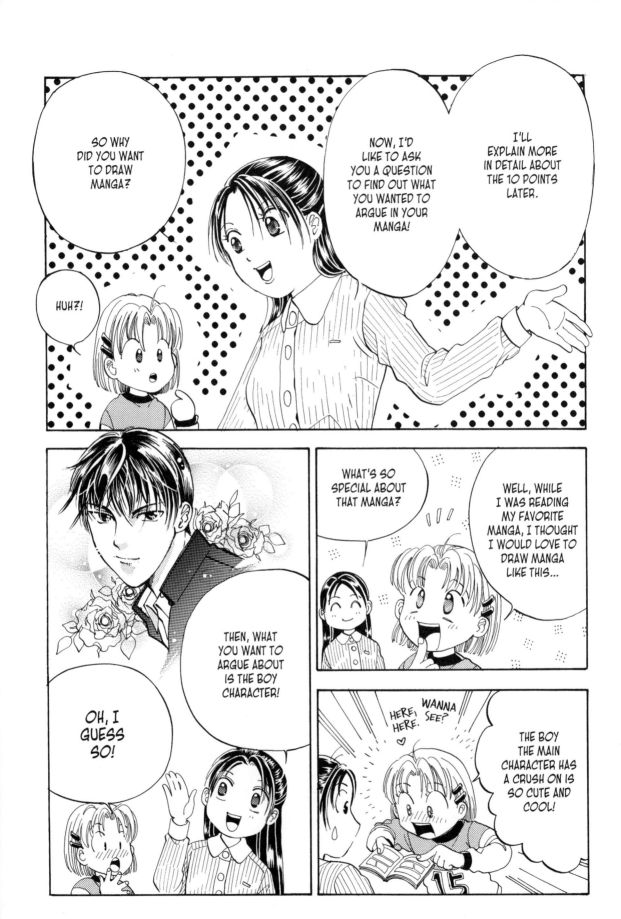

OH, THERE IS A SECTION REGARDING CHARACTERS!

NOW, TAKE A LOOK AT THE INTERMEDIATE SECTION IN THE "CLASSIFICATION OF POINTS IN STORY-MAKING".

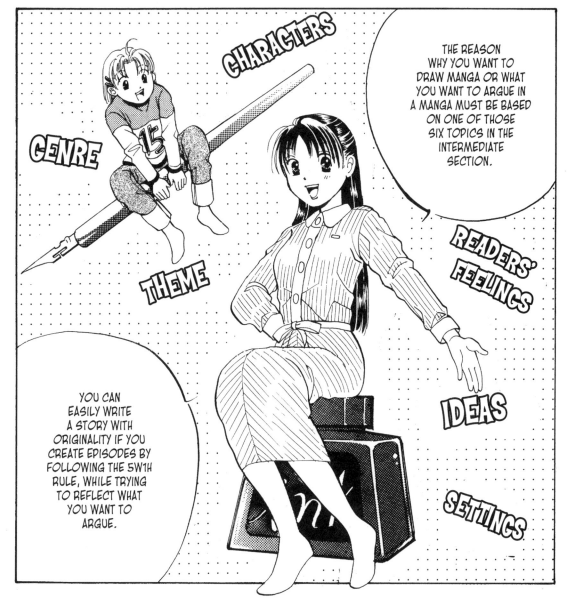

CHARACTERS

GENRE

THEME

READERS' FEELINGS

IDEAS

SETTINGS

THE REASON WHY YOU WANT TO DRAW MANGA OR WHAT YOU WANT TO ARGUE IN A MANGA MUST BE BASED ON ONE OF THOSE SIX TOPICS IN THE INTERMEDIATE SECTION.

YOU CAN EASILY WRITE A STORY WITH ORIGINALITY IF YOU CREATE EPISODES BY FOLLOWING THE 5W1H RULE, WHILE TRYING TO REFLECT WHAT YOU WANT TO ARGUE.

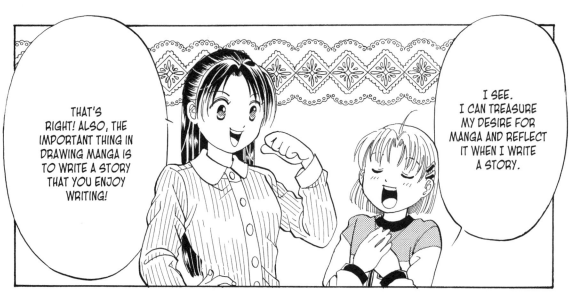

THAT'S RIGHT! ALSO, THE IMPORTANT THING IN DRAWING MANGA IS TO WRITE A STORY THAT YOU ENJOY WRITING!

I SEE. I CAN TREASURE MY DESIRE FOR MANGA AND REFLECT IT WHEN I WRITE A STORY.

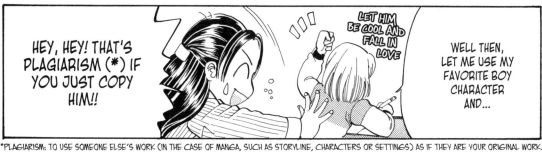

HEY, HEY! THAT'S PLAGIARISM (*) IF YOU JUST COPY HIM!!

LET HIM BE COOL AND FALL IN LOVE

WELL THEN, LET ME USE MY FAVORITE BOY CHARACTER AND...

*PLAGIARISM: TO USE SOMEONE ELSE'S WORK (IN THE CASE OF MANGA, SUCH AS STORYLINE, CHARACTERS OR SETTINGS) AS IF THEY ARE YOUR ORIGINAL WORK.

...WILL MAKE HIM ORIGINAL!

REARRANGING HIM...

*BING

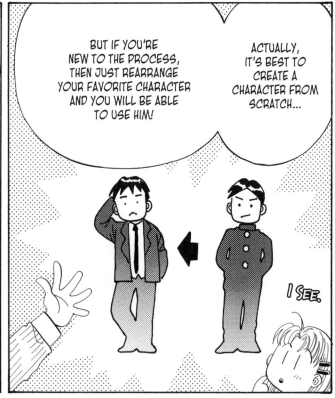

BUT IF YOU'RE NEW TO THE PROCESS, THEN JUST REARRANGE YOUR FAVORITE CHARACTER AND YOU WILL BE ABLE TO USE HIM!

ACTUALLY, IT'S BEST TO CREATE A CHARACTER FROM SCRATCH...

I SEE.

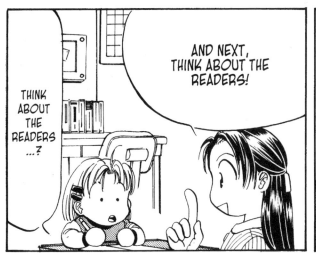

THINK ABOUT THE READERS...?

AND NEXT, THINK ABOUT THE READERS!

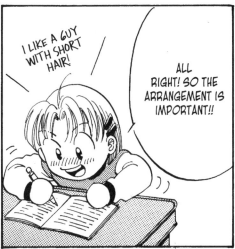

I LIKE A GUY WITH SHORT HAIR!

ALL RIGHT! SO THE ARRANGEMENT IS IMPORTANT!!

RIGHT. IT'S IMPORTANT THAT YOU WRITE SOMETHING YOU ENJOY. BUT IN THAT WAY, YOU TEND TO WRITE A SELF-SATISFYING STORY...

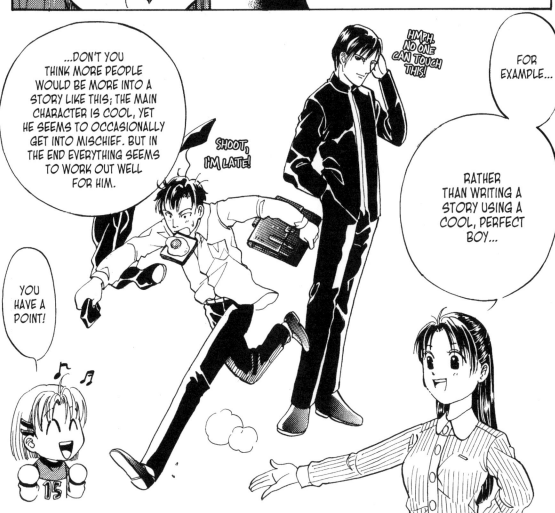

...DON'T YOU THINK MORE PEOPLE WOULD BE MORE INTO A STORY LIKE THIS; THE MAIN CHARACTER IS COOL, YET HE SEEMS TO OCCASIONALLY GET INTO MISCHIEF. BUT IN THE END EVERYTHING SEEMS TO WORK OUT WELL FOR HIM.

SHOOT, I'M LATE!

HMPH. NO ONE CAN TOUCH THIS!

FOR EXAMPLE...

RATHER THAN WRITING A STORY USING A COOL, PERFECT BOY...

YOU HAVE A POINT!

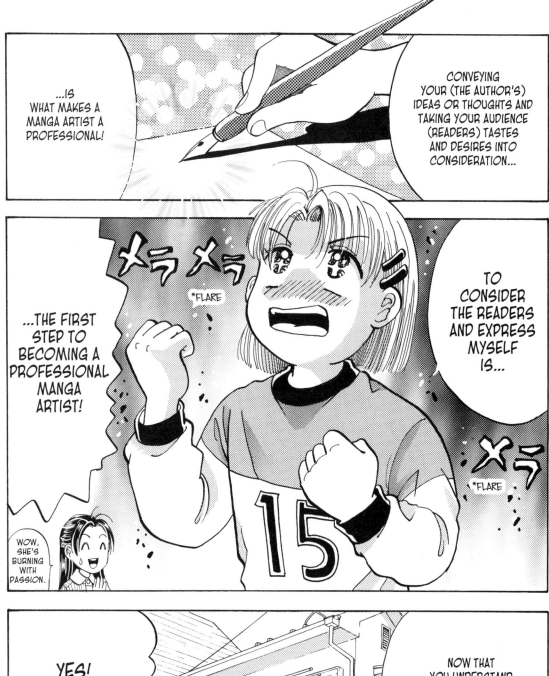

CONVEYING YOUR (THE AUTHOR'S) IDEAS OR THOUGHTS AND TAKING YOUR AUDIENCE (READERS) TASTES AND DESIRES INTO CONSIDERATION...

...IS WHAT MAKES A MANGA ARTIST A PROFESSIONAL!

TO CONSIDER THE READERS AND EXPRESS MYSELF IS...

...THE FIRST STEP TO BECOMING A PROFESSIONAL MANGA ARTIST!

*FLARE

*FLARE

WOW, SHE'S BURNING WITH PASSION.

NOW THAT YOU UNDERSTAND THE FLOW OF WRITING A STORY, LET'S TAKE IT TO THE NEXT LEVEL!

YES! PLEASE TEACH ME!!

● THE END ●

■ HOW TO DRAW A MANGA USING THE EPISODES YOU CAME UP WITH (2) ■

◎ APPLYING THE "5W1H RULE" IN PANELING AND ILLUSTRATING

IN ORDER TO HAVE THE READERS UNDERSTAND THE CONTENTS OF THE STORY OR EPISODES, YOU HAVE TO EXPLAIN THE CONTEXT BY FOLLOWING THE "5W1H RULE" EVERY TIME YOU PROCEED INTO A NEW EPISODE (SCENE). IT'S EASY IF YOU EXPLAIN THE CONTEXT USING SEVERAL PANELS LIKE IN THIS EXAMPLE.

↓WHO	↓WHEN	↓WHERE
ALISA MIZUKI	THIS AFTERNOON	ON THE BENCH IN A PARK

↓WHY
BECAUSE SHE COULDN'T WRITE A MANGA STORY

↓DO WHAT	↓HOW DID IT GO
ASKED KYOKO NAKASATO HOW TO WRITE A STORY	THEN SHE COULD WRITE A STORY.

KYOKO'S

ONE POINT ADVICE

IF YOU BREAK DOWN PAGES 8 – 16 BY FOLLOWING THE "5W1H RULE", IT SHOULD TURN OUT LIKE THE EXAMPLE ABOVE, RIGHT? THE FOLLOWING IS A DETAILED DESCRIPTION OF HOW TO DRAW A MANGA BY FOLLOWING THE RULE.

● WHO (WHO?): REFERS TO THE CHARACTERS. READERS KNOW WHO THE CHARACTERS ARE BY LOOKING AT THE ILLUSTRATION. YOU NEED TO MAKE SCENES TALKING ABOUT THE DETAILED DATA ABOUT THE CHARACTERS (SUCH AS NAMES OR PROFILES) SOMEWHERE AT THE BEGINNING.

▲ WHO: ALISA MIZUKI
THIS IS THE PANEL INTRODUCING THE CHARACTERS OF THIS MANGA. YOU CAN TELL BY THEIR LINES THAT KYOKO IS GOING TO TEACH ALISA. THE ROLES OF TWO CHARACTERS ARE EXPLAINED IN THIS PANEL.

◄ WHEN: THIS AFTERNOON. THE PANEL IS SHOWING THE TIME OF DAY THROUGH THE SCENERY.
*THESE KINDS OF PANELS ARE SOMETIMES USED TO SHOW HOW MUCH TIME HAS PASSED.

KYOKO'S ONE-POINT ADVICE

● *WHEN (WHEN?):* REFERS WHAT TIME IT IS IN THE STORY. YOU CAN SHOW THE TIME BY DRAWING A CLOCK IN THE BACKGROUND, THE POSITION OF THE SUN/MOON OR THE COLOR OF THE SKY. YOU CAN ALSO SHOW THIS BY HAVING THE CHARACTER LOOK AT HIS/HER WATCH.

● *WHERE (WHERE?):* REFERS TO THE PLACE THE CHARACTERS ARE. YOU CAN SHOW THE READERS WHERE THE CHARACTERS ARE BY DRAWING A BACK-GROUND. YOU CAN ALSO DRAW SOMETHING THAT SYMBOLIZES THE PLACE SUCH AS A SIGNBOARD OR A STATUE.

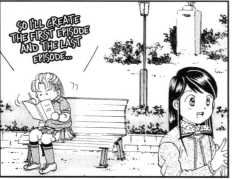

SO I'LL CREATE THE FIRST EPISODE AND THE LAST EPISODE...

▲ WHERE: ON THE BENCH IN A PARK. THIS PANEL SHOWS THE LOCATION WHERE THIS STORY TAKES PLACE. WHEN YOU WORK ON A NEW EPISODE, IT'S ALWAYS GOOD TO DRAW AN ESTABLISHING SHOT (THE LOCATION/SCENERY WHERE THE STORY TAKES PLACE) IN THE FIRST PANEL BECAUSE YOU CAN EXPLAIN "WHERE" AND WHEN" THE EPISODE TAKES PLACE.

● *WHAT (DO WHAT?):* THIS REFERS TO WHAT THE CHARACTER WANTS TO DO. YOU CAN SHOW IT THROUGH THE CHARACTER'S DIALOG OR ACTIONS.

● *WHY (WHY?):* THIS REFERS TO THE REASON WHY THE CHARACTER ACTS THE WAY HE/SHE DOES. YOU CAN EXPRESS IT THROUGH THE CHARACTER'S DIALOG OR ACTIONS.

● *HOW (HOW DID IT GO?):* THIS REFERS TO THE RESULTS OF THE CHARACTER'S ACTIONS. THE CHARACTER'S DIALOG OR ACTIONS SHOULD EXPRESS THIS POINT. YOU CAN ALSO USE NARRATION.

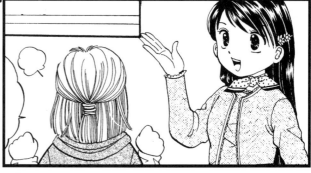

▲ WHAT: ALISA ASKED KYOKO HOW TO WRITE A STORY. IN ADDITION TO THIS PANEL, THE FOLLOWING PANELS WILL SHOW WHAT ALISA DOES IN THIS STORY.

◄ WHY: BECAUSE ALISA COULDN'T WRITE A MANGA STORY THIS PANEL SHOWS THE REASON BEHIND ALISA'S ACTION THROUGH HER DIALOG.

*PAT PAT PAT

▲ HOW DID IT GO: ALISA COULD WRITE A STORY. THE PANEL SHOWS THE RESULTS THROUGH THE DIALOG AND THE CHARACTER'S FACIAL EXPRESSION.

③ HAKOGAKI TECHNIQUE: THE BASICS OF WRITING STORIES

THE HAKOGAKI TECHNIQUE IS A SPECIAL TECHNIQUE THAT THE PROFESSIONAL MANGA ARTISTS ALSO USE! IT'S LIKE CONNECTING EPISODES WITH GLUE. THIS TECHNIQUE IS THE BASIS FOR VARIOUS TYPES OF STORY-MAKING, SO YOU HAVE TO MASTER IT!

WHOOPEE! WHAT SHALL I EAT? I CAN'T MAKE UP MY MIND.

IT'S ALL YOU CAN EAT.

IT'S MY TREAT TODAY.

BUFFET LUNCH

AND WE CAN FIND SOME TIPS FOR WRITING MANGA STORIES HERE!

DESSERT, FRUITS, DRINKS...

ANTIPASTO, SOUP, SALAD, MAIN DISHES...

MANGA TIPS? HERE?

HUH!?

WOW

ゴ゙ッ゙でり
*FULL PLATE

YES!

NOW THAT WE'VE FINISHED EATING, SHALL WE LEARN MORE ABOUT MANGA?

THAT WAS GOOD, WASN'T IT?

レ゙ッ゙プ゚
*BURP

GOSH. I'M FULL.

I MENTIONED IT A LITTLE IN THE PREVIOUS LESSON, BUT LET ME EXPLAIN MORE.

NO, "BOX WRITING" OR "HAKOGAKI" IS THE BASIS OF STORY-MAKING THAT EVERYBODY CAN USE.

OK!

"BOX RIDING?"

TODAY, WE'LL DISCUSS THE "HAKOGAKI" OR "BOX WRITING" TECHNIQUE.

ORANGE

32

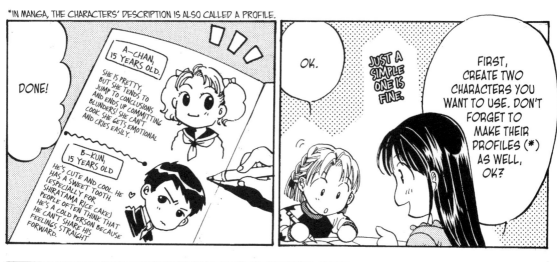

DONE!

A-CHAN, 15 YEARS OLD.

SHE IS PRETTY, BUT SHE TENDS TO JUMP TO CONCLUSIONS AND ENDS UP COMMITTING BLUNDERS! SHE CAN'T COOK. SHE GETS EMOTIONAL AND CRIES EASILY.

B-KUN, 15 YEARS OLD.

HE'S CUTE AND COOL. HE HAS A SWEET TOOTH. (ESPECIALLY FOR SHIRATAMA RICE CAKE) PEOPLE OFTEN THINK THAT HE'S A COLD PERSON BECAUSE HE CAN'T SHARE HIS FEELINGS STRAIGHT FORWARD.

OK.

JUST A SIMPLE ONE IS FINE.

FIRST, CREATE TWO CHARACTERS YOU WANT TO USE. DON'T FORGET TO MAKE THEIR PROFILES (*) AS WELL, OK?

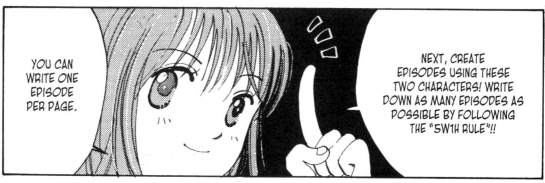

YOU CAN WRITE ONE EPISODE PER PAGE.

NEXT, CREATE EPISODES USING THESE TWO CHARACTERS! WRITE DOWN AS MANY EPISODES AS POSSIBLE BY FOLLOWING THE "5W1H RULE"!!

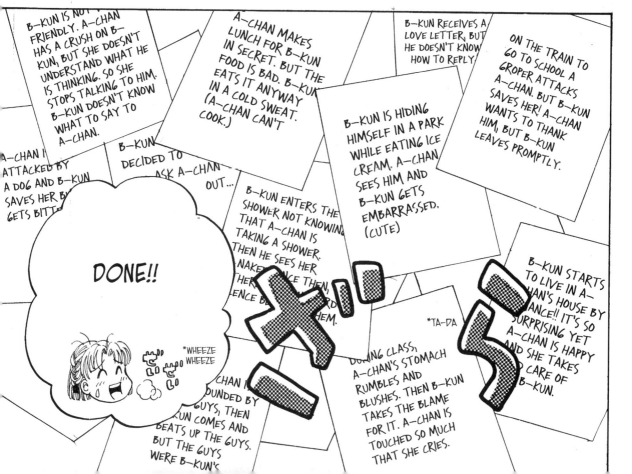

B-KUN IS NOT FRIENDLY. A-CHAN HAS A CRUSH ON B-KUN, BUT SHE DOESN'T UNDERSTAND WHAT HE IS THINKING. SO SHE STOPS TALKING TO HIM. B-KUN DOESN'T KNOW WHAT TO SAY TO A-CHAN.

A-CHAN MAKES LUNCH FOR B-KUN IN SECRET. BUT THE FOOD IS BAD. B-KUN EATS IT ANYWAY IN A COLD SWEAT. (A-CHAN CAN'T COOK.)

B-KUN RECEIVES A LOVE LETTER, BUT HE DOESN'T KNOW HOW TO REPLY.

ON THE TRAIN TO GO TO SCHOOL A GROPER ATTACKS A-CHAN. BUT B-KUN SAVES HER! A-CHAN WANTS TO THANK HIM, BUT B-KUN LEAVES PROMPTLY.

A-CHAN IS ATTACKED BY A DOG AND B-KUN SAVES HER BUT GETS BITTEN.

B-KUN DECIDED TO ASK A-CHAN OUT...

B-KUN IS HIDING HIMSELF IN A PARK WHILE EATING ICE CREAM. A-CHAN SEES HIM AND B-KUN GETS EMBARRASSED. (CUTE)

B-KUN ENTERS THE SHOWER NOT KNOWING THAT A-CHAN IS TAKING A SHOWER. THEN HE SEES HER NAKED. THEN...

DONE!!

*WHEEZE WHEEZE

*TA-DA

B-KUN STARTS TO LIVE IN A-CHAN'S HOUSE BY SURPRISING YET A-CHAN IS HAPPY AND SHE TAKES CARE OF B-KUN.

CHAN IS OUNDED BY GUYS, THEN UN COMES AND BEATS UP THE GUYS. BUT THE GUYS WERE B-KUN'S

DURING CLASS, A-CHAN'S STOMACH RUMBLES AND BLUSHES. THEN B-KUN TAKES THE BLAME FOR IT. A-CHAN IS TOUCHED SO MUCH THAT SHE CRIES.

OH!

OK.

THANKS

*CLAP CLAP

YOU DID A GREAT JOB! NOW, LINE THEM UP IN THE ORDER YOU LIKE...

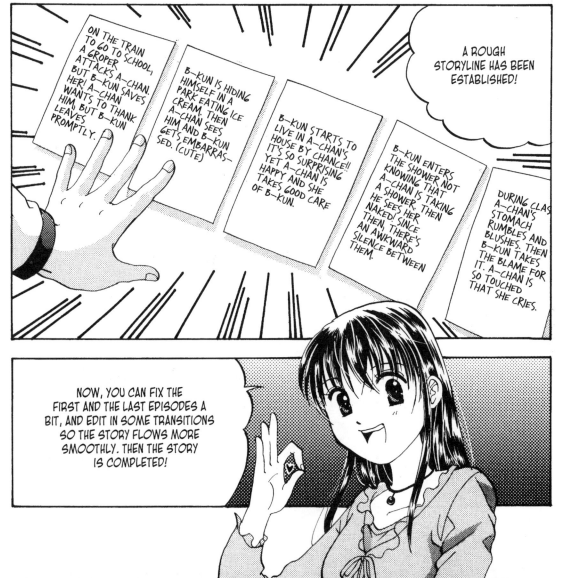

A ROUGH STORYLINE HAS BEEN ESTABLISHED!

ON THE TRAIN TO GO TO SCHOOL, A GROPER ATTACKS A-CHAN, BUT B-KUN SAVES HER! A-CHAN WANTS TO THANK HIM, BUT B-KUN LEAVES PROMPTLY.

B-KUN IS HIDING HIMSELF IN A PARK EATING ICE CREAM. THEN A-CHAN SEES HIM AND B-KUN GETS EMBARRAS-SED. (CUTE)

B-KUN STARTS TO LIVE IN A-CHAN'S HOUSE BY CHANCE!! IT'S SO SURPRISING YET A-CHAN IS HAPPY AND SHE TAKES GOOD CARE OF B-KUN.

B-KUN ENTERS THE SHOWER NOT KNOWING THAT A-CHAN IS TAKING A SHOWER. THEN HE SEES HER NAKED! SINCE THEN, THERE'S AN AWKWARD SILENCE BETWEEN THEM.

DURING CLASS A-CHAN'S STOMACH RUMBLES AND BLUSHES. THEN B-KUN TAKES THE BLAME FOR IT. A-CHAN IS SO TOUCHED THAT SHE CRIES.

NOW, YOU CAN FIX THE FIRST AND THE LAST EPISODES A BIT, AND EDIT IN SOME TRANSITIONS SO THE STORY FLOWS MORE SMOOTHLY. THEN THE STORY IS COMPLETED!

34

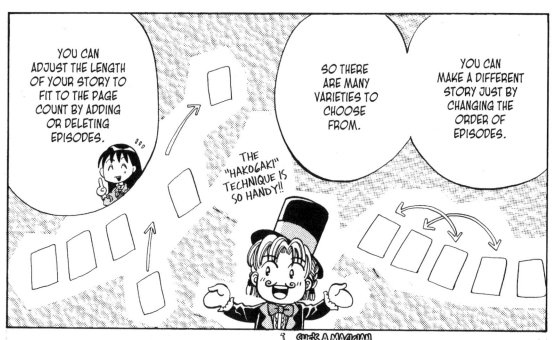

YOU CAN ADJUST THE LENGTH OF YOUR STORY TO FIT TO THE PAGE COUNT BY ADDING OR DELETING EPISODES.

THE "HAKOGAKI" TECHNIQUE IS SO HANDY!!

SO THERE ARE MANY VARIETIES TO CHOOSE FROM.

YOU CAN MAKE A DIFFERENT STORY JUST BY CHANGING THE ORDER OF EPISODES.

SHE'S A MAGICIAN.

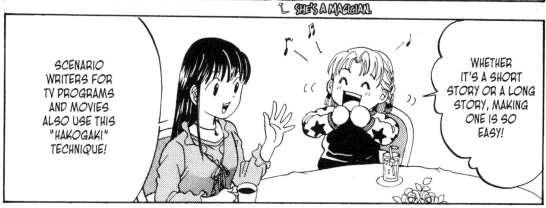

SCENARIO WRITERS FOR TV PROGRAMS AND MOVIES ALSO USE THIS "HAKOGAKI" TECHNIQUE!

WHETHER IT'S A SHORT STORY OR A LONG STORY, MAKING ONE IS SO EASY!

LEAVE IT TO ME! I'VE ALREADY MADE NOTEBOOKS FOR EACH SUBJECT!!

*TA-DA

OF COURSE YOU MUST KEEP THE EPISODES YOU DON'T USE.

MATERIALS FOR CHARACTERS

MATERIALS FOR IDEAS

MATERIALS FOR A STORYLINE

THEN ADD ORIGINALITY BY ADDING SOME INTERESTING IDEAS AND TAKING THE READERS INTO CONSIDERATION.

THE POINT OF THE "HAKOGAKI" TECHNIQUE IS TO DECIDE THE ORDER OF THE EPISODES.

SO, PLEASE MASTER THIS ONE. ♡

OTHER METHODS FOR STORY-MAKING ARE VARIATIONS OF THE "HAKOGAKI" TECHNIQUE.

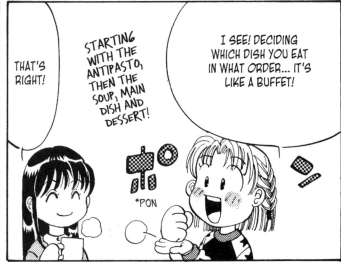

THAT'S RIGHT!

STARTING WITH THE ANTIPASTO, THEN THE SOUP, MAIN DISH AND DESSERT!

I SEE! DECIDING WHICH DISH YOU EAT IN WHAT ORDER... IT'S LIKE A BUFFET!

*PON

WHAT!?

YOU'RE STILL EATING!

*SHOCK!

HUMMING ♪

NOW THAT I'VE LEARNED ABOUT "HAKOGAKI," LET'S GET DESSERT!

● THE END ●

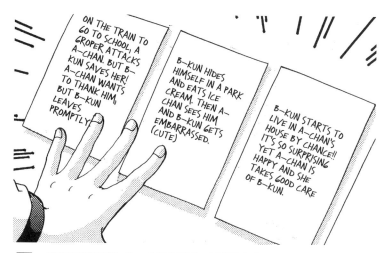

ON THE TRAIN TO GO TO SCHOOL, A GROPER ATTACKS A-CHAN. BUT B-KUN SAVES HER! A-CHAN WANTS TO THANK HIM, BUT B-KUN LEAVES PROMPTLY.

B-KUN HIDES HIMSELF IN A PARK AND EATS ICE CREAM. THEN A-CHAN SEES HIM AND B-KUN GETS EMBARRASSED. (CUTE)

B-KUN STARTS TO LIVE IN A-CHAN'S HOUSE BY CHANCE!! IT'S SO SURPRISING YET A-CHAN IS HAPPY AND SHE TAKES GOOD CARE OF B-KUN.

■ CREATING CHARACTERS USING THE HAKOGAKI TECHNIQUE ■

◎ THE APPLIED TECHNIQUE OF HAKOGAKI

FROM PAGE 31 TO 36, WE HAVE STUDIED HOW TO USE THE HAKOGAKI TECHNIQUE AS FOLLOWS; (1) CREATE CHARACTERS FIRST; (2) CREATE EPISODES USING CHARACTERS; (3) CONNECT EACH EPISODE AND MAKE A STORY.

ON THE OTHER HAND, THERE IS A WAY TO CREATE CHARACTERS LATER. TO DO SO, (1) FIRST, CREATE AN EPISODE THAT INCLUDES THE SCENE YOU WANT TO DRAW; (2) CREATE OTHER EPISODES AND CONNECT THEM TO MAKE A STORY. YOU CAN TAKE OUT AN EPISODE THAT DOESN'T FIT, OR CHANGE THE ORDER OF EPISODES AND MODULATE THE STORY.

THEN YOU CAN CREATE CHARACTERS AND SETTINGS BASED ON THE EPISODES AND STORY THAT YOU'VE MADE.

▲ YOU CAN DO WHATEVER YOU WANT SUCH AS ADDING OR TAKING OUT EPISODES, OR CHANGING THE ORDER OF EPISODES. WHAT'S GOOD ABOUT HAKOGAKI IS THAT IT IS A FLEXIBLE TECHNIQUE AND IT CAN BE WIDELY APPLIED.

KYOKO'S ONE POINT ADVICE

◎ *CHARACTERS SHOULD HAVE THEIR OWN INDIVIDUALITIES.*

IF YOU LIKE MANGA, ONCE YOU ESTABLISH THE STORYLINE, YOU SHOULD HAVE A ROUGH IDEA OF THE CHARACTERS YOU NEED, RIGHT?

HOWEVER, IF YOU CREATE CHARACTERS JUST FROM ROUGH IDEAS, THEY TEND TO LACK INDIVIDUALITY.

THIS IS BECAUSE YOU, AS THE AUTHOR, UNCONSCIOUSLY INHIBIT THE CHARACTERS FROM TAKING ACTIONS THAT MAKE THE STORY GO SMOOTHLY. IN THIS CASE, YOU CAN THINK "UNIQUE ACTIONS" AS "INDIVIDUALITY".

SO, LET ME EXPLAIN HOW TO GIVE INDIVIDUALITIES TO THE CHARACTERS, ESPECIALLY THE MAIN CHARACTER IF YOU'VE ALREADY ESTABLISHED THE STORYLINE. WELL, YOU CAN DO THAT BY DISTINGUISHING THE MAIN CHARACTER FROM THE OTHER CHARACTERS! MAKE THE MAIN CHARACTER THE MOST OUTSTANDING ONE BY GIVING HIM/HER DIFFERENT FASHION, HABITS, OR EXTRAORDINARY FEATURES.

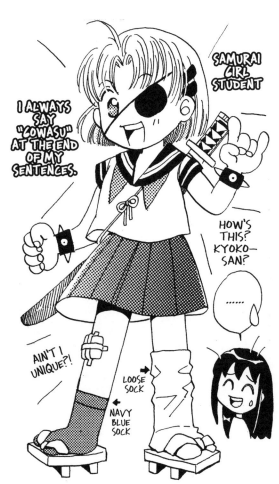

SAMURAI GIRL STUDENT

I ALWAYS SAY "COWASU" AT THE END OF MY SENTENCES.

HOW'S THIS? KYOKO-SAN?

......

AIN'T I UNIQUE?!

← LOOSE SOCK

← NAVY BLUE SOCK

● *FASHION:* MAKE THE MAIN CHARACTER'S SCHOOL UNIFORM INTO A LOUD, GAUDY ONE. IF THE STORY IS TAKING PLACE AT A SCHOOL AND CHARACTERS ARE WEARING SCHOOL UNIFORMS, CREATE SOME ACCESSORIES SPECIFIC TO THE MAIN CHARACTER. THE DISTINCTIVE LOOK BECOMES HER INDIVIDUALITY.

● *HABITS:* GIVE SOME DISTINCTIVE FEATURES TO THE MAIN CHARACTER, SUCH AS A SPEECH PATTERN OR DIALECT, WEIRD LIFE STYLE OR THE FACT THAT SHE HAS TO STRIKE A POSE WHEN SHE DOES SOMETHING. THE DISTINCTIVE ACTION BECOMES HER INDIVIDUALITY.

● *EXTRAORDINARY FEATURE:* GIVE AN EXTRAORDINARY FEATURE TO THE MAIN CHARACTER THAT SURPRISES THE READERS, SUCH AS HER PERSONALITY IS TOTALLY DIFFERENT FROM HOW SHE LOOKS OR SHE'S ROUGH AROUND THE EDGES, BUT SHE HAS SWEET TOOTH. THE EXTRAORDINARY FEATURE BECOMES HER INDIVIDUALITY.

④ WRITING STORIES OUT OF A THEME

THE WORD "THEME" MAY SOUND DIFFICULT TO UNDERSTAND, BUT DON'T THINK TOO HARD. YOU CAN TAKE "THEME" AS "WHAT YOU WANT TO EXPRESS". THIS WAY, IT'LL BE EASY TO WRITE A STORY, WON'T IT? FIRST, LET'S SPECIFY WHAT YOU WANT TO EXPRESS!

ONCE YOU UNDERSTAND THE BASICS, WRITING STORIES AREN'T SCARY AT ALL, ARE THEY?

THANKS TO YOU, I HAVE A BETTER GRASP OF THE STORY-MAKING PROCESS!

WHAT!?

THAT WAS JUST THE TIP OF THE ICEBERG OF STORY-MAKING!

OH YEAH! MY G-PEN THIRSTS FOR WORK!

*RRUMMBLE

NOW I CAN FINALLY DRAW A MANGA!

OH, WAS THAT ENOUGH?

THE ROUGH STORYLINE IS DONE, RIGHT?

B~KUN IS HIDING HIMSELF IN A PARK EATING ICE CREAM. THEN A~CHAN SEES HIM AND B~KUN GETS EMBARRAS- SED. (CUTE)

B~KUN STARTS TO LIVE IN A~CHAN'S HOUSE BY CHANCE!! IT'S SO SURPRISING YET A~CHAN IS HAPPY AND SHE TAKES GOOD CARE OF B~KUN.

B~KUN ENTERS THE SHOWER NOT KNOWING THAT A~CHAN IS TAKING A SHOWER. THEN HE SEES HER NAKED! SINCE THEN, THERE'S AN AWKWARD SILENCE BETWEEN THEM.

BUT...

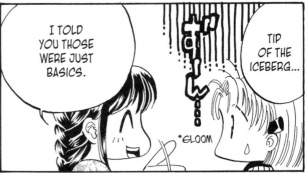

I TOLD YOU THOSE WERE JUST BASICS.

*GLOOM

TIP OF THE ICEBERG...

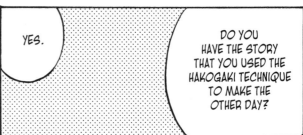

YES.

DO YOU HAVE THE STORY THAT YOU USED THE HAKOGAKI TECHNIQUE TO MAKE THE OTHER DAY?

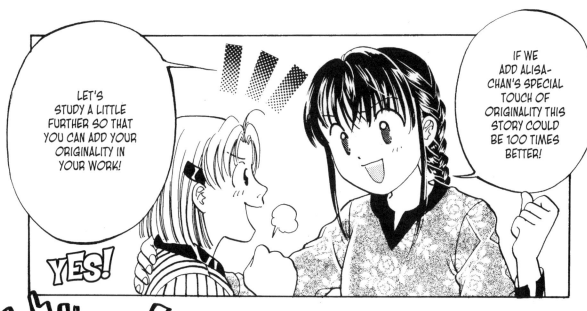

IF WE ADD ALISA-CHAN'S SPECIAL TOUCH OF ORIGINALITY THIS STORY COULD BE 100 TIMES BETTER!

LET'S STUDY A LITTLE FURTHER SO THAT YOU CAN ADD YOUR ORIGINALITY IN YOUR WORK!

YES!

YES! RIGHT HERE!!

TAKE A LOOK AT THE "CLASSIFICATION OF POINTS IN STORY-MAKING" (*) THAT I TAUGHT YOU THE OTHER DAY.

*REFER TO PAGE 23.

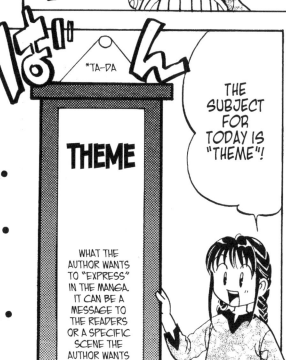

*TA-DA

THE SUBJECT FOR TODAY IS "THEME"!

THEME

WHAT THE AUTHOR WANTS TO "EXPRESS" IN THE MANGA. IT CAN BE A MESSAGE TO THE READERS OR A SPECIFIC SCENE THE AUTHOR WANTS TO DRAW.

NOW THAT WE'VE MASTERED THE BEGINNER'S LEVEL, LET US PROCEED TO THE INTERMEDIATE LEVEL.

OK

A THEME SHOULD BE SIMPLE AND EASY AS POSSIBLE TO UNDERSTAND.

SIMPLE

IN MANGA, THE "THEME" IS MERELY "WHAT THE AUTHOR WANTS TO EXPRESS".

THE WORD "THEME" MAKES IT SOUND VERY DIFFICULT.

MMM

 IF THERE IS A SOLID THEME THE FOLLOWING ADVANTAGES WILL BE PRESENT.

PREVENT THE STORY FROM GETTING OFF TRACK	IT'LL PREVENT THE AUTHOR FROM USING EPISODES THAT COULD MAKE THE STORY DIGRESS FROM WHAT THE AUTHOR WANTS TO EXPRESS.
INTEGRATE THE STORY	IT'LL INTEGRATE THE STORY SINCE THE AUTHOR WILL CHOOSE THE EPISODES WHICH CONTAINS; 1) THE MESSAGE HE/SHE WANTS TO EXPRESS TO THE READERS OR 2) THE SCENE HE/SHE WANTS TO DRAW.
MAKES IT EASY TO FOLLOW THE 5W1H RULE	SINCE WHAT THE AUTHOR WANTS TO EXPRESS IS CLEAR, HE/SHE CAN EASILY FOLLOW THE 5W1H RULE AND CREATE MULTIPLE EPISODES.

TO EXPLAIN IT SIMPLY, THERE'RE THREE CATEGORIES FOR THEMES.

DON'T THINK TOO HARD.

MMM...

WHAT DO I WANT TO DRAW...? WHAT DO I WANT TO EXPRESS...?

 CATEGORIES OF THEME

ILLUSTRATION THEME	THE SCENE THE AUTHOR WANTS TO DRAW. FOR EXAMPLE, "I WANT TO DRAW THE SCENE IN WHICH THE MAIN CHARACTER AND HER BOYFRIEND KISS." THIS WILL MAKE THE ILLUSTRATION MORE DYNAMIC.
TEXT THEME	THE STORY OR DIALOG THE AUTHOR WANTS TO WRITE. FOR EXAMPLE, "I WANT TO MAKE A STORY WHERE THE MAIN CHARACTER FALLS IN LOVE WITH AN ALIEN." THIS WILL MAKE THE SETTINGS AND DEVELOPMENT OF THE STORY MORE DYNAMIC.
BOTH ILLUSTRATION AND TEXT THEME	THE CHARACTERS OR THE WORLD THE AUTHOR WANTS TO DRAW. FOR EXAMPLE, "I WISH THERE WAS A NICE CHARACTER LIKE THIS..." THIS WILL MAKE THE CHARACTERS AND THE GENRE MORE DYNAMIC.

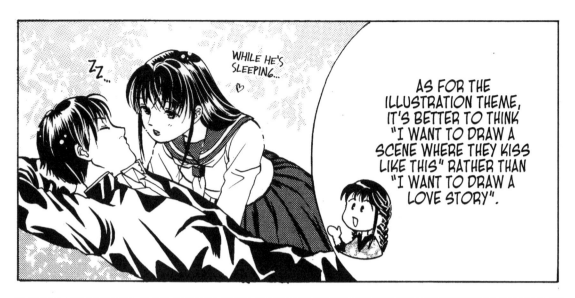

WHILE HE'S SLEEPING...

ZZ...

AS FOR THE ILLUSTRATION THEME, IT'S BETTER TO THINK "I WANT TO DRAW A SCENE WHERE THEY KISS LIKE THIS" RATHER THAN "I WANT TO DRAW A LOVE STORY".

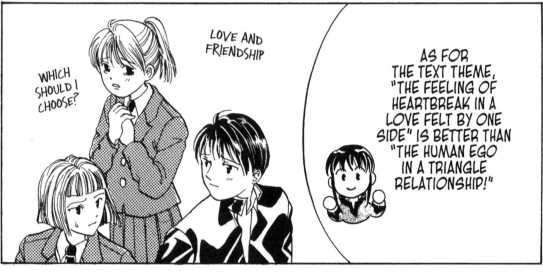

WHICH SHOULD I CHOOSE?

LOVE AND FRIENDSHIP

AS FOR THE TEXT THEME, "THE FEELING OF HEARTBREAK IN A LOVE FELT BY ONE SIDE" IS BETTER THAN "THE HUMAN EGO IN A TRIANGLE RELATIONSHIP!"

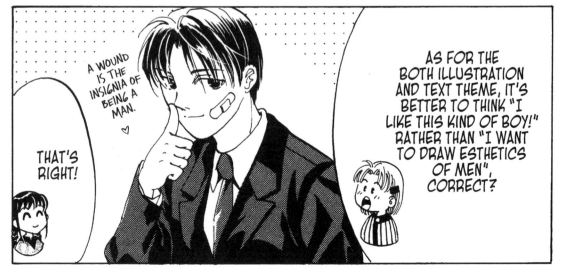

A WOUND IS THE INSIGNIA OF BEING A MAN.

THAT'S RIGHT!

AS FOR THE BOTH ILLUSTRATION AND TEXT THEME, IT'S BETTER TO THINK "I LIKE THIS KIND OF BOY!" RATHER THAN "I WANT TO DRAW ESTHETICS OF MEN", CORRECT?

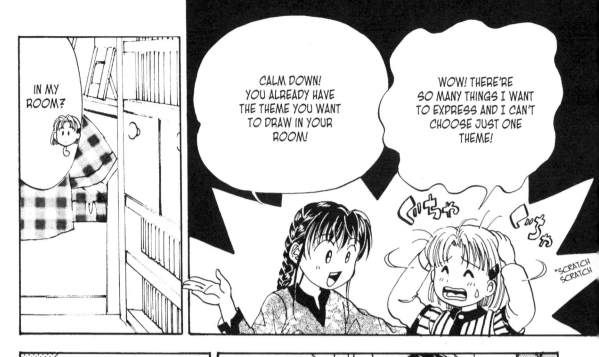

IN MY ROOM?

CALM DOWN! YOU ALREADY HAVE THE THEME YOU WANT TO DRAW IN YOUR ROOM!

WOW! THERE'RE SO MANY THINGS I WANT TO EXPRESS AND I CAN'T CHOOSE JUST ONE THEME!

*SCRATCH SCRATCH

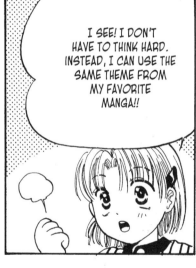

I SEE! I DON'T HAVE TO THINK HARD. INSTEAD, I CAN USE THE SAME THEME FROM MY FAVORITE MANGA!!

RIGHT! JUST LOOK THROUGH ALL OF THE MANGA BOOKS YOU HAVE!!

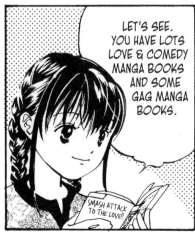

LET'S SEE. YOU HAVE LOTS LOVE & COMEDY MANGA BOOKS AND SOME GAG MANGA BOOKS.

SMASH ATTACK TO THE LOVE!!

"I WANT TO DRAW A FUNNY LOVE RELATIONSHIP" OR "I WANT TO DRAW A GIRL WHO FALLS IN LOVE AND BLUNDERS ALL THE TIME".

WELL THEN, HOW ABOUT THESE?

IT'LL BE EASIER TO COME UP WITH THE EPISODES AND IDEAS IF THE THEME IS ABOUT SOMETHING YOU'RE INTERESTED IN.

IDEA
IDEA
EA
DEA
IDEA
IDEA

*POP POP POP

WOW! THEY BOTH SOUND REALLY FUN.

OH! HOW ABOUT THIS...?

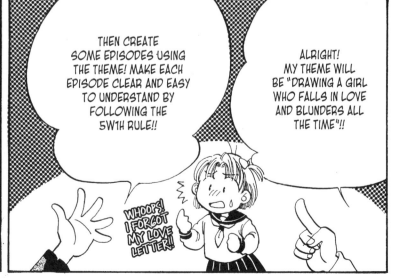

THEN CREATE SOME EPISODES USING THE THEME! MAKE EACH EPISODE CLEAR AND EASY TO UNDERSTAND BY FOLLOWING THE 5W1H RULE!!

ALRIGHT! MY THEME WILL BE "DRAWING A GIRL WHO FALLS IN LOVE AND BLUNDERS ALL THE TIME"!!

WHOOPS! I FORGOT MY LOVE LETTER!!

45

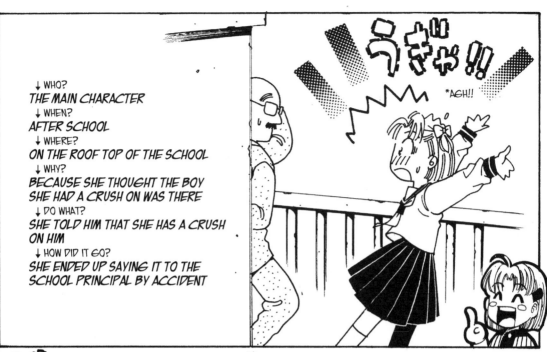

↓ WHO?
THE MAIN CHARACTER
↓ WHEN?
AFTER SCHOOL
↓ WHERE?
ON THE ROOF TOP OF THE SCHOOL
↓ WHY?
BECAUSE SHE THOUGHT THE BOY
SHE HAD A CRUSH ON WAS THERE
↓ DO WHAT?
SHE TOLD HIM THAT SHE HAS A CRUSH
ON HIM
↓ HOW DID IT GO?
SHE ENDED UP SAYING IT TO THE
SCHOOL PRINCIPAL BY ACCIDENT

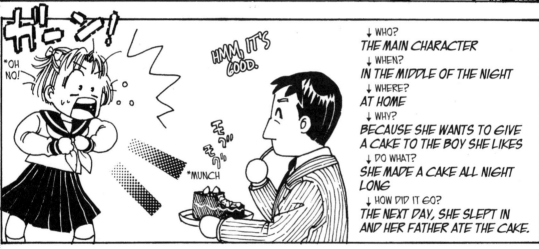

↓ WHO?
THE MAIN CHARACTER
↓ WHEN?
IN THE MIDDLE OF THE NIGHT
↓ WHERE?
AT HOME
↓ WHY?
BECAUSE SHE WANTS TO GIVE
A CAKE TO THE BOY SHE LIKES
↓ DO WHAT?
SHE MADE A CAKE ALL NIGHT
LONG
↓ HOW DID IT GO?
THE NEXT DAY, SHE SLEPT IN
AND HER FATHER ATE THE CAKE.

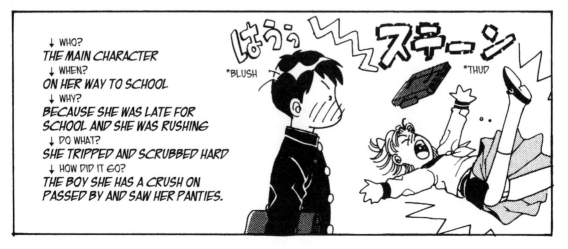

↓ WHO?
THE MAIN CHARACTER
↓ WHEN?
ON HER WAY TO SCHOOL
↓ WHY?
BECAUSE SHE WAS LATE FOR
SCHOOL AND SHE WAS RUSHING
↓ DO WHAT?
SHE TRIPPED AND SCRUBBED HARD
↓ HOW DID IT GO?
THE BOY SHE HAS A CRUSH ON
PASSED BY AND SAW HER PANTIES.

AS LONG AS YOU HAVE A THEME, YOU CAN COME UP WITH A TON OF EPISODES!

THEME

OK!

*BARI BARI

THESE ARE PRETTY FUN!

RIGHT ON. JUST KEEP WRITING MORE EPISODES!

YAHOO! I GOT MY STORY DONE!

HURRAY

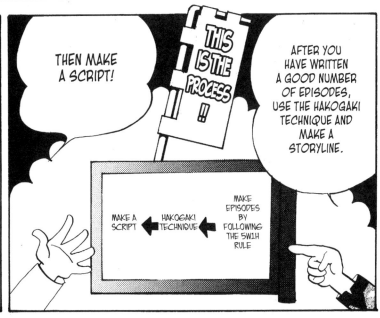

THEN MAKE A SCRIPT!

THIS IS THE PROCESS !!

MAKE A SCRIPT ← HAKOGAKI TECHNIQUE ← MAKE EPISODES BY FOLLOWING THE 5W1H RULE

AFTER YOU HAVE WRITTEN A GOOD NUMBER OF EPISODES, USE THE HAKOGAKI TECHNIQUE AND MAKE A STORYLINE.

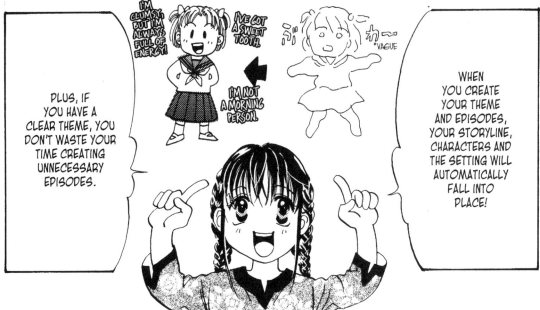

I'M CLUMSY, BUT I'M ALWAYS FULL OF ENERGY!

I'VE GOT A SWEET TOOTH.

I'M NOT A MORNING PERSON.

*VAGUE

PLUS, IF YOU HAVE A CLEAR THEME, YOU DON'T WASTE YOUR TIME CREATING UNNECESSARY EPISODES.

WHEN YOU CREATE YOUR THEME AND EPISODES, YOUR STORYLINE, CHARACTERS AND THE SETTING WILL AUTOMATICALLY FALL INTO PLACE!

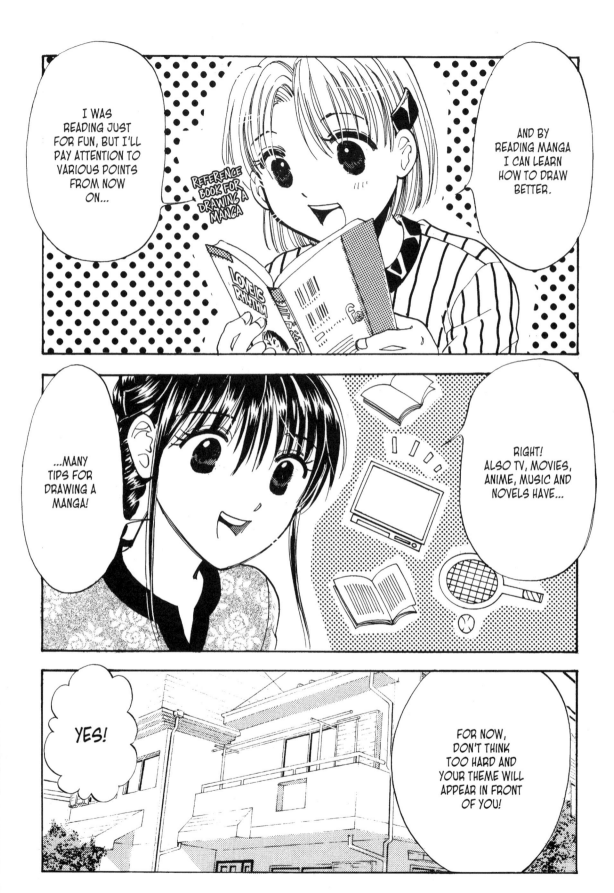

I WAS READING JUST FOR FUN, BUT I'LL PAY ATTENTION TO VARIOUS POINTS FROM NOW ON...

REFERENCE BOOK FOR DRAWING A MANGA

AND BY READING MANGA I CAN LEARN HOW TO DRAW BETTER.

...MANY TIPS FOR DRAWING A MANGA!

RIGHT! ALSO TV, MOVIES, ANIME, MUSIC AND NOVELS HAVE...

YES!

FOR NOW, DON'T THINK TOO HARD AND YOUR THEME WILL APPEAR IN FRONT OF YOU!

●THE END●

MMM...

▲ TRY TO PUT THE THEME INTO THE MAIN CHARACTER'S DIALOG.

■ EXPRESSING THE THEME THROUGH ILLUSTRATIONS ■

◎ EXPRESSING THE THEME USING CHARACTERS

FROM PAGES 39 TO 48, WE LEARNED THAT A THEME IS "WHAT THE AUTHOR WANTS TO EXPRESS." WHAT DO YOU THINK YOU CAN DO TO HAVE YOUR READERS UNDERSTAND YOUR THEME?

IN THIS CASE USE YOUR CHARACTERS. ESPECIALLY, IF YOU EXPRESS YOUR THEME THROUGH THE MAIN CHARACTER'S ACTIONS OR DIALOG, IT'LL BE EASIER FOR THE READERS TO UNDERSTAND YOUR THEME.

*AGH!!

▲ WHEN WRITING A STORY OR WORKING ON THE PANEL COMPOSITION, ALWAYS REMEMBER THE THEME AND TRY TO MAKE THE MAIN CHARACTER TAKE AN ACTION THAT FOLLOWS THE THEME.

KYOKO'S ONE POINT ADVICE

◎ ILLUSTRATIONS WHICH REFLECT THE THEME

THERE ARE MANY WAYS TO SHOW THE THEME IN MANGA. THE ILLUSTRATION THEME SHOULD BE REFLECTED IN THE ILLUSTRATIONS, AND THE TEXT THEME SHOULD BE EXPRESSED THROUGH THE DIALOG OR NARRATION.

● *ILLUSTRATION THEME:* THE SCENE THE AUTHOR WANTS TO DRAW. ADD YOUR IDEAS TO THE ILLUSTRATION SO THAT IT ATTRACTS THE READERS. ALSO, IF YOU COME UP WITH A SCENE THAT YOU'VE NEVER SEEN IN ANY MANGA, THAT CAN BE YOUR IDEA.

▲IF YOUR THEME IS "I WANT TO DRAW A ROMANTIC SCENE WHERE THEY KISS", DRAW THE ILLUSTRATION BY MATERIALIZING THE SCENE.

A WOUND IS THE INSIGNIA OF BEING A MAN.

▲ IF THE THEME IS "I LIKE THIS KIND OF BOY!", THINK ABOUT THE FACTORS THAT MAKE A BOY COOL AND REFLECT IT IN THE ILLUSTRATION.

▼ THE WORLD SETTINGS CAN BE EXHIBITED BY THE BACKGROUND.

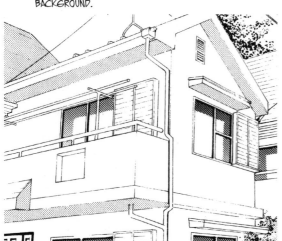

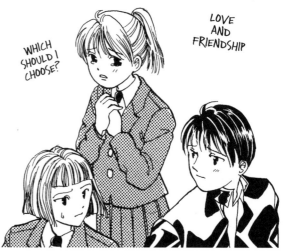

WHICH SHOULD I CHOOSE?

LOVE AND FRIENDSHIP

▲ IF THE THEME IS "THE FEELING OF HEARTBREAK IN A LOVE FELT BY ONE SIDE", EXPRESS THE "THE FEELING OF HEART-BREAK IN A LOVE FELT BY ONE SIDE" THROUGHOUT THE STORY.

● *TEXT THEME:* THE STORY OR DIALOG THE AUTHOR WANTS TO WRITE. AS FOR THE STORY, EXPRESS THE THEME THROUGHOUT THE STORY, NOT JUST IN ONE PANEL. AS FOR THE DIALOG, TRY TO COMBINE THE DIALOG WITH AN IMPRESSIVE ILLUSTRATION SO THAT IT'LL MAKE A BIG IMPRESSION ON THE READERS.

● *BOTH ILLUSTRATION AND TEXT THEME:* THE CHARACTERS AND THE WORLD THE AUTHOR WANTS TO DRAW. TAKE THE "ILLUSTRATION THEME" AND THINK "APPEARANCE" AND "TEXT THEME" AS "SETTINGS", AND THEN EXPRESS THEM IN THE STORY.

⑤WRITING STORIES FROM IDEAS

YOUR IDEAS SYMBOLIZE YOUR ORIGINALITY! JUST BY ADDING SOME SMALL TWISTS, YOUR STORY WILL BECOME EXPONENTIALLY BETTER.

THE POINT OF COMING UP WITH IDEAS IS TO "CONNECT A FEW WORDS (KEY WORDS) AND TO CREATE A WORD THAT INSPIRES YOUR IMAGINATION."

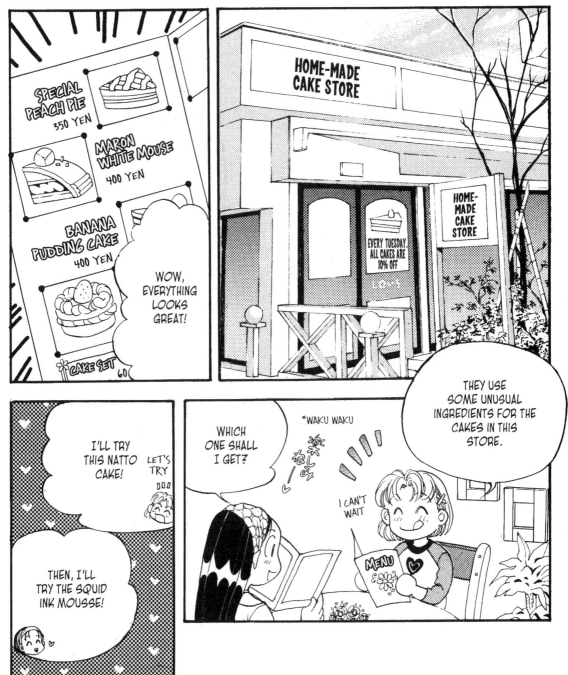

IDEAS ARE ALSO IMPORTANT IN MANGA!

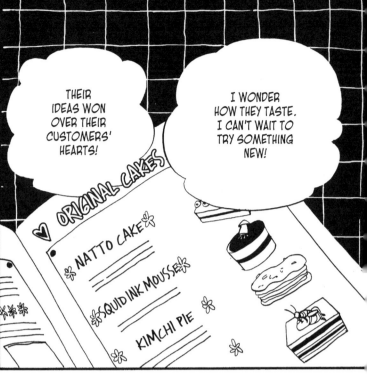

THEIR IDEAS WON OVER THEIR CUSTOMERS' HEARTS!

I WONDER HOW THEY TASTE. I CAN'T WAIT TO TRY SOMETHING NEW!

♥ ORIGINAL CAKES ✿

✿ NATTO CAKE ✿

✿ SQUID INK MOUSSE ✿

KIMCHI PIE

...THE THEME WE LEARNED IN THE PREVIOUS LESSON AND IDEAS?

WHAT'S THE DIFFERENCE BETWEEN...

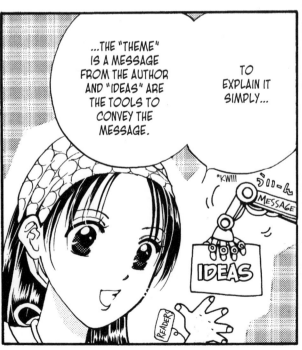

...THE "THEME" IS A MESSAGE FROM THE AUTHOR AND "IDEAS" ARE THE TOOLS TO CONVEY THE MESSAGE.

TO EXPLAIN IT SIMPLY...

*KW!!!

ゴロロ〜ム MESSAGE

IDEAS

READERS

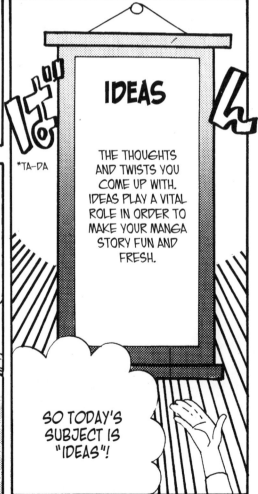

*TA-DA

IDEAS

THE THOUGHTS AND TWISTS YOU COME UP WITH. IDEAS PLAY A VITAL ROLE IN ORDER TO MAKE YOUR MANGA STORY FUN AND FRESH.

SO TODAY'S SUBJECT IS "IDEAS"!

 # USING GOOD IDEAS WILL BENEFIT YOU GREATLY!

MAKES THE STORY AND EPISODES BETTER	BY ADDING INTERESTING IDEAS, READERS WILL TAKE INTEREST IN WHAT WILL HAPPEN NEXT.
MAKES THE ILLUSTRATION BETTER	YOU CAN EXPRESS THE IMPACT OR IMAGES THROUGH ILLUSTRATION EFFICIENTLY IF YOU STRUCTURE THE SCENES TO REFLECT THE IDEAS.
MAKES IT EASIER TO WRITE A STORY	IF YOU TRY TO WRITE A STORY THAT REFLECTS THE IDEAS, YOU WILL HAVE AN EASIER TIME DEVELOPING THE STORY.
MAKES IT EASIER TO CREATE CHARACTERS	YOU CAN CREATE CHARACTERS EASILY AS LONG AS YOU KEEP YOUR IDEAS IN MIND WHILE YOU CREATE THEM. TRY TO MAKE THE CHARACTERS' PERSONALITIES, APPEARANCE AND THE PROFILES REFLECT THE IDEAS.
MAKES IT EASIER TO ADD ORIGINALITY	BRAND NEW IDEAS THAT NOBODY HAS THOUGHT OF WILL HELP TO CREATE A UNIQUE STORY.
GIVES INSPIRATION	GOOD IDEAS MOTIVATE THE AUTHOR TO CONTINUE TO WORK.

YOUR IDEAS ARE ESSENTIAL FOR YOUR ORIGINALITY!

AS SHOWN IN THE DIAGRAM ABOVE, USING GOOD IDEAS HELPS IN VARIOUS ASPECTS WHEN YOU DRAW A MANGA.

...I'M AFRAID I WON'T BE ABLE TO COME UP WITH GOOD IDEAS SO EASILY...

I UNDERSTAND THAT IDEAS ARE IMPORTANT, BUT...

...HEY, WHAT'S WRONG, ALISA?

*GLOOMY

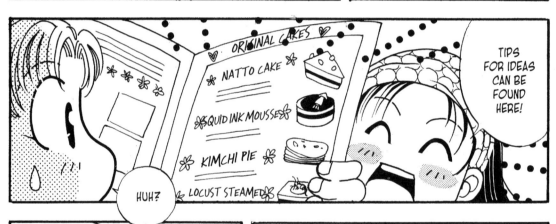

ORIGINAL CAKES

* NATTO CAKE

* SQUID INK MOUSSE *

* KIMCHI PIE *

* LOCUST STEAMED

HUH?

TIPS FOR IDEAS CAN BE FOUND HERE!

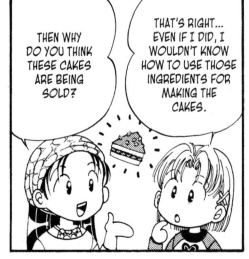

THEN WHY DO YOU THINK THESE CAKES ARE BEING SOLD?

THAT'S RIGHT... EVEN IF I DID, I WOULDN'T KNOW HOW TO USE THOSE INGREDIENTS FOR MAKING THE CAKES.

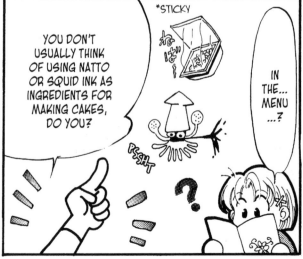

*STICKY

YOU DON'T USUALLY THINK OF USING NATTO OR SQUID INK AS INGREDIENTS FOR MAKING CAKES, DO YOU?

PSSHT

IN THE... MENU ...?

THANKS FOR COMING

HELLO

THAT'S RIGHT. THEY MUST HAVE SPENT DAYS TRYING TO MAKE A CAKE USING NATTO.

THEY MADE AN EFFORT TO MATERIALIZE THEIR IDEAS!

I GOT IT!

I SEE. IT'S NOT BECAUSE I CAN'T COME UP WITH IDEAS, IT'S BECAUSE I CAN'T MATERIALIZE MY IDEAS!

IN SHORT, IT'S ALL UP TO YOU WHETHER YOU MAKE GOOD USE OF THE IDEAS OR KILL THE IDEAS!

YES!

WELL THEN, LET'S COME UP WITH SOME GOOD IDEAS TOGETHER.

LET'S SEE...

IS THERE ANYTHING YOU WANT TO DRAW ABOUT NOW?

FIRST, LET'S DECIDE WHAT'S GOING TO BE THE BASIS OF THE IDEAS.

SO WHAT DO YOU WANT TO EXHIBIT TO THE READERS BY DRAWING THAT SCENE? JUST A SIMPLE ANSWER IS FINE.

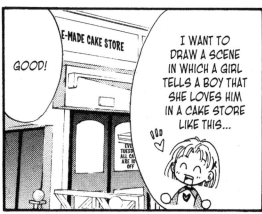

GOOD!

I WANT TO DRAW A SCENE IN WHICH A GIRL TELLS A BOY THAT SHE LOVES HIM IN A CAKE STORE LIKE THIS...

IN THIS CASE, I THINK "CAKE STORE" IS FINE.

NEXT, WE HAVE TO COME UP WITH SOME IDEAS, RIGHT...?

らーむ
*MMM...

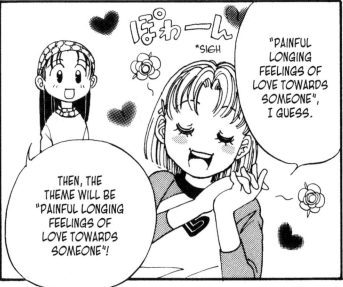

ぽわーん
*SIGH

"PAINFUL LONGING FEELINGS OF LOVE TOWARDS SOMEONE", I GUESS.

THEN, THE THEME WILL BE "PAINFUL LONGING FEELINGS OF LOVE TOWARDS SOMEONE"!

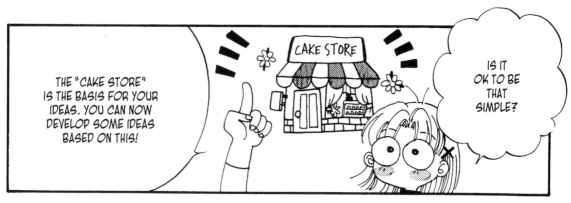

THE "CAKE STORE" IS THE BASIS FOR YOUR IDEAS. YOU CAN NOW DEVELOP SOME IDEAS BASED ON THIS!

IS IT OK TO BE THAT SIMPLE?

WHAT DO YOU THINK OF WHEN YOU HEAR THE WORD "CAKE STORE"?

WELL...

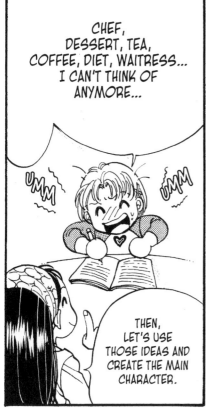

CHEF, DESSERT, TEA, COFFEE, DIET, WAITRESS... I CAN'T THINK OF ANYMORE...

UMM

UMM

THEN, LET'S USE THOSE IDEAS AND CREATE THE MAIN CHARACTER.

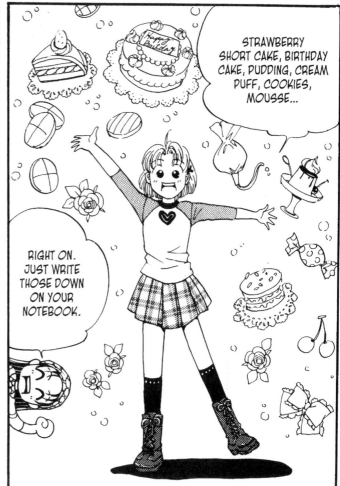

STRAWBERRY SHORT CAKE, BIRTHDAY CAKE, PUDDING, CREAM PUFF, COOKIES, MOUSSE...

RIGHT ON. JUST WRITE THOSE DOWN ON YOUR NOTEBOOK.

A HIGH SCHOOL GIRL!

WILL THE MAIN CHARACTER BE A GIRL OR A BOY?

USING THE WORDS YOU CAME UP WITH EARLIER, YOU CAN CONNECT THE WORDS TO EACH OTHER OR ADD A NEW WORD TO AN EXISTING WORD AND MAKE A GOOD SETTING BASED ON THAT!

NEXT, LET'S ADD SOME FEATURES TO HER SO THAT SHE LOOKS LIKE THE MAIN CHARACTER.

FOR EXAMPLE, CONNECTING THE WORD "DIET" WITH THE WORD "WAITRESS" WILL GIVE YOU "A WAITRESS WHO'S ON A DIET." OR IF YOU ADD SOME WORDS TO "BIRTHDAY CAKE", YOU'LL GET "MAKE A BIRTHDAY CAKE FOR HER BOYFRIEND".

CAN'T FOLLOW

CONNECT-ING WORDS? ADDING A WORD?

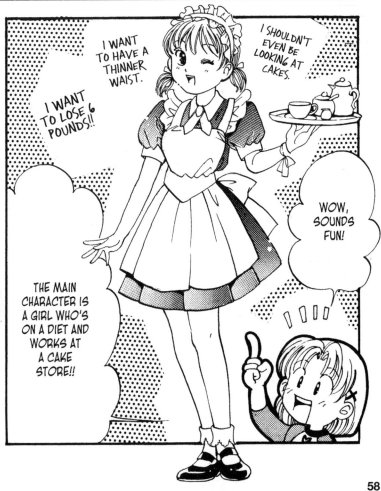

THIS WAY, YOU CAN KEEP CREATING INTERESTING FEATURES THAT WILL CONTINUE TO INSPIRE YOU!

THIS IS THE SUPER EASY IDEA-MAKING METHOD!

I WANT TO HAVE A THINNER WAIST.

I WANT TO LOSE 6 POUNDS!!

I SHOULDN'T EVEN BE LOOKING AT CAKES.

WOW, SOUNDS FUN!

THE MAIN CHARACTER IS A GIRL WHO'S ON A DIET AND WORKS AT A CAKE STORE!!

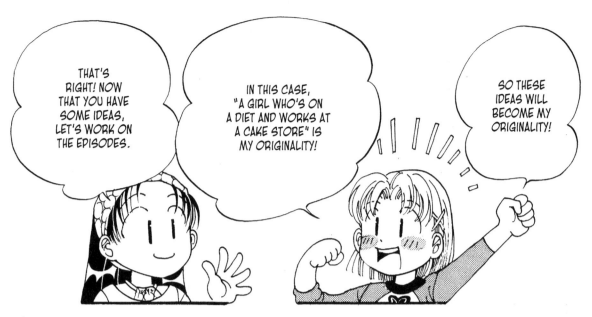

THAT'S RIGHT! NOW THAT YOU HAVE SOME IDEAS, LET'S WORK ON THE EPISODES.

IN THIS CASE, "A GIRL WHO'S ON A DIET AND WORKS AT A CAKE STORE" IS MY ORIGINALITY!

SO THESE IDEAS WILL BECOME MY ORIGINALITY!

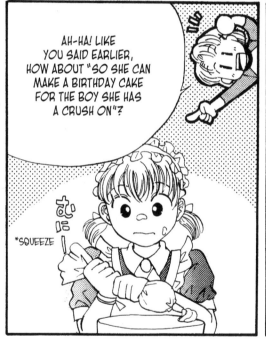

AH-HA! LIKE YOU SAID EARLIER, HOW ABOUT "SO SHE CAN MAKE A BIRTHDAY CAKE FOR THE BOY SHE HAS A CRUSH ON"?

*SQUEEZE

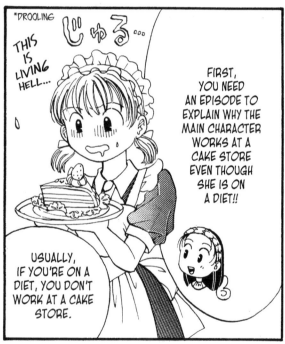

*DROOLING

THIS IS LIVING HELL....

FIRST, YOU NEED AN EPISODE TO EXPLAIN WHY THE MAIN CHARACTER WORKS AT A CAKE STORE EVEN THOUGH SHE IS ON A DIET!!

USUALLY, IF YOU'RE ON A DIET, YOU DON'T WORK AT A CAKE STORE.

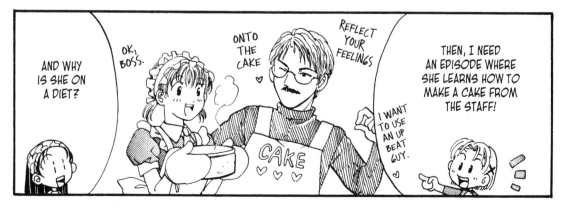

AND WHY IS SHE ON A DIET?

OK, BOSS.

ONTO THE CAKE

REFLECT YOUR FEELINGS

CAKE

I WANT TO USE AN UP BEAT GUY.

THEN, I NEED AN EPISODE WHERE SHE LEARNS HOW TO MAKE A CAKE FROM THE STAFF!

THAT'S NICE! YOU CAME UP WITH GOOD EPISODES ONE AFTER ANOTHER.

THEN, WHAT'LL THE CLIMAX BE?

SHE WANTS TO CONFESS HER FEELINGS TO THE BOY SHE HAS A CRUSH ON WEARING THAT DRESS!

OH!

GOTTA GET MY WAIST ONE INCH SMALLER!

BECAUSE THERE'S A DRESS SHE WANTS TO WEAR...

I'M GONNA TELL HIM I LOVE HIM WEARING THIS PINK DRESS!

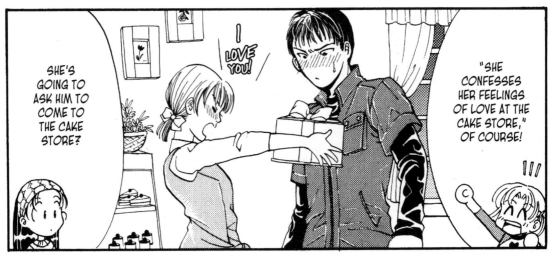

SHE'S GOING TO ASK HIM TO COME TO THE CAKE STORE?

I LOVE YOU!

"SHE CONFESSES HER FEELINGS OF LOVE AT THE CAKE STORE," OF COURSE!

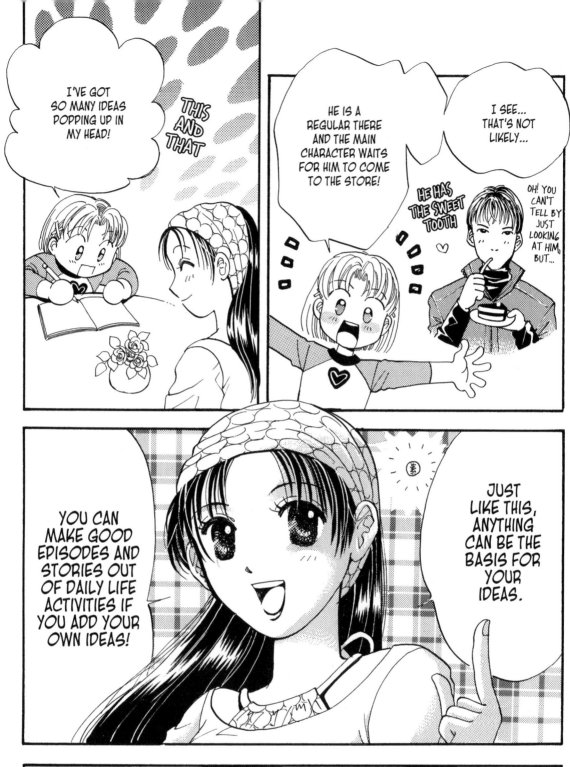

I'VE GOT SO MANY IDEAS POPPING UP IN MY HEAD!

THIS AND THAT

HE IS A REGULAR THERE AND THE MAIN CHARACTER WAITS FOR HIM TO COME TO THE STORE!

HE HAS THE SWEET TOOTH

I SEE... THAT'S NOT LIKELY...

OH! YOU CAN'T TELL BY JUST LOOKING AT HIM, BUT...

YOU CAN MAKE GOOD EPISODES AND STORIES OUT OF DAILY LIFE ACTIVITIES IF YOU ADD YOUR OWN IDEAS!

JUST LIKE THIS, ANYTHING CAN BE THE BASIS FOR YOUR IDEAS.

YOU USE THE HAKOGAKI TECHNIQUE AND CREATE A SCRIPT!

THIS IS THE ROUTINE IN STORY-MAKING!

THEN, AFTER YOU FINISH MAKING SEVERAL EPISODES...

THANK YOU FOR WAITING!

JUST A SINGLE IDEA CAN MAKE A STORY INTEGRATED AND FUN LIKE THIS!

YAY! LET'S EAT!

LOOKS GOOD ♥

← THE SQUID IS MADE FROM ALMOND PASTE

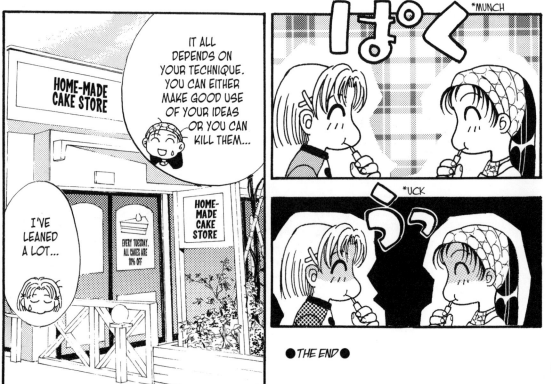

HOME-MADE CAKE STORE

IT ALL DEPENDS ON YOUR TECHNIQUE. YOU CAN EITHER MAKE GOOD USE OF YOUR IDEAS OR YOU CAN KILL THEM...

I'VE LEANED A LOT...

HOME-MADE CAKE STORE

EVERY TUESDAY, ALL CAKES ARE 10% OFF

*MUNCH

*UCK

● THE END ●

◀ CREATE A SCENE THAT MAKES GOOD USE OF IDEAS

■ EXPRESSING IDEAS USING ILLUSTRATIONS ■
◎ ADDING IDEAS TO THE CHARACTERS

HAVE YOU EVER HAD A HARD TIME PUTTING YOUR IDEAS INTO YOUR WORK? IF YOU PUT UNNECESSARY IDEAS IN THE STORY OR THE THEME, YOU END UP WASTING PAGES EXPLAINING YOUR IDEAS. THIS WAY, THE IDEAS WON'T BE REFLECTED IN YOUR WORK.

IN ORDER TO MAKE GOOD, EFFECTIVE IDEAS, YOU NEED TO ASSOCIATE IDEAS WITH THE CHARACTERS. IN THAT WAY, YOU CAN SHOW YOUR IDEAS THROUGH THE CHARACTER'S ACTIONS. PLUS, THE IDEAS WILL BE NATURALLY INTEGRATED INTO THE STORY AND THEME.

KYOKO'S

ONE POINT ADVICE

CHARACTERS WITH IDEAS DRAW THE ATTENTION FROM READER. SO, THE MORE IDEAS YOU USE WHEN CREATING THE MAIN CHARACTER, THE MORE HE/SHE IS GOING TO STAND OUT.

I WANT TO HAVE A THINNER WAIST.

I SHOULDN'T EVEN BE LOOKING AT CAKES.

▲ ESPECIALLY WHEN YOU HAVE THE STORY DONE FIRST, THE IDEAS ARE VERY IMPORTANT WHEN CREATING CHARACTERS.

THEME = IDEAS

◎ "IDEAS" CAN BE THE SAME AS "THEME".

FROM PAGE 51 TO 62, WE LEARNED THAT THEME IS "SOMETHING THE AUTHOR WANTS TO EXPRESS", AND IDEAS ARE "NEW THOUGHTS THAT NOBODY HAS EVER COME UP WITH". SO THESE TWO LOOK DIFFERENT FROM EACH OTHER, DON'T THEY? HOWEVER, DEPENDING ON THE SITUATION, THE "THEME" AND THE "IDEA" CAN BE THE SAME THING.

FOR EXAMPLE, SAY YOU'VE COME UP WITH THE IDEA "A BOY WITH CHARISMA THAT HAS NEVER BEEN SEEN BEFORE". IN YOUR MANGA, HIS CHARISMA CAN BE WHAT YOU (THE AUTHOR) WANT TO EXHIBIT ALSO. IN THIS CASE, YOU DON'T HAVE TO SPEND A LOT OF TIME CREATING A THEME. YOU CAN JUST USE YOUR "IDEAS" AS THE "THEME" AND WRITE A STORY. IN THIS CASE, YOU CAN WRITE A BETTER STORY.

▲ IF YOUR "THEME" IS THE SAME AS THE "IDEAS" IN YOUR MANGA, IT WILL MAKE THE STORY EASIER TO UNDERSTAND. IN THIS MANGA, THE THEME IS TO INTRODUCE IDEAS FOR DRAWING MANGA.

⑥ WRITING STORIES BY ESTABLISHING THE SETTING

WHAT'S MOST IMPORTANT ABOUT CREATING THE "SETTING" IS "TO LIMIT THE NUMBER OF PLACES WHERE THE MAIN CHARACTER GOES". IF YOU FOLLOW THIS RULE, YOU CAN COME UP WITH MANY INTERESTING SETTINGS. MOREOVER, IF YOU "EXPLAIN WHY THINGS HAPPEN THE WAY THEY DO" SOMEWHERE IN THE SETTINGS, YOUR STORY WILL ADVANCE ONE LEVEL HIGHER.

ME TOO. I HEAR THAT THE TWO ACTORS THEY GOT TO PLAY THE MAIN CHARACTERS ARE REALLY HOT!

I'VE BEEN LOOKING FORWARD TO THIS SOAP OPERA FOR A LONG TIME.

*WAKU WAKU WAKU

*TA-DA

THE LOVE SUSPENSE DETECTIVE

FIRST EPISODE

THAT'S RIGHT! YOU'LL LOSE TRACK OF THE CHARACTERS' RELATIONSHIPS OR THE STORYLINE...

*CRUNCH CRUNCH

*MUNCH MUNCH

ESPECIALLY IF YOU MISS THE FIRST EPISODE, YOU WON'T UNDERSTAND THE STORY AT ALL.

*CRUNCH CRUNCH

YOU KNOW, IF YOU MISS ONE EPISODE OF A SOAP OPERA, YOU LOSE TRACK OF WHAT'S GOING ON.

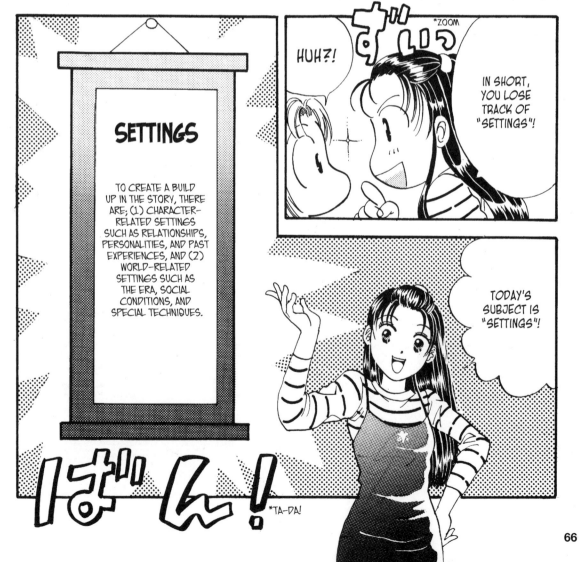

SETTINGS

TO CREATE A BUILD UP IN THE STORY, THERE ARE; (1) CHARACTER-RELATED SETTINGS SUCH AS RELATIONSHIPS, PERSONALITIES, AND PAST EXPERIENCES, AND (2) WORLD-RELATED SETTINGS SUCH AS THE ERA, SOCIAL CONDITIONS, AND SPECIAL TECHNIQUES.

*ZOOM

HUH?!

IN SHORT, YOU LOSE TRACK OF "SETTINGS"!

TODAY'S SUBJECT IS "SETTINGS"!

*TA-DA!

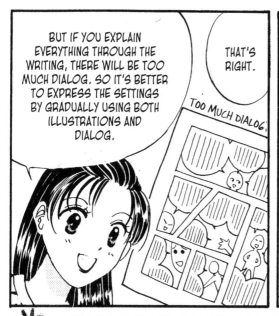

BUT IF YOU EXPLAIN EVERYTHING THROUGH THE WRITING, THERE WILL BE TOO MUCH DIALOG. SO IT'S BETTER TO EXPRESS THE SETTINGS BY GRADUALLY USING BOTH ILLUSTRATIONS AND DIALOG.

THAT'S RIGHT.

TOO MUCH DIALOG

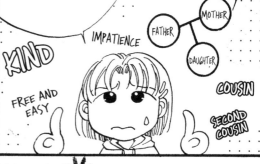

LOOKING AT IT THIS WAY, THERE ARE A LOT OF SETTINGS THAT YOU CAN'T REALLY SHOW THROUGH THE ILLUSTRATIONS.

RELATIONSHIPS, PERSONALITIES, AND ERA...

KIND

IMPATIENCE

FREE AND EASY

MOTHER

FATHER

DAUGHTER

COUSIN

SECOND COUSIN

 MAIN TYPES OF THE SETTINGS

CHARACTER-RELATED SETTINGS	THERE ARE ILLUSTRATION SETTINGS AND TEXT SETTINGS. MOREOVER, FOR TEXT SETTINGS, THERE ARE INNER SETTINGS AND OUTER SETTINGS.	
ILLUSTRATION SETTINGS	TEXT SETTINGS	
	INNER SETTINGS	OUTER SETTINGS
SETTINGS REGARDING THE CHARACTERS' APPEARANCE OR FASHION.	SETTINGS BASED ON THE CHARACTERS' PERSONALITIES, SKILLS, OR PAST EXPERIENCES.	SETTINGS BASED ON HUMAN RELATIONSHIP SUCH AS THE CHARACTERS' SOCIAL STATUS, OR THE RELATIONSHIP BETWEEN TEACHER AND STUDENT.
WORLD-RELATED SETTINGS	THERE ARE ILLUSTRATION AND TEXT WORLD SETTINGS	
ILLUSTRATION SETTINGS	TEXT SETTINGS	
SETTINGS SUCH AS IN THE HOUSE, SCHOOL OR IN ANOTHER WORLD.	LIMIT WHAT THE CHARACTERS CAN DO IN THE STORY.	

JUST THINK OF THE SETTINGS AS THE RULES TO ENJOY THE STORY!

SETTINGS WITH ORIGINALITY CAN HELP YOU WRITE INTERESTING STORIES.

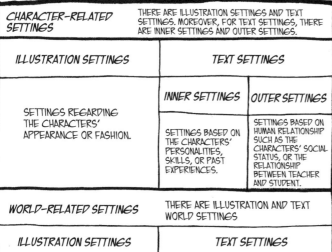

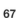

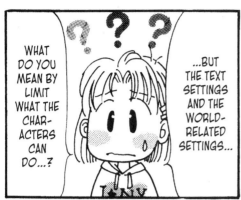

WHAT DO YOU MEAN BY LIMIT WHAT THE CHARACTERS CAN DO...?

...BUT THE TEXT SETTINGS AND THE WORLD-RELATED SETTINGS...

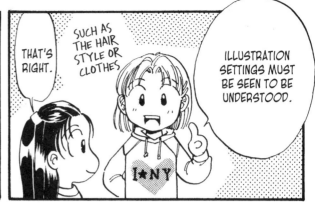

THAT'S RIGHT.

SUCH AS THE HAIR STYLE OR CLOTHES

ILLUSTRATION SETTINGS MUST BE SEEN TO BE UNDERSTOOD.

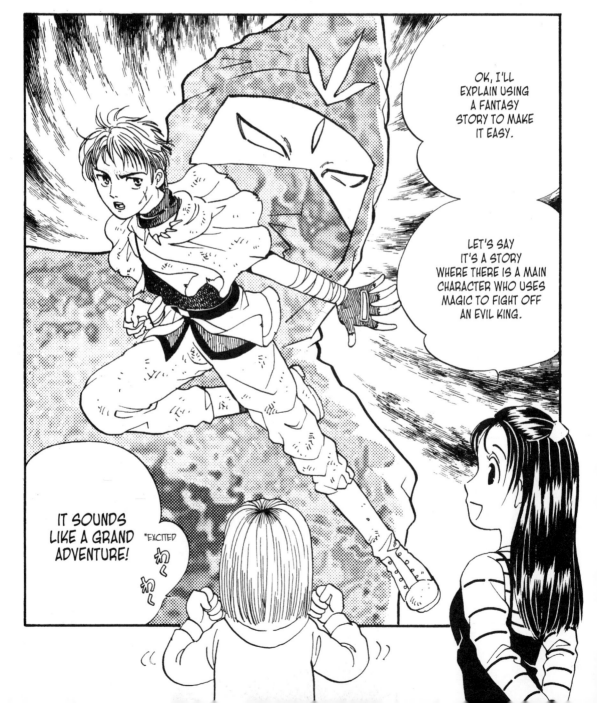

OK, I'LL EXPLAIN USING A FANTASY STORY TO MAKE IT EASY.

LET'S SAY IT'S A STORY WHERE THERE IS A MAIN CHARACTER WHO USES MAGIC TO FIGHT OFF AN EVIL KING.

IT SOUNDS LIKE A GRAND ADVENTURE!

*EXCITED

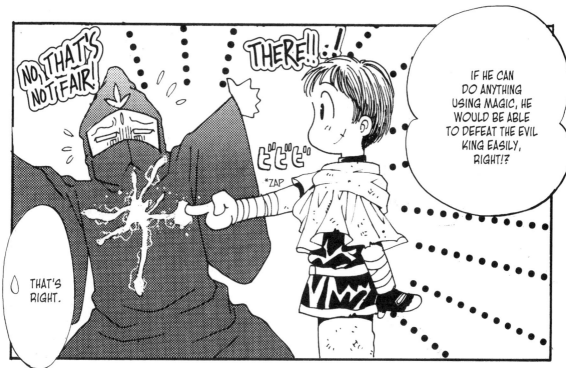

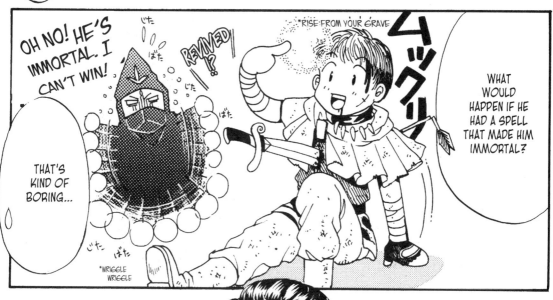

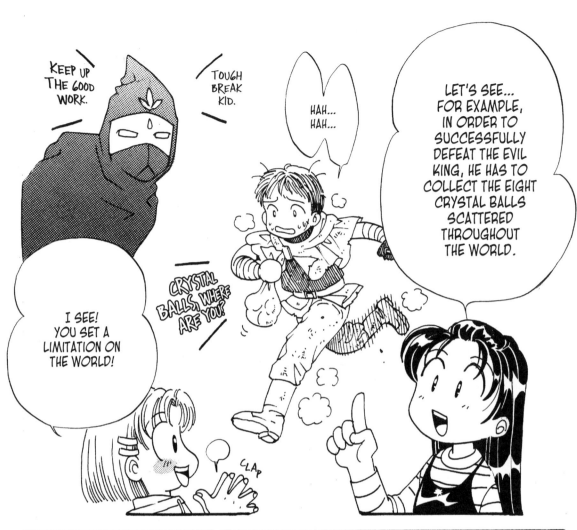

KEEP UP THE GOOD WORK.

TOUGH BREAK KID.

HAH... HAH...

LET'S SEE... FOR EXAMPLE, IN ORDER TO SUCCESSFULLY DEFEAT THE EVIL KING, HE HAS TO COLLECT THE EIGHT CRYSTAL BALLS SCATTERED THROUGHOUT THE WORLD.

CRYSTAL BALLS, WHERE ARE YOU?

I SEE! YOU SET A LIMITATION ON THE WORLD!

CLAP

I UNDERSTAND NOW THAT SETTINGS ARE EXTREMELY IMPORTANT FOR MANGA!

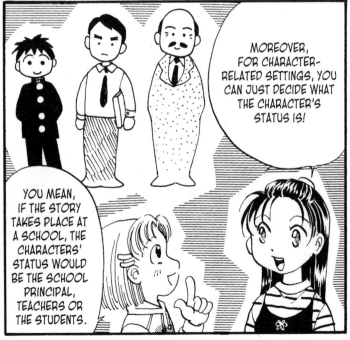

MOREOVER, FOR CHARACTER-RELATED SETTINGS, YOU CAN JUST DECIDE WHAT THE CHARACTER'S STATUS IS!

YOU MEAN, IF THE STORY TAKES PLACE AT A SCHOOL, THE CHARACTERS' STATUS WOULD BE THE SCHOOL PRINCIPAL, TEACHERS OR THE STUDENTS.

RIGHT. YOU MUST COME UP WITH A GOOD WAY TO EXPLAIN THE SETTINGS TO THE READERS!

むむむ…
MMM…

BUT IT MUST BE DIFFICULT TO EXPLAIN THE SETTINGS THOROUGHLY…

YOU MEAN… TV?

THE REASON WHY TV SOAP OPERAS ARE SO MUCH FUN IS BECAUSE THEY USE THE SETTINGS EFFECTIVELY IN THE STORY.

*TA-DA

YOU'RE NEXT, SUSPENSE DETECTIVE!

HERE'S A HINT!

WHY DID THE MURDERER…

…DO THESE THINGS… I DON'T GET IT.

I SEE!

THEY MADE IT INTO A PUZZLE TO DRAW IN THE VIEWER'S ATTENTION!

THE SETTING FOR THE PART WHERE THE DETECTIVE IS CONFUSED SHOULD HAVE BEEN MADE PRIOR TO SHOOTING THIS SOAP OPERA, RIGHT?

HUH...? YOU MEAN THIS?

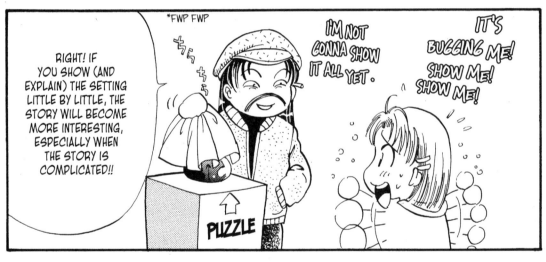

*FWP FWP

RIGHT! IF YOU SHOW (AND EXPLAIN) THE SETTING LITTLE BY LITTLE, THE STORY WILL BECOME MORE INTERESTING, ESPECIALLY WHEN THE STORY IS COMPLICATED!!

I'M NOT GONNA SHOW IT ALL YET.

IT'S BUGGING ME! SHOW ME! SHOW ME!

PUZZLE

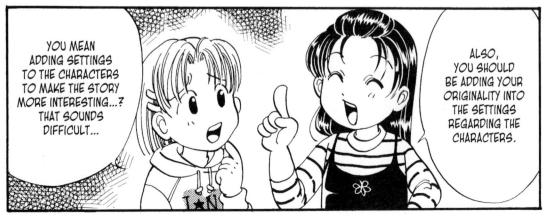

YOU MEAN ADDING SETTINGS TO THE CHARACTERS TO MAKE THE STORY MORE INTERESTING...? THAT SOUNDS DIFFICULT...

ALSO, YOU SHOULD BE ADDING YOUR ORIGINALITY INTO THE SETTINGS REGARDING THE CHARACTERS.

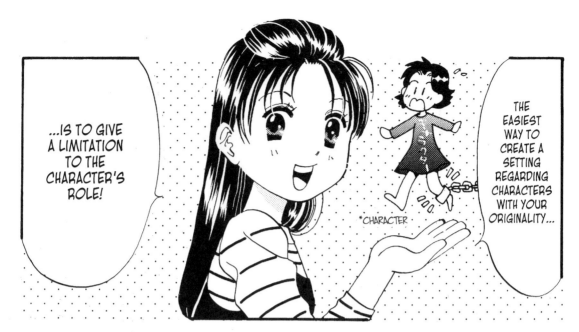

...IS TO GIVE A LIMITATION TO THE CHARACTER'S ROLE!

THE EASIEST WAY TO CREATE A SETTING REGARDING CHARACTERS WITH YOUR ORIGINALITY...

*CHARACTER

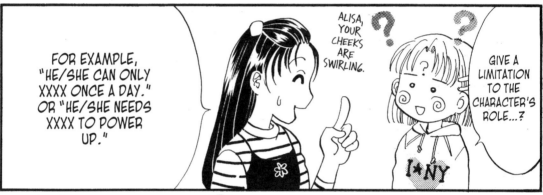

FOR EXAMPLE, "HE/SHE CAN ONLY XXXX ONCE A DAY." OR "HE/SHE NEEDS XXXX TO POWER UP."

ALISA, YOUR CHEEKS ARE SWIRLING.

GIVE A LIMITATION TO THE CHARACTER'S ROLE...?

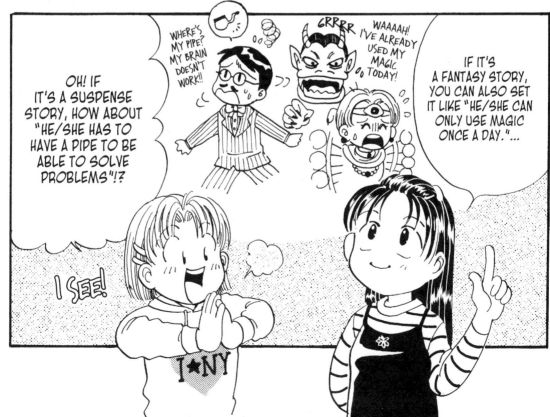

OH! IF IT'S A SUSPENSE STORY, HOW ABOUT "HE/SHE HAS TO HAVE A PIPE TO BE ABLE TO SOLVE PROBLEMS"!?

WHERE'S MY PIPE? MY BRAIN DOESN'T WORK!!

GRRRR

WAAAAH! I'VE ALREADY USED MY MAGIC TODAY!

IF IT'S A FANTASY STORY, YOU CAN ALSO SET IT LIKE "HE/SHE CAN ONLY USE MAGIC ONCE A DAY."...

I SEE!

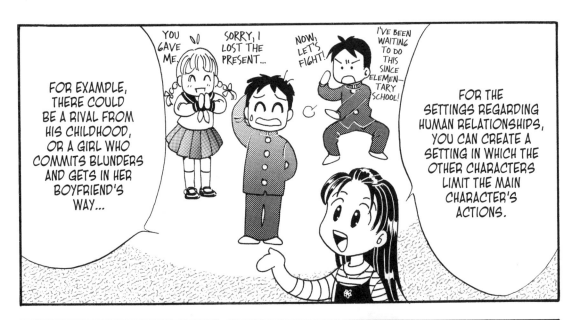

FOR EXAMPLE, THERE COULD BE A RIVAL FROM HIS CHILDHOOD, OR A GIRL WHO COMMITS BLUNDERS AND GETS IN HER BOYFRIEND'S WAY...

YOU GAVE ME.

SORRY, I LOST THE PRESENT...

NOW, LET'S FIGHT!

I'VE BEEN WAITING TO DO THIS SINCE ELEMENTARY SCHOOL!

FOR THE SETTINGS REGARDING HUMAN RELATIONSHIPS, YOU CAN CREATE A SETTING IN WHICH THE OTHER CHARACTERS LIMIT THE MAIN CHARACTER'S ACTIONS.

SOAP OPERAS CAN BE A VERY EDUCATIONAL GUIDE IF YOU REALLY PAY ATTENTION TO THEM.

*GASP

SEE!? AFTER THAT, USE THE HAKOGAKI TECHNIQUE TO WRITE YOUR SCRIPT!

COOL. THIS IS FUN! JUST ONE SETTING CAN MAKE THE STORY SO DEEP!

BINGO

HURRAY

...OVER...

*SHOCKED

NEWS

TOMORROW'S WEATHER

THE SOAP OPERA IS...

● THE END ●

WHERE'S MY PIPE? MY BRAIN DOESN'T WORK!!

▲ IF THE SETTING IS "UNLESS HE HAS A PIPE, HE CANNOT SOLVE PROBLEMS", YOU CAN USE IT TO ESTABLISH THE CHARACTER'S APPEARANCE BY DRAWING THE CHARACTER ALWAYS CARRYING A PIPE.

■ CREATING CHARACTERS FROM THE SETTINGS ■

◎ CREATING A CHARACTER'S APPEARANCE FROM THE CHARACTER'S TEXT SETTING

FROM PAGE 65 TO 74, WE LEARNED THAT THE TEXT SETTINGS REGARDING THE CHARACTERS ARE "RULES TO LIMIT THE CHARACTER'S ROLE" WHETHER IT'S THE INNER SETTINGS OR OUTER SETTINGS, THE TEXT SETTINGS MAKE THE STORY MORE INTERESTING. THIS CAN ALSO BE USED FOR CREATING THE CHARACTER'S WARDROBE OR APPEARANCE (ILLUSTRATION SETTINGS).

KYOKO'S ONE POINT ADVICE

YOU GAVE ME.

SORRY, I LOST THE PRESENT...

LET ME SHOW YOU HOW TO DO THAT. YOU CAN ADD SOMETHING THAT SYMBOLIZES THE TEXT SETTING TO A CHARACTER'S APPEARANCE. IN OTHER WORDS, YOU ADD SOMETHING THAT SYMBOLIZES THE LIMITA-TION IN THE ILLUSTRATION. FOR EXAMPLE, TAKE A LOOK AT THE PANEL ON THE LEFT.

▲ HOW TO ADD SETTINGS REGARDING "THE MAIN CHARACTER'S GIRLFRIEND" TO THE MAIN CHARACTER'S APPEARANCE: DRAW THE ILLUSTRATION THAT SYMBOLIZES THE BONDS BETWEEN THE BOY AND HIS GIRLFRIEND. FOR EXAMPLE, LET THE MAIN CHARACTER WEAR THE ACCESSORY THAT HIS GIRLFRIEND GAVE HIM.

◎ REFLECT THE WORLD-RELATED SETTINGS ON THE ILLUSTRATION

MOREOVER, WE'VE LEARNED THAT FOR WORLD-RELATED SETTINGS, YOU NEED TO "SET LIMITATIONS ON WHAT THE CHARACTERS CAN DO IN THE WORLD". SO HOW DO YOU THINK YOU CAN REFLECT THAT THROUGH THE PICTURES? IT'S HARD FOR READERS TO UNDERSTAND YOUR MANGA IF YOU DRAW AN ILLUSTRATION WITH IMAGES THAT ONLY YOU ARE FAMILIAR WITH. IF YOU THINK YOU ARE DOING JUST THIS, I RECOMMEND THAT YOU READ YOUR MANGA FROM THE VIEWPOINT OF THE READER.

▲ YOU CAN REFLECT THE WORLD-RELATED SETTINGS OF THE MODERN ERA BY DRAWING THINGS YOU SEE IN EVERYDAY LIFE. EVEN IF YOUR STORY IS ABOUT ANOTHER COUNTRY THAT YOU AREN'T TOO FAMILIAR WITH, IF THE STORY TAKES PLACE IN THE MODERN ERA, FINDING THE INFORMATION IS RELATIVELY EASY. FOR WORLD-RELATED SETTINGS THAT TAKES PLACE DURING THE SAMURAI ERA (OR THE PAST), YOU SHOULD RESEARCH THE INFORMATION THEN DRAW THE ACCORDINGLY.

READERS ABSORB A LOT OF INFORMATION FROM THE ILLUSTRATIONS WHEN THEY READ MANGA. FOR EXAMPLE, THEY ARE CONSTANTLY THINKING TO THEMSELVES, "WHO IS THE MAIN CHARACTER?" OR "WHAT KIND OF WORLD ARE THEY IN?", THE ANSWERS COME FROM THE CHARACTER'S OUTFIT OR THE BACK-GROUND. THE WORLD-RELATED SETTINGS CAN BE EXPLAINED IN THE ART. SO IF THE CHARACTERS ARE WEARING SOMETHING THAT'S POPULAR NOW, THEN THE STORY IS TAKING PLACE IN THE MODERN ERA. IF THERE IS A CASTLE IN THE BACK-GROUND, IT'S IN THE SAMURAI OR MEDIEVAL ERA.

▲ YOU NEED GOOD ILLUSTRATION SKILLS TO CREATE WORLD-RELATED SETTINGS THAT ONLY YOU CAN IMAGINE, SUCH AS FANTASY OR SCIENCE FICTION.

7 WRITING STORIES BY CHOOSING A GENRE

"GENRES" ARE THE CLASSIFICATIONS OF THE STORY CONTENTS IN MANGA. EVERYONE HAS HIS/HER FAVORITE STORY GENRE. SO BY CHOOSING A GENRE, YOU CAN DRAW A MANGA THAT WILL BE APPRECIATED AMONG CERTAIN GROUPS OF READERS.

IT'S EASY TO CHOOSE SINCE THEY ARE SORTED BY GENRES.

LOVE ROMANCE,

ACTION, SUSPENSE,

SCIENCE FICTION...

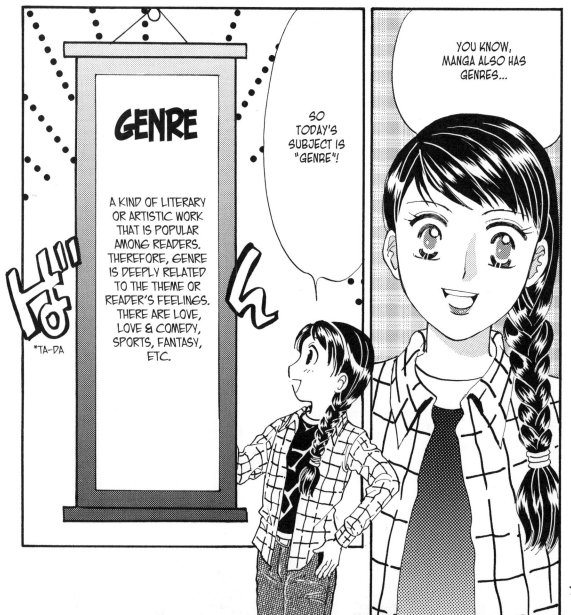

YOU KNOW, MANGA ALSO HAS GENRES...

SO TODAY'S SUBJECT IS "GENRE"!

GENRE

A KIND OF LITERARY OR ARTISTIC WORK THAT IS POPULAR AMONG READERS. THEREFORE, GENRE IS DEEPLY RELATED TO THE THEME OR READER'S FEELINGS. THERE ARE LOVE, LOVE & COMEDY, SPORTS, FANTASY, ETC.

*TA-DA

MAIN GENRES IN MANGA

LOVE	A STORY IN WHICH THE THEME IS ABOUT LOVE BETWEEN MEN AND WOMEN. IT IS USUALLY ILLUSTRATED IN A PRACTICAL WAY TO SHOW THE FEELINGS AND THE ACTIONS REGARDING LOVE. THE MAIN CHARACTER IS INVOLVED IN LOVE. READERS ARE LOOKING FOR THE VIRTUAL LOVE EXPERIENCE FOR THIS GENRE.
LOVE & COMEDY	BASICALLY, THE THEME IS ABOUT LOVE, BUT THE HUMOR IS APPARENT THROUGHOUT THE BOOK. IT IS DESIGNED TO MAKE THE READERS LAUGH RATHER THAN DEPICT ROMANCE. THEREFORE, IT IS EXTREMELY FAR FROM REALITY AND THERE ARE MANY EXPRESSIONS WE DON'T USE IN REAL LIFE. READERS ARE LOOKING FOR LAUGHTER.
GAG	THE MAIN PURPOSE IS TO MAKE THE READERS LAUGH AND THERE IS NO SOLID STORYLINE. READERS ARE LOOKING FOR A GOOD LAUGH.
SCHOOL	A STORY THAT TAKES PLACE AT SCHOOL. THE MAIN CHARACTER GOES TO SCHOOL (FROM KINDERGARTEN TO UNIVERSITY). READERS ARE LOOKING FOR THE VIRTUAL EXPERIENCE AT SCHOOL.
MYSTERY	THE THEME IS TO SOLVE A MYSTERY. THE MAIN CHARACTER IS INVOLVED IN SOLVING THE MYSTERY. READERS ARE TRYING TO SOLVE THE MYSTERY THEMSELVES AND ARE INTERESTED IN THE DRAMA THAT EXISTS AMONG THE PEOPLE INVOLVED IN IT.
HORROR	A STORY ABOUT SPIRITS, GHOSTS, OR SOME MYSTERIOUS PHENOMENON. THE MAIN CHARACTER IS INVOLVED IN THE MYSTERIOUS PHENOMENON. READERS ARE LOOKING FOR A FRIGHTENING EXPERIENCE.
FANTASY	A STORY THAT TAKES PLACE IN AN IMAGINARY WORLD OR SOME ANCIENT CIVILIZATION. READERS WANT TO ENJOY THE UNIQUE EXPERIENCE OF THE FANTASY WORLD. READERS ARE ALSO LOOKING FOR THE HUMAN DRAMA THAT EXISTS IN THE WORLD.
SCIENCE FICTION	A STORY THAT TAKES PLACE IN AN IMAGINARY FUTURE WORLD. READERS WANT TO ENJOY THE UNIQUE WORLD EXPERIENCE OF SCIENCE FICTION. READERS ARE ALSO LOOKING FOR THE HUMAN DRAMA THAT EXISTS IN THE WORLD.
SPORTS	A STORY ABOUT SPORTS. THE MAIN CHARACTER IS INVOLVED IN A SPORT. READERS ARE LOOKING FOR THE HUMAN RELATIONSHIP THAT OCCURS WITH THE SPORT AND THE REFRESHING FEELINGS THAT SPORTS CAN GIVE.
HISTORICAL DRAMA	A STORY THAT TAKES PLACE SOME TIME IN HISTORY. IT RANGES FROM THE STONE AGE TO THE EARLY 1900'S. IT COVERS WIDE RANGE. READERS ARE LOOKING FOR THE HUMAN DRAMA THAT OCCURS IN THE HISTORY.
PARODY	A STORY THAT IS RE-CREATED USING AN EXISTING STORY WITH A UNIQUE VIEWPOINT. READERS ARE LOOKING FOR THE EXPANSION OF THE ORIGINAL STORY. (NOTE: THAT IT'LL BE A PLAGIARISM IF YOU DESTROY THE WORLD-RELATED SETTINGS OF THE ORIGINAL STORY.)

WOW, THERE'RE SO MANY.

SUCH AS LOVE + COMEDY AND GAG, OR SCIENCE FICTION AND FANTASY.

OF COURSE YOU CAN ALSO COMBINE TWO GENRES TOGETHER!

I KNOW. BUT IF YOU ARE A BEGINNER, IT'S BETTER TO START WITH ONE THAT YOU ARE MOST FAMILIAR WITH. SUCH AS A SCHOOL, LOVE, OR GAG MANGA.

SCHOOL,

LOVE,

GAG

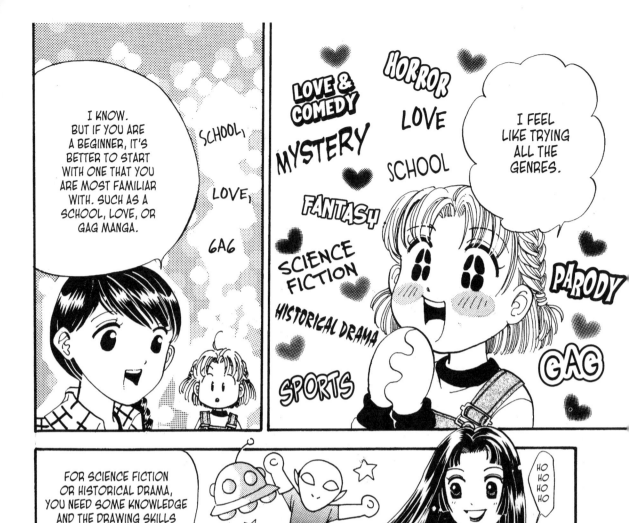

I FEEL LIKE TRYING ALL THE GENRES.

LOVE & COMEDY

HORROR

LOVE

MYSTERY

SCHOOL

FANTASY

SCIENCE FICTION

PARODY

HISTORICAL DRAMA

GAG

SPORTS

FOR SCIENCE FICTION OR HISTORICAL DRAMA, YOU NEED SOME KNOWLEDGE AND THE DRAWING SKILLS TO EXHIBIT THE WORLD-RELATED SETTINGS!

KYOKO-SAN...

YOU NEED TO THINK ABOUT THE STRUCTURE OF A SPACE SHIP, OR THE FUTURE TECHNOLOGY IF IT'S SCIENCE FICTION.

HO HO HO HO HO

IF YOU CHOOSE A HISTORICAL DRAMA, YOU WILL NEED TO RESEARCH WARDROBE AND LIFESTYLE.

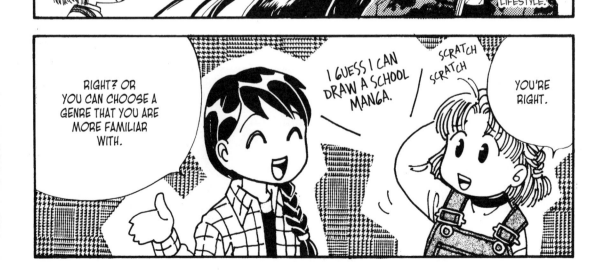

RIGHT? OR YOU CAN CHOOSE A GENRE THAT YOU ARE MORE FAMILIAR WITH.

I GUESS I CAN DRAW A SCHOOL MANGA.

SCRATCH SCRATCH

YOU'RE RIGHT.

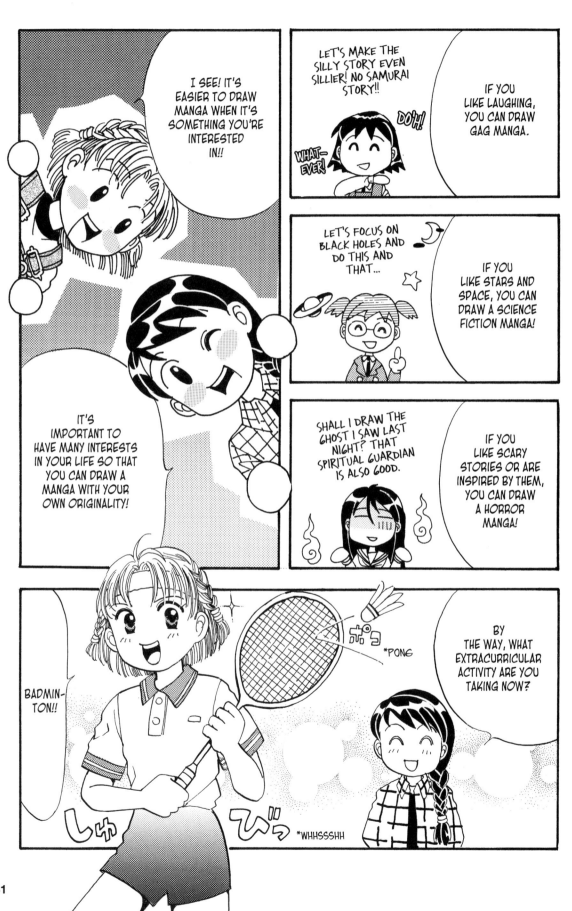

I SEE! IT'S EASIER TO DRAW MANGA WHEN IT'S SOMETHING YOU'RE INTERESTED IN!!

LET'S MAKE THE SILLY STORY EVEN SILLIER! NO SAMURAI STORY!!

WHAT-EVER!

DOH!

IF YOU LIKE LAUGHING, YOU CAN DRAW GAG MANGA.

LET'S FOCUS ON BLACK HOLES AND DO THIS AND THAT...

IF YOU LIKE STARS AND SPACE, YOU CAN DRAW A SCIENCE FICTION MANGA!

IT'S IMPORTANT TO HAVE MANY INTERESTS IN YOUR LIFE SO THAT YOU CAN DRAW A MANGA WITH YOUR OWN ORIGINALITY!

SHALL I DRAW THE GHOST I SAW LAST NIGHT? THAT SPIRITUAL GUARDIAN IS ALSO GOOD.

IF YOU LIKE SCARY STORIES OR ARE INSPIRED BY THEM, YOU CAN DRAW A HORROR MANGA!

BADMIN-TON!!

*PONG

BY THE WAY, WHAT EXTRACURRICULAR ACTIVITY ARE YOU TAKING NOW?

しゅ

ぴっ

*WHHSSSHH

RESEARCHING THE RULES AND HOW TO PRACTICE...

FOR SOMEONE WHO DOESN'T KNOW MUCH ABOUT BADMINTON, IT WOULD BE A VERY HARD MANGA TO DRAW, WOULDN'T IT?

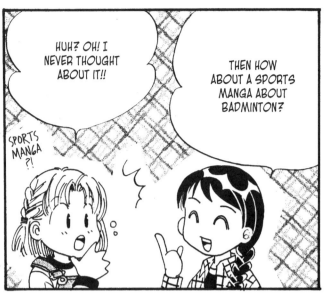

HUH? OH! I NEVER THOUGHT ABOUT IT!!

SPORTS MANGA?!

THEN HOW ABOUT A SPORTS MANGA ABOUT BADMINTON?

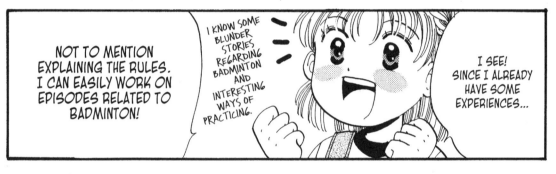

NOT TO MENTION EXPLAINING THE RULES. I CAN EASILY WORK ON EPISODES RELATED TO BADMINTON!

I KNOW SOME BLUNDER STORIES REGARDING BADMINTON AND INTERESTING WAYS OF PRACTICING.

I SEE! SINCE I ALREADY HAVE SOME EXPERIENCES...

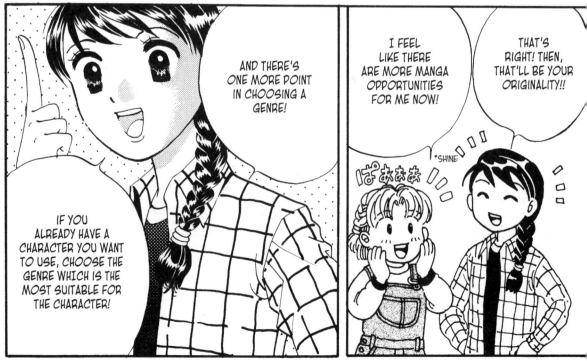

AND THERE'S ONE MORE POINT IN CHOOSING A GENRE!

IF YOU ALREADY HAVE A CHARACTER YOU WANT TO USE, CHOOSE THE GENRE WHICH IS THE MOST SUITABLE FOR THE CHARACTER!

I FEEL LIKE THERE ARE MORE MANGA OPPORTUNITIES FOR ME NOW!

THAT'S RIGHT! THEN, THAT'LL BE YOUR ORIGINALITY!!

*SHINE

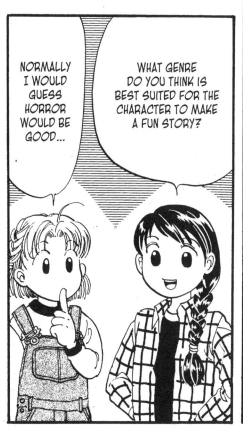

NORMALLY I WOULD GUESS HORROR WOULD BE GOOD...

WHAT GENRE DO YOU THINK IS BEST SUITED FOR THE CHARACTER TO MAKE A FUN STORY?

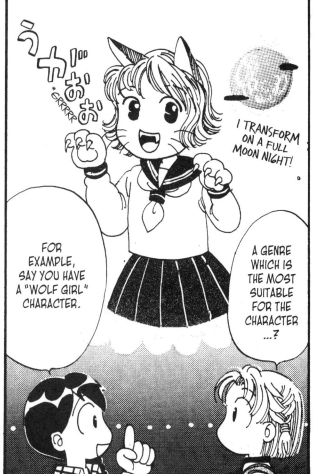

I TRANSFORM ON A FULL MOON NIGHT!

FOR EXAMPLE, SAY YOU HAVE A "WOLF GIRL" CHARACTER.

A GENRE WHICH IS THE MOST SUITABLE FOR THE CHARACTER ...?

GAG OR SCHOOL COULD BE FUN, TOO!

*WAKU WAKU

BUT LOVE COULD BE ALSO GOOD.

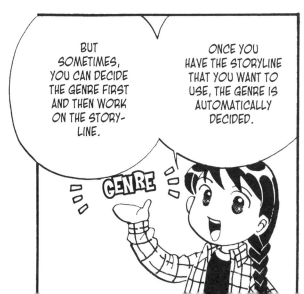

BUT SOMETIMES, YOU CAN DECIDE THE GENRE FIRST AND THEN WORK ON THE STORY-LINE.

ONCE YOU HAVE THE STORYLINE THAT YOU WANT TO USE, THE GENRE IS AUTOMATICALLY DECIDED.

GENRE

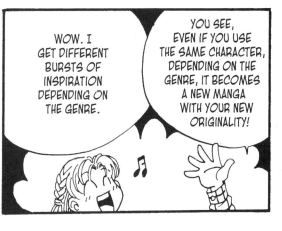

WOW. I GET DIFFERENT BURSTS OF INSPIRATION DEPENDING ON THE GENRE.

YOU SEE, EVEN IF YOU USE THE SAME CHARACTER, DEPENDING ON THE GENRE, IT BECOMES A NEW MANGA WITH YOUR NEW ORIGINALITY!

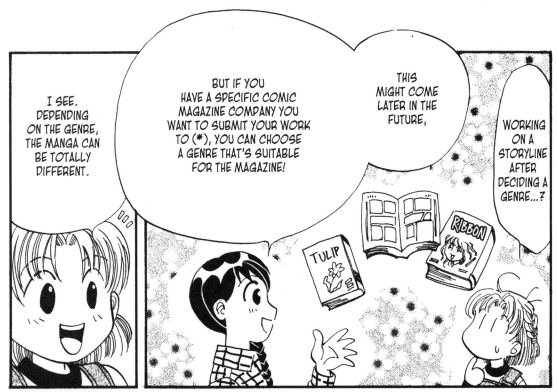

I SEE. DEPENDING ON THE GENRE, THE MANGA CAN BE TOTALLY DIFFERENT.

BUT IF YOU HAVE A SPECIFIC COMIC MAGAZINE COMPANY YOU WANT TO SUBMIT YOUR WORK TO (*), YOU CAN CHOOSE A GENRE THAT'S SUITABLE FOR THE MAGAZINE!

THIS MIGHT COME LATER IN THE FUTURE,

WORKING ON A STORYLINE AFTER DECIDING A GENRE...?

*SUBMITTING YOUR WORK TO A COMIC MAGAZINE COMPANY: YOU CAN SUBMIT YOUR MANGA TO THE EDITORS OF A COMIC MAGAZINE COMPANY AND HAVE YOUR MANGA CRITIQUED.

ALRIGHT! I'M GONNA WATCH MOVIES FROM DIFFERENT GENRES SO THAT I CAN STUDY UP ON THEM!!

YOU STUDY HARD.

*TMP TMP TMP

SHOOT! SORRY!! I FORGOT TO BRING MY MEMBERSHIP CARD!

*DENIED

● THE END ●

■ CREATING CHARACTERS AFTER CHOOSING A GENRE ■

© EXPRESSING THE GENRE THROUGH ILLUSTRATION

KYOKO'S

ONE POINT ADVICE

IF YOU HAVE READ MANY MANGA STORIES FROM DIFFERENT GENRES, YOU KNOW THAT THE ILLUSTRATION IN EACH GENRE IS DIFFERENT.

IF YOU ALREADY HAVE A GENRE YOU WANT TO WORK ON, IT'S IMPORTANT TO DRAW PICTURES THAT FIT TO THE GENRE. THE INFORMATION YOU RECEIVE FROM YOUR EYES IS EVERYTHING IN MANGA. IF YOUR ILLUSTRATIONS REFLECT THE GENRE CLEARLY, YOUR READERS WILL UNDERSTAND YOUR MANGA BETTER.

--

▲ WHEN YOU READ MANGA, YOUR EYES RECEIVE ALL THE INFORMATION SUCH AS CHARACTERS, BACKGROUND AND SPECIAL EFFECTS. READERS USE THEIR IMAGINATION WHILE THEY READ THE MANGA ASSUMING THE AUTHOR'S INTENTIONS.

● **THE TYPE THAT SHOWS THE FACIAL EXPRESSIONS WELL**

THIS TYPE IS USED IN GENRES SUCH AS LOVE, LOVE & COMEDY OR SCHOOL. THE ILLUSTRATION SHOWS THE FACIAL EXPRESSIONS WELL SO THAT THE READERS KNOW HOW THE CHARACTERS FEEL. IT'S A SOFT IMAGED ILLUSTRATION WITH THIN LINES. THIS TYPE IS USED OFTEN IN SHOUJO MANGA.

● **THE TYPE THAT SHOWS THE MOVE-MENT WELL**

THIS TYPE IS USED IN GENRES SUCH AS GAG OR SPORTS. THE ILLUSTRATION SHOWS THE CHARACTER'S MOVEMENT WELL SO THAT THE READERS CAN SEE THEIR ACTIONS CLEARLY. IT'S A STRONG IMAGED ILLUSTRATION WITH BOLD LINES. THIS TYPE IS USED OFTEN IN SHONEN MANGA.

● **THE TYPE THAT SHOWS THE SENSE OF THE OTHER WORLD**

THIS TYPE IS USED IN GENRES SUCH AS HORROR, FANTASY OR SCIENCE FICTION. THE ILLUSTRATION FITS THE WORLD-RELATED SETTINGS WHERE IMAGINARY THINGS SUCH AS SPIRITS, MONSTERS OR SPACESHIPS APPEAR. THIS TYPE OFTEN GIVES A DARK IMPRESSION.

◎ **CREATING CHARACTERS THAT FIT WELL TO THE GENRE**

WE LEARNED THAT READERS UNDERSTAND A MANGA ONLY FROM THE INFORMATION THEY RECEIVE THROUGH THEIR EYES. THEY PAY SPECIAL ATTENTION TO THE CHARACTERS. READERS WILL UNDERSTAND THE GENRE AUTOMATICALLY IF YOU DRAW THE CHARACTERS THAT FIT WELL INTO THE GENRE.

YOU CAN REFERENCE YOUR FAVORITE MANGA ARTISTS' BOOKS AND STUDY THE DIFFERENT ILLUSTRATION TYPES. HOWEVER, YOU HAVE TO DRAW WITH YOUR OWN ORIGINALITY, SO DON'T JUST COPY THEIR WORK! PLEASE REFER TO THE LEFT PANEL REGARDING THE CHARACTER-ISTICS OF EACH GENRE'S ILLUSTRATIONS.

⑧ CONSIDERING THE READERS' FEELINGS IN STORY-MAKING PROCESS

THE FIRST STEP TO BECOMING A PROFESSIONAL MANGA ARTIST IS TO TAKE THE READERS' FEELINGS INTO CONSIDERATION WHEN YOU WRITE STORIES! THE TIP TO SHARING THE FEELINGS WITH THE READERS IS TO "USE YOUR OWN EXPERIENCES". READERS WILL BE MORE LIKELY TO SHARE YOUR FEELINGS IF THE STORY IS BASED ON YOUR EXPERIENCES.

LET'S EAT!

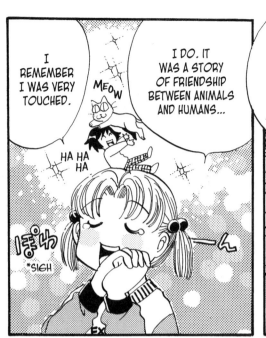

I REMEMBER I WAS VERY TOUCHED.

MEOW

HA HA HA

*SIGH

I DO. IT WAS A STORY OF FRIENDSHIP BETWEEN ANIMALS AND HUMANS...

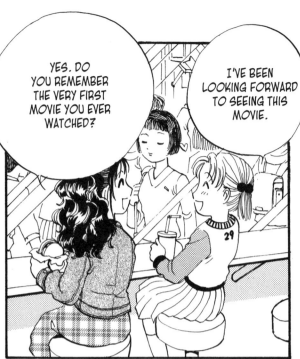

YES. DO YOU REMEMBER THE VERY FIRST MOVIE YOU EVER WATCHED?

I'VE BEEN LOOKING FORWARD TO SEEING THIS MOVIE.

29

THE READERS' FEELINGS

THE FEELINGS YOU HAVE AFTER READING A MANGA. THINK ABOUT THE FEELINGS YOU AS THE AUTHOR WANT YOUR READERS TO HAVE, SUCH AS JOY, SORROW OR BEING TOUCHED.

*TA-DA

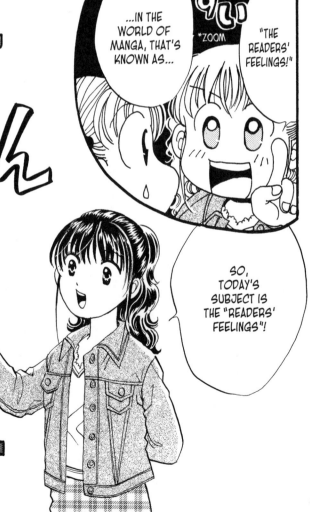

...IN THE WORLD OF MANGA, THAT'S KNOWN AS...

*ZOOM

"THE READERS' FEELINGS!"

SO, TODAY'S SUBJECT IS THE "READERS' FEELINGS"!

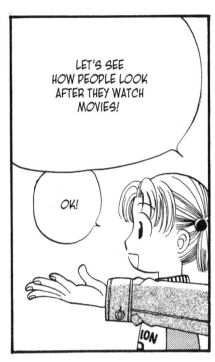

LET'S SEE HOW PEOPLE LOOK AFTER THEY WATCH MOVIES!

OK!

WHEN YOU START OUT DRAWING MANGA, IT'S ALWAYS HARD TO TAKE THOSE THINGS INTO CONSIDERATION!

THE READERS' FEELINGS... I THINK I KNOW WHAT YOU'RE TALKING ABOUT, BUT I'M AFRAID I DON'T KNOW MUCH ABOUT IT...

MMM

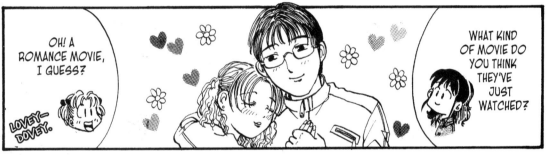

OH! A ROMANCE MOVIE, I GUESS?

LOVEY-DOVEY.

WHAT KIND OF MOVIE DO YOU THINK THEY'VE JUST WATCHED?

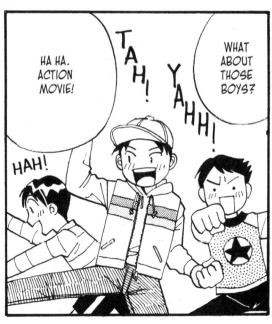

HA HA. ACTION MOVIE!

TAH! YAHH!

HAH!

WHAT ABOUT THOSE BOYS?

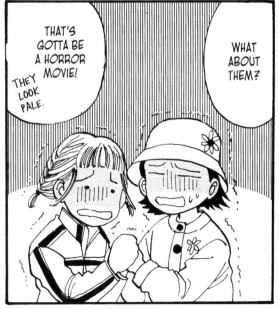

THAT'S GOTTA BE A HORROR MOVIE!

THEY LOOK PALE.

WHAT ABOUT THEM?

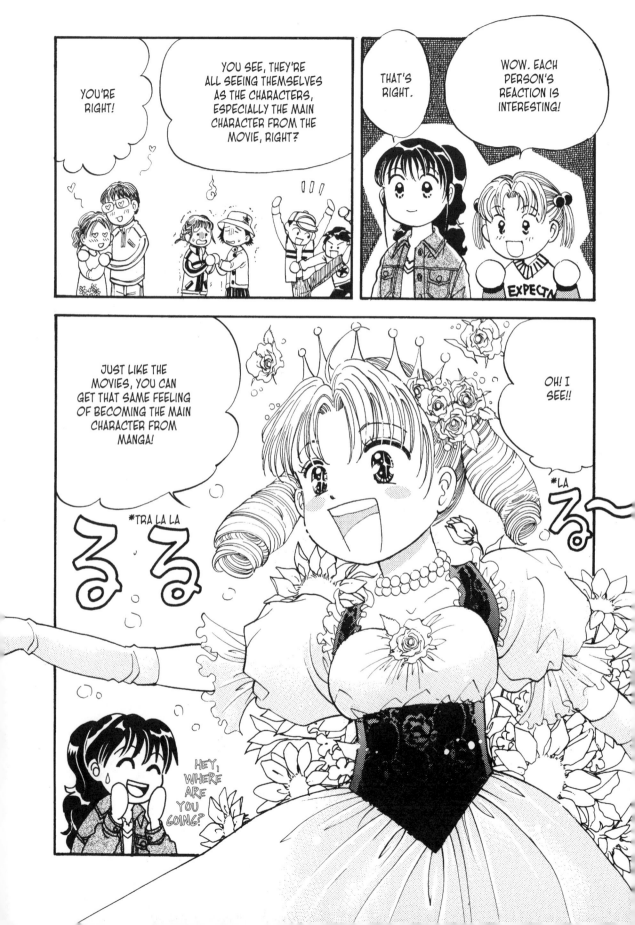

❋ READERS' FEELINGS ❋

TOUCHED	YOU'RE TOUCHED BY A STORY. YOU SHARE THE FEELINGS WITH THE CHARACTERS.
HAPPY	YOU FEEL UPLIFTED AND CHEERFUL.
FUNNY	YOU FEEL LIKE LAUGHING BECAUSE IT'S FUNNY.
ANGER	YOU GET EMOTIONAL AND FEELINGS OF ANGER.
SAD	YOU FEEL LIKE CRYING BECAUSE YOU FEEL THE PAIN IN YOUR HEART.
THINK OVER	YOU JUDGE THE STORY BASED ON YOUR KNOWLEDGE OR PAST EXPERIENCES.
UNCOMFORTABLE OR PUZZLED (*)	YOU DON'T FEEL GOOD AFTER READING. THIS IS NOT A SUITABLE FEELING AFTER READING A MANGA.

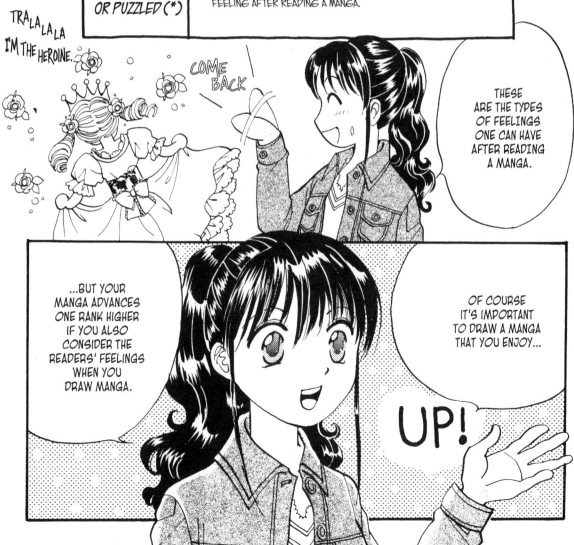

TRA LA LA LA I'M THE HEROINE.

COME BACK

THESE ARE THE TYPES OF FEELINGS ONE CAN HAVE AFTER READING A MANGA.

...BUT YOUR MANGA ADVANCES ONE RANK HIGHER IF YOU ALSO CONSIDER THE READERS' FEELINGS WHEN YOU DRAW MANGA.

OF COURSE IT'S IMPORTANT TO DRAW A MANGA THAT YOU ENJOY...

UP!

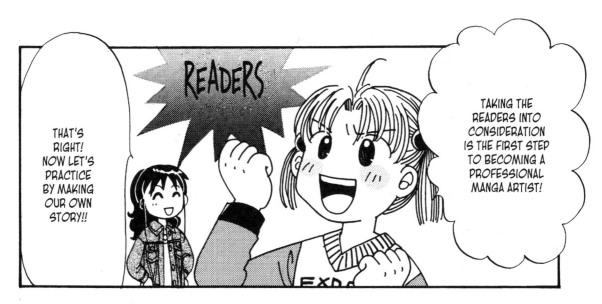

TAKING THE READERS INTO CONSIDERATION IS THE FIRST STEP TO BECOMING A PROFESSIONAL MANGA ARTIST!

THAT'S RIGHT! NOW LET'S PRACTICE BY MAKING OUR OWN STORY!!

READERS

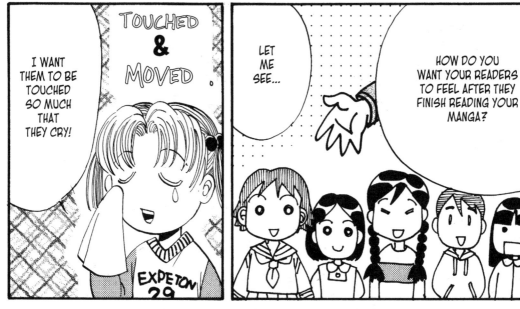

I WANT THEM TO BE TOUCHED SO MUCH THAT THEY CRY!

TOUCHED & MOVED

LET ME SEE...

HOW DO YOU WANT YOUR READERS TO FEEL AFTER THEY FINISH READING YOUR MANGA?

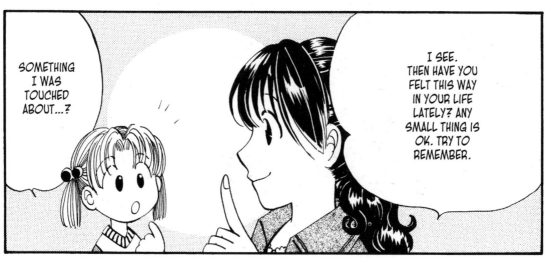

SOMETHING I WAS TOUCHED ABOUT...?

I SEE. THEN HAVE YOU FELT THIS WAY IN YOUR LIFE LATELY? ANY SMALL THING IS OK. TRY TO REMEMBER.

THEN WHY DON'T WE MAKE A STORY BASED ON THAT?

HOW NICE!

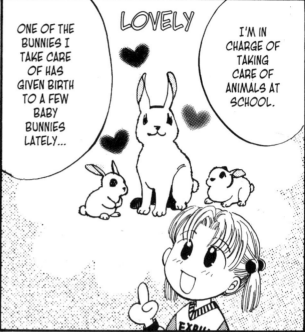

ONE OF THE BUNNIES I TAKE CARE OF HAS GIVEN BIRTH TO A FEW BABY BUNNIES LATELY...

LOVELY

I'M IN CHARGE OF TAKING CARE OF ANIMALS AT SCHOOL.

EXP...

NOT AT ALL! THAT'S WHERE YOUR ORIGINALITY KICKS IN!!

WHAT...!? BUT ISN'T THAT TOO BORING?

THEY WERE SO MEAN...

WELL, AT FIRST I DIDN'T LIKE TO GO TO SCHOOL EARLY TO TAKE CARE OF THEM.

*SCRATCH SCRATCH

YOUR REAL LIFE EXPERIENCES ARE IMPORTANT. CAN YOU TELL ME MORE ABOUT IT?

MY ORIGINALITY!?

*GLITTER

EXP

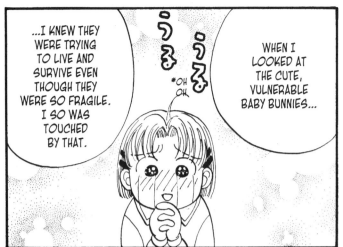

...I KNEW THEY WERE TRYING TO LIVE AND SURVIVE EVEN THOUGH THEY WERE SO FRAGILE. I SO WAS TOUCHED BY THAT.

WHEN I LOOKED AT THE CUTE, VULNERABLE BABY BUNNIES...

*OH OH

PRETTY

BUT THEN ONE DAY, THE FEMALE BUNNY GAVE BIRTH TO THE BABIES...

THEN, USE THE HAKOGAKI TECHNIQUE AND WRITE A SCRIPT.

I SEE

WHAT A GREAT STORY. NOW, YOU CAN ADD VARIOUS SETTINGS SO THAT THE STORY DRAWS THE ATTENTION FROM THE READERS. FOR EXAMPLE, YOU AND THE BOY YOU HAVE A CRUSH ON CAN TAKE CARE OF THE BUNNIES TOGETHER...

PONTA BURGER

OH! THE MOVIE'S STARTING!!

LET'S GO!!

YIKES! PLEASE WAIT FOR ME!

WOW. IT'S A BIT EMBARRASSING, BUT I'M SURE IT'LL HELP ME OUT A LOT!

IT'S ALSO A GOOD IDEA TO HAVE YOUR FAMILY OR FRIENDS READ YOUR STORY AND GIVE SOME OBJECTIVE OPINIONS!

● THE END ●

HA HA HA

*SIGH

EX

■ CREATING CHARACTERS THAT APPEAL TO THE READERS ■

◎ EXPRESSING THE CHARACTERS' FEELINGS THROUGH ILLUSTRATION

IN ORDER TO APPEAL TO THE READERS, IT'S IMPORTANT TO HAVE THE CHARACTERS EXPRESS THEMSELVES WELL. THERE ARE THREE WAYS THAT THE CHARACTERS CAN EXPRESS THEMSELVES; DIALOG, BACKGROUND, AND FACIAL EXPRESSIONS. PAY ATTENTION TO THE FACIAL EXPRESSIONS THE MOST. BECAUSE THE READERS WILL BE CONFUSED IF THE TONE OF THE DIALOG AND THE FACIAL EXPRESSIONS DO NOT MATCH.

*DROOL

*STARE

I'VE ALREADY EATEN MINE. I WONDER IF KYOKO WILL SHARE HERS WITH ME. LOOKS SO GOOD...

● FACIAL EXPRESSIONS: THE EXPRESSION ON THE CHARACTERS' FACE TO SHOW HOW THEY FEEL. BOTH THE FACE AND BODY ARE USED TO EXPRESS FEELINGS.

● BACKGROUND: ONE OF THE SPECIAL EFFECTS TO SHOW HOW THE CHARACTERS ARE FEELING. USUALLY IT IS DRAWN BEHIND THE CHARACTERS.

● DIALOG: WHAT CHARACTERS SAY TO EXPRESS THEMSELVES. THERE IS DIALOG THAT THEY SAY OUT LOUD AND NARRATION. (*)
*NARRATION: THE DIALOG THE CHARACTERS SPEAK IN THEIR MIND. IT IS ALSO CALLED "MONOLOGUE". (ANOTHER FORM OF NARRATION IS TEXT THAT NONE OF THE CHARACTERS ARE SPEAKING THAT DESCRIBES THE CHARACTER, PLACE OR A LAPSE OF TIME.)

KYOKO'S

ONE POINT ADVICE

◎ ADD "SOMETHING" TO ATTRACT THE READERS

IF YOU CREATE A STORY BASED ON YOUR PAST EXPERIENCES, IT SOMETIMES ENDS UP BEING A BORING STORY. IN THAT CASE, ADD "SOMETHING" TO DRAW THE READERS' ATTENTION.

INCLUDE SOME THINGS THAT EVERYBODY "DESIRES TO READ" ABOUT. IT CAN BE ABOUT THE CHARACTERS, SETTINGS OR IDEAS. HOWEVER, THERE ARE SOME FACTORS THAT ARE NOT SUITABLE TO ADD DEPENDING ON YOUR STORY'S GENRE.

LET'S TAKE A LOOK AT SOME SAMPLE STORIES BASED ON ALISA'S PAST EXPERIENCES...

● CREATING A LOVE OR LOVE & COMEDY STORY:

ADD SOME LOVE-RELATED FACTORS. FOR EXAMPLE, "THE MAIN CHARACTER GOES ANYWHERE THE BOY SHE LIKES GOES." OR "SHE MEETS A CUTE VET." BY ADDING THESE FACTORS, YOU CAN ATTRACT READERS WHO LIKE LOVE STORIES.

● CREATING A SCIENCE FICTION, FANTASY OR HORROR STORY:

ADD SOME IMAGINARY ELEMENTS DEPENDING ON THE GENRE. FOR EXAMPLE, "THE RABBITS TALK" OR "THE RABBITS RETURN THE GRATITUDE TO THE MAIN CHARACTER FOR TAKING CARE OF THEM". BY ADDING THESE ELEMENTS, YOU CAN ATTRACT THE READERS WHO LIKE THESE GENRES.

● CREATING A GAG, SCHOOL OR MYSTERY STORY:

ADD SOME EXTRAORDINARY ELEMENTS. FOR EXAMPLE, "A THREATENING LETTER SAYING THAT THE RABBIT HOUSE WILL BE ATTACKED. " OR "A TOURNAMENT IN WHICH THEY COMPETE FOR THE RESPONSIBILITY OF TAKING CARE OF RABBITS". BY ADDING THESE ELEMENTS, YOU CAN ATTRACT READERS WHO LIKE THESE GENRES.

● CREATING A SPORTS, HISTORICAL DRAMA OR PARODY STORY:

ADDING AN APPROPRIATE FACTOR BASED ON ALISA'S STORY, IS DIFFICULT WHEN DEALING WITH THESE GENRES. HOWEVER, IF YOU CAN FIND A FACTOR THAT FITS PERFECTLY, YOU CAN CREATE A FANTASTIC STORY WITH YOUR OWN ORIGINALITY.

⑨ WRITING STORIES BY CREATING CHARACTERS FIRST

WRITING A GOOD STORY ALWAYS DEPENDS ON THE MAIN CHARACTER'S CHARACTERISTICS (IDENTITY). YOU CAN CREATE A MAIN CHARACTER BASED ON YOURSELF (THE AUTHOR)! ADDITIONALLY, IT'S IMPORTANT TO ADD YOUR "UNIQUE TASTES" WHEN YOU WORK ON THE CHARACTER'S ROLE.

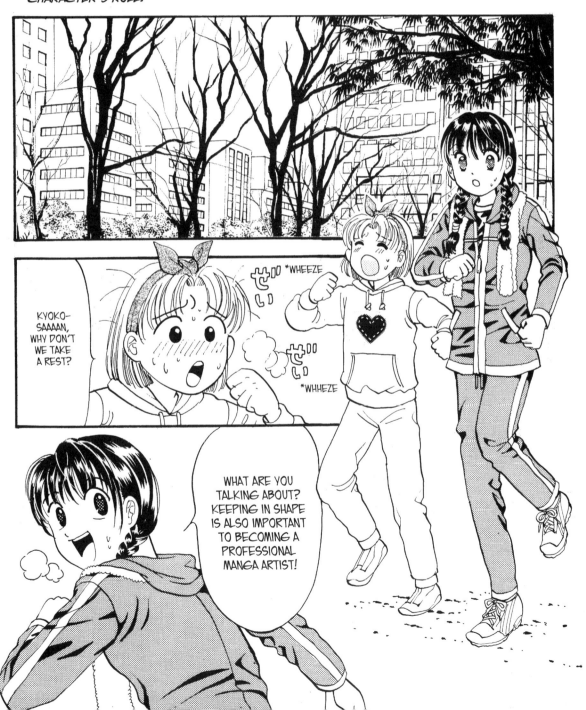

UM... OK.

*ZOOM

ALISA, NO ONE NEEDS TO KNOW THAT!

*STOP

*MUMBLE

BUT BEFORE YOU SAID YOU WERE DOING THIS BECAUSE YOU'RE GETTING CHUBBY...

THERE ARE SO MANY DIFFERENT PEOPLE HERE.

YES. THEY DON'T JUST LOOK DIFFERENT, BUT THEY HAVE DIFFERENT PERSONALITIES TOO.

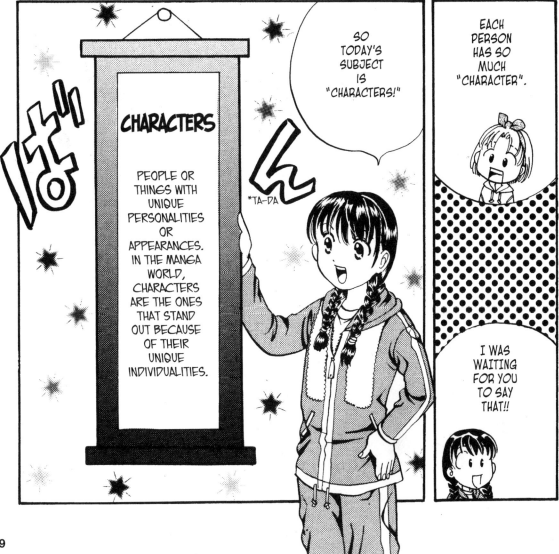

EACH PERSON HAS SO MUCH "CHARACTER".

I WAS WAITING FOR YOU TO SAY THAT!!

SO TODAY'S SUBJECT IS "CHARACTERS!"

*TA-DA

CHARACTERS

PEOPLE OR THINGS WITH UNIQUE PERSONALITIES OR APPEARANCES. IN THE MANGA WORLD, CHARACTERS ARE THE ONES THAT STAND OUT BECAUSE OF THEIR UNIQUE INDIVIDUALITIES.

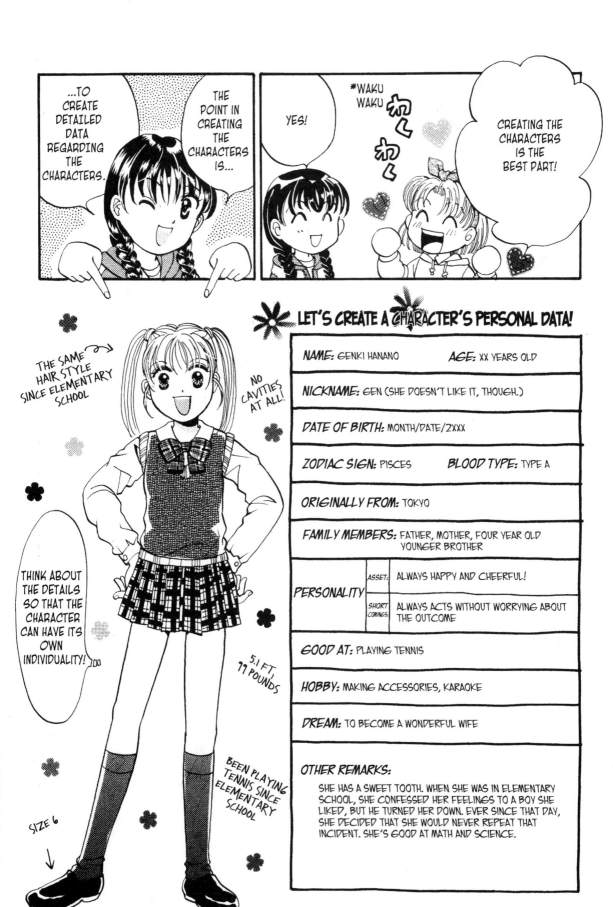

...TO CREATE DETAILED DATA REGARDING THE CHARACTERS.

THE POINT IN CREATING THE CHARACTERS IS...

YES!

*WAKU WAKU

CREATING THE CHARACTERS IS THE BEST PART!

THE SAME HAIR STYLE SINCE ELEMENTARY SCHOOL

NO CAVITIES AT ALL!

THINK ABOUT THE DETAILS SO THAT THE CHARACTER CAN HAVE ITS OWN INDIVIDUALITY!

5.1 FT, 99 POUNDS

BEEN PLAYING TENNIS SINCE ELEMENTARY SCHOOL

SIZE 6

LET'S CREATE A CHARACTER'S PERSONAL DATA!

NAME: GENKI HANANO **AGE:** XX YEARS OLD

NICKNAME: GEN (SHE DOESN'T LIKE IT, THOUGH.)

DATE OF BIRTH: MONTH/DATE/2XXX

ZODIAC SIGN: PISCES **BLOOD TYPE:** TYPE A

ORIGINALLY FROM: TOKYO

FAMILY MEMBERS: FATHER, MOTHER, FOUR YEAR OLD YOUNGER BROTHER

PERSONALITY
| ASSET: | ALWAYS HAPPY AND CHEERFUL! |
| SHORT COMINGS: | ALWAYS ACTS WITHOUT WORRYING ABOUT THE OUTCOME |

GOOD AT: PLAYING TENNIS

HOBBY: MAKING ACCESSORIES, KARAOKE

DREAM: TO BECOME A WONDERFUL WIFE

OTHER REMARKS:

SHE HAS A SWEET TOOTH. WHEN SHE WAS IN ELEMENTARY SCHOOL, SHE CONFESSED HER FEELINGS TO A BOY SHE LIKED, BUT HE TURNED HER DOWN. EVER SINCE THAT DAY, SHE DECIDED THAT SHE WOULD NEVER REPEAT THAT INCIDENT. SHE'S GOOD AT MATH AND SCIENCE.

RIGHT. IT'S ALSO EASIER TO FOLLOW THE 5W1H RULE THIS WAY!

IF YOU HAVE ALL OF THE CHARACTER DETAILS MAPPED OUT LIKE THIS, THEN THE STORY WILL COME A LOT EASIER!!

 ## ✳ TYPES OF CHARACTERS IN A MANGA ✳

MAIN CHARACTER	THE PRIMARY CHARACTER IN A MANGA
RIVALS	THE CHARACTERS TO CONFRONT OR OPPOSE THE MAIN CHARACTER
FRIENDS	CHARACTERS THAT SUPPORT OR HELP THE MAIN CHARACTER
BOYFRIEND/ GIRLFRIEND	THE CHARACTER WHOM THE MAIN CHARACTER LOVES
FAMILY	THE CHARACTERS WHO LIVE WITH THE MAIN CHARACTER
ADVISER	THE CHARACTER WHO WATCHES AND GIVES ADVICE TO THE MAIN CHARACTER.

*PASSERS-BY, CLASSMATES AND OTHER PEOPLE WITHOUT LINES DON'T BECOME CHARACTERS. YOU DON'T WANT TO GIVE PERSONALITIES TO THEM BECAUSE YOU WANT THE CHARACTERS WITH SPECIFIC ROLES TO STAND OUT.

THERE ARE OTHER CHARACTERS BESIDES THE MAIN CHARACTER IN MANGA! CREATE THE PERSONAL DATA OF THOSE CHARACTERS, TOO!!

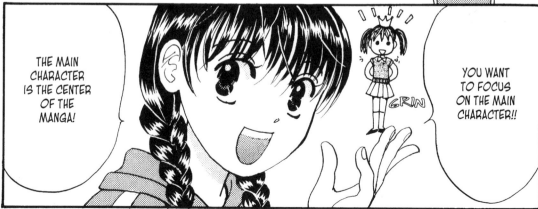

THE MAIN CHARACTER IS THE CENTER OF THE MANGA!

GRIN

YOU WANT TO FOCUS ON THE MAIN CHARACTER!!

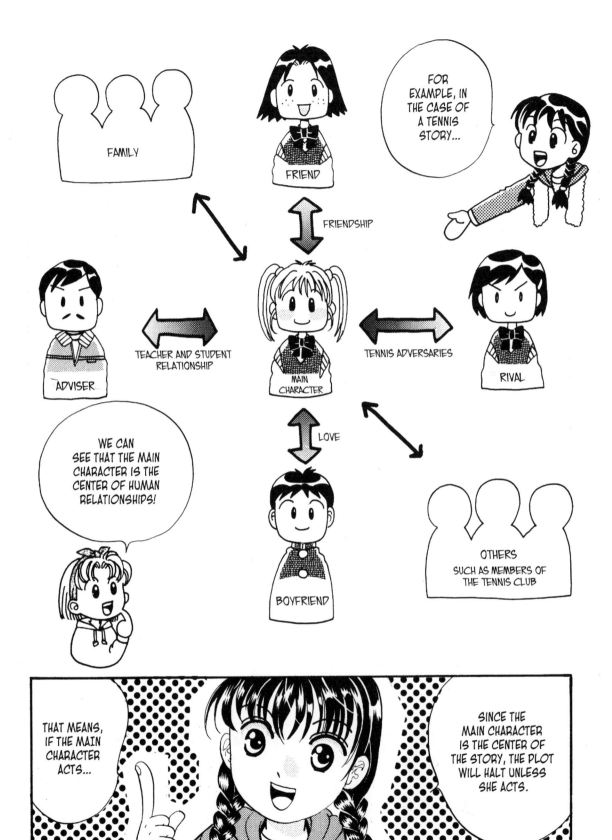

FAMILY

FRIEND

FOR EXAMPLE, IN THE CASE OF A TENNIS STORY...

FRIENDSHIP

TEACHER AND STUDENT RELATIONSHIP

ADVISER

MAIN CHARACTER

TENNIS ADVERSARIES

RIVAL

WE CAN SEE THAT THE MAIN CHARACTER IS THE CENTER OF HUMAN RELATIONSHIPS!

LOVE

BOYFRIEND

OTHERS
SUCH AS MEMBERS OF THE TENNIS CLUB

THAT MEANS, IF THE MAIN CHARACTER ACTS...

SINCE THE MAIN CHARACTER IS THE CENTER OF THE STORY, THE PLOT WILL HALT UNLESS SHE ACTS.

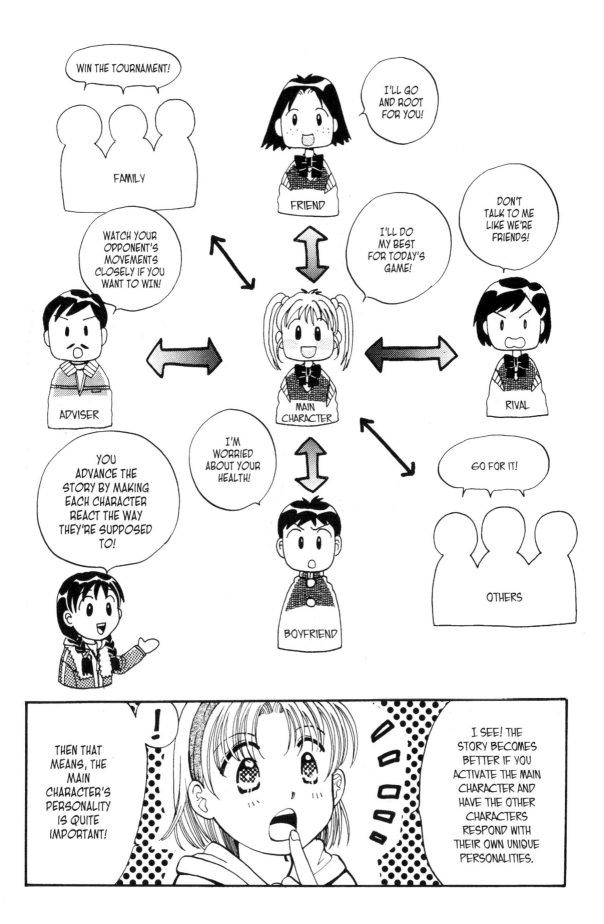

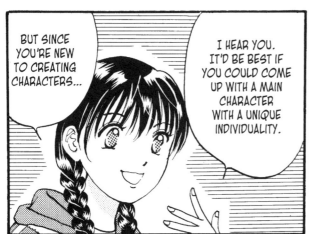

BUT SINCE YOU'RE NEW TO CREATING CHARACTERS...

I HEAR YOU. IT'D BE BEST IF YOU COULD COME UP WITH A MAIN CHARACTER WITH A UNIQUE INDIVIDUALITY.

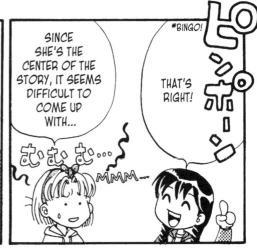

SINCE SHE'S THE CENTER OF THE STORY, IT SEEMS DIFFICULT TO COME UP WITH...

*BINGO!

THAT'S RIGHT!

MMM...

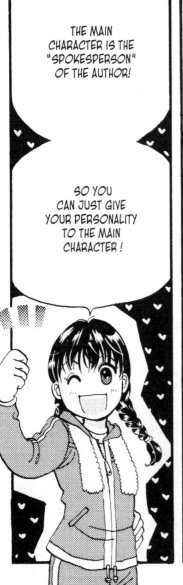

THE MAIN CHARACTER IS THE "SPOKESPERSON" OF THE AUTHOR!

SO YOU CAN JUST GIVE YOUR PERSONALITY TO THE MAIN CHARACTER!

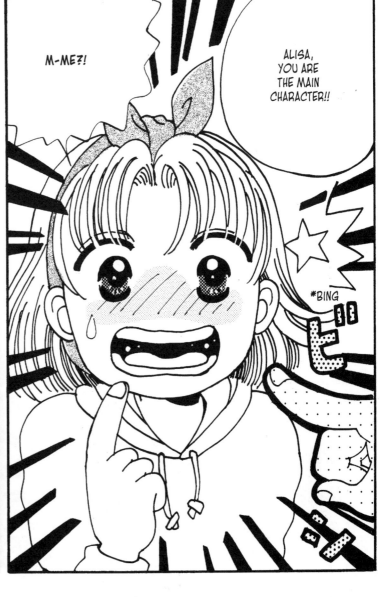

M-ME?!

ALISA, YOU ARE THE MAIN CHARACTER!!

*BING

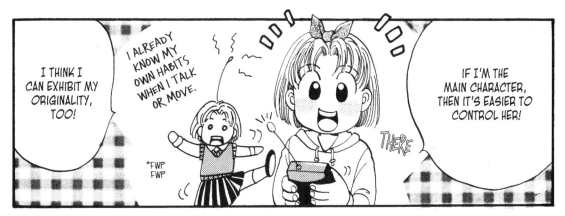

I THINK I CAN EXHIBIT MY ORIGINALITY, TOO!

I ALREADY KNOW MY OWN HABITS WHEN I TALK OR MOVE.

*FWP FWP

THERE

IF I'M THE MAIN CHARACTER, THEN IT'S EASIER TO CONTROL HER!

YOU CAN GIVE THE MAIN CHARACTER A CLEAR "PURPOSE".

RIGHT! IF YOU WANT TO MAKE HER PERSONALITY STAND OUT MORE...

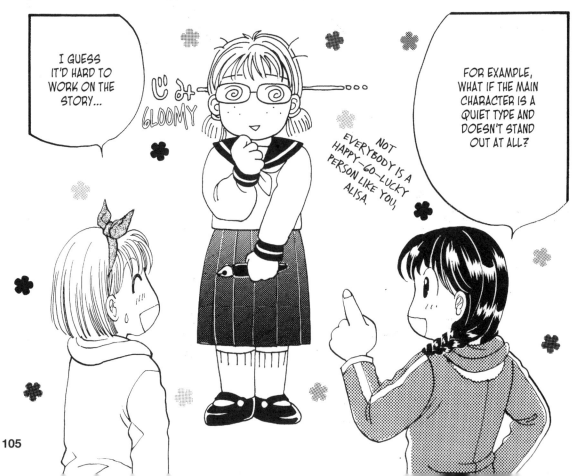

I GUESS IT'D HARD TO WORK ON THE STORY...

GLOOMY

NOT EVERYBODY IS A HAPPY-GO-LUCKY PERSON LIKE YOU, ALISA.

FOR EXAMPLE, WHAT IF THE MAIN CHARACTER IS A QUIET TYPE AND DOESN'T STAND OUT AT ALL?

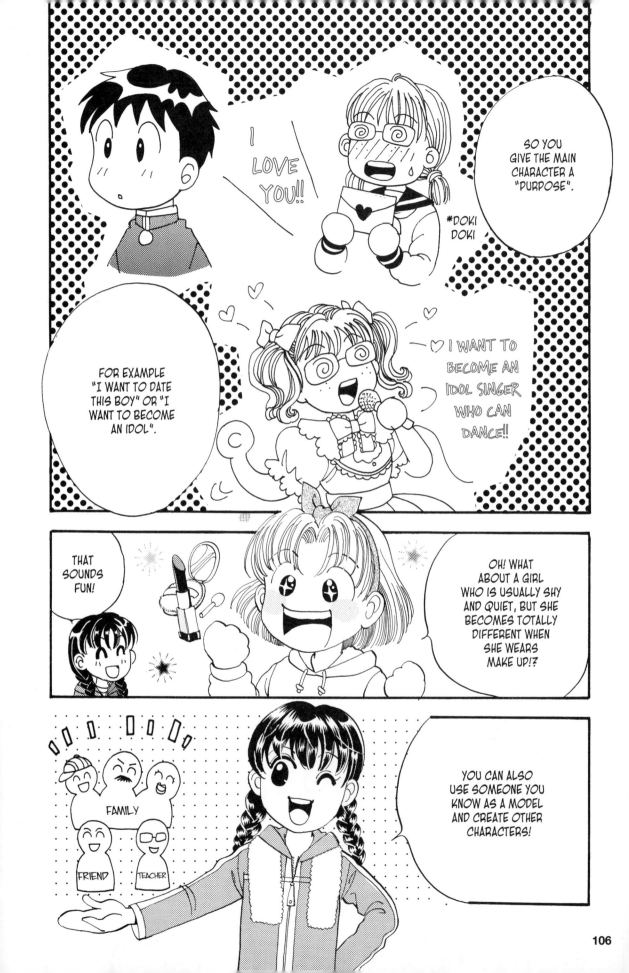

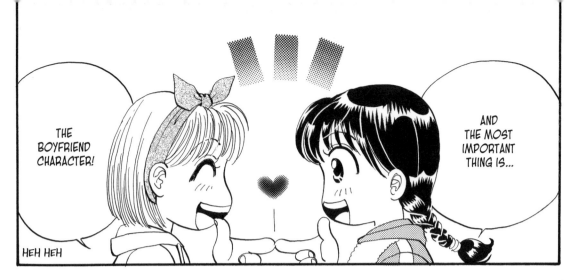

THE BOYFRIEND CHARACTER!

AND THE MOST IMPORTANT THING IS...

HEH HEH

DOES THE BOY HAVE ANY SHORT-COMINGS?

NOT AT ALL!

ASSERTIVELY

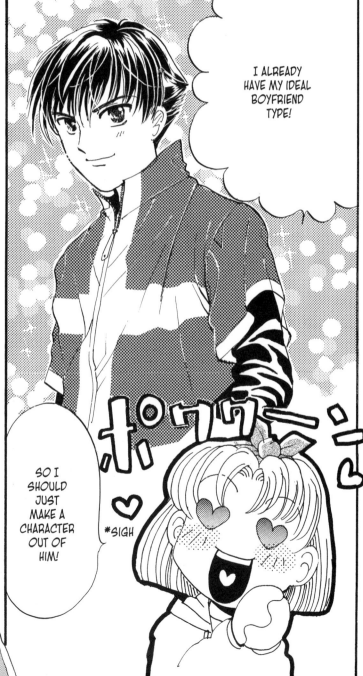

I ALREADY HAVE MY IDEAL BOYFRIEND TYPE!

SO IT'S BETTER THAT A CHARACTER HAS SOME SHORTCOMINGS OR WEAK POINTS!

NOBODY IS PERFECT IN THIS WORLD, RIGHT?

SO I SHOULD JUST MAKE A CHARACTER OUT OF HIM!

*SIGH

WEAK POINT

I SEE! THIS INSPIRES ME A LOT!!

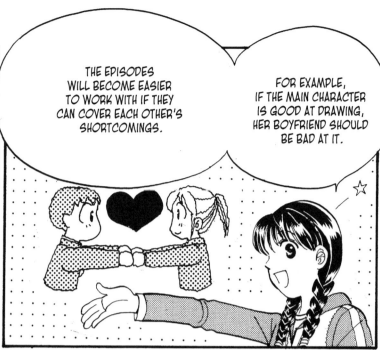

THE EPISODES WILL BECOME EASIER TO WORK WITH IF THEY CAN COVER EACH OTHER'S SHORTCOMINGS.

FOR EXAMPLE, IF THE MAIN CHARACTER IS GOOD AT DRAWING, HER BOYFRIEND SHOULD BE BAD AT IT.

IT'LL HELP YOU CREATE ORIGINAL CHARACTERS IF YOU WATCH AS MANY PEOPLE AS POSSIBLE IN VARIOUS DIFFERENT PLACES.

YOU NEED TO WATCH VARIOUS PEOPLE TO CREATE DIFFERENT TYPES OF CHARACTERS!

ONCE YOU HAVE MADE SEVERAL EPISODES...

THIS IS THE ROUTINE!!

USE THE HAKOGAKI TECHNIQUE AND MAKE THE SCRIPT!

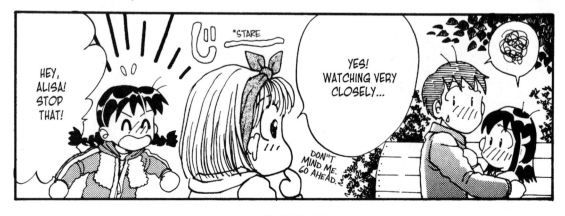

HEY, ALISA! STOP THAT!

*STARE

YES! WATCHING VERY CLOSELY...

DON'T MIND ME. GO AHEAD.

● THE END ●

■ HOW TO CREATE A CHARACTER ■

◎ CREATING A CHARACTER THAT FITS INTO THE STORY

THIS BOOK INTRODUCES MANY WAYS TO WRITE A STORY. BUT HOW DO YOU CREATE CHARACTERS WHEN YOU ALREADY HAVE A STORY WRITTEN?

WHILE YOU WERE WORKING ON THE STORY, DID YOU CREATE CHARACTERS BASED ON A VAGUE IDEA? USING CHARACTERS LIKE THAT WILL DEGRADE YOUR MANGA.

CHARACTERS ARE SO CRUCIAL IN MANGA! AT THE LEAST, THE MAIN CHARACTER AND THE BOYFRIEND/GIRLFRIEND (OR THE RIVAL) MUST BE CREATED IN THE PROPER WAY. AND IF ONE OF THESE CHARACTERS HAPPENS TO BE UNIQUE, YOUR MANGA WILL BECOME EVEN BETTER.

▶ THE INNER PART OF A CHARACTER IS HIS/HER PERSONALITY OR SKILLS. MAKE THEIR ACTIONS OR LINES UNIQUE.

▶ THE OUTER PART OF A CHARACTER IS HIS/HER APPEARANCE OR OUTFIT. MAKE THE ILLUSTRATION UNIQUE.

*GLOOMY

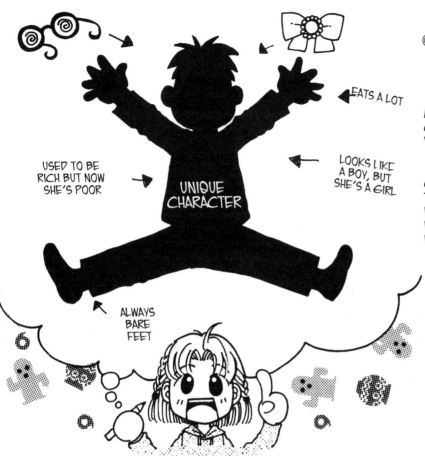

◎ CREATE A CHARACTER THAT BRIGHTENS UP THE MANGA.

LET ME TEACH YOU HOW TO ADD SOME UNIQUENESS TO THE CHARACTER YOU CREATED OUT OF A VAGUE IDEA.

WHAT'S MOST IMPORTANT IN CREATING A UNIQUE CHARACTER IS THEIR INDIVIDUALITY! READERS CANNOT IGNORE THE CHARACTERS WITH UNIQUE INDIVIDUALITIES. THEY MAKE A BIG IMPRESSION ON THE READERS!

IN ORDER TO ADD UNIQUE INDIVIDUALITY TO A CHARACTER, YOU NEED TO THINK ABOUT A CHARACTER'S SURPRISING FEATURE. THE ABILITY TO THROW OFF THE BALANCE BETWEEN ONE'S APPEARANCE AND PERSONALITY IS THE KEY TO CREATE CHARACTERS WITH SURPRISING FEATURES. THERE ARE FOUR CATEGORIES FOR THE BALANCE BETWEEN APPEARANCE AND PERSONALITY. PLEASE SEE THE FOLLOWINGS.

● GAP BETWEEN THE APPEARANCE AND THE PERSONALITY

GIVE THE CHARACTER A PERSONALITY THAT'S QUITE OPPOSITE FROM HIS/HER APPEARANCE. FOR EXAMPLE, "PRETTY BUT MEAN" OR "NICE AND KIND DESPITE THE GANGSTER LOOK".

● PERSONALITY CHANGE WHEN TRIGGERED BY SOMETHING

MAKE THE CHARACTER CHANGE WHEN TRIGGERED BY SOMETHING. FOR EXAMPLE "USUALLY SHY AND QUIET, BUT BECOMES VIOLENT BY LOOKING AT A FULL MOON", "USUALLY ROUGH, BUT TENDS TO CRY WHEN DRINKING ALCOHOL."

● GAP BETWEEN THE REALITY AND THE STATUS

PUT A CHARACTER IN AN OPPOSITE CIRCUMSTANCE FROM WHAT HE/SHE IS SUPPOSED TO BE. FOR EXAMPLE, "FATHER OF THE STUDENT COUNCIL PRESIDENT IS THE LEADER OF YAKUZA", "A SWIMMING TEAM MEMBER EVEN THOUGH HE/SHE CAN'T SWIM"

● EXTREMELY UNIQUE IN SOMETHING

GIVE THE CHARACTER A VERY UNIQUE POINT REGARDING HIS/HER APPEARANCE OR PERSONALITY. FOR EXAMPLE, "PERFECTLY BEAUTIFUL EXCEPT THE OVERLY FAT LIPS", "EXCESSIVELY NEAT AND CLEAN"

⑩THE INTRODUCTION, DEVELOPMENT, TURN AND CONCLUSION METHOD

THE "INTRODUCTION, DEVELOPMENT, TURN AND CONCLUSION" IS THE FORMULA TO DEVELOP A MANGA STORY. READERS WILL BE ABLE TO UNDERSTAND THE CONTENTS CLEARLY IF THE STORY IS COMPOSED THIS WAY. ONCE YOU MASTER THIS METHOD, YOU WILL BE ABLE TO CREATE A MANGA THAT ATTRACTS LOTS OF READERS WITH EASE! LET'S LEARN EACH ROLE OF THE "INTRODUCTION", "DEVELOPMENT", "TURN" AND "CONCLUSION"!

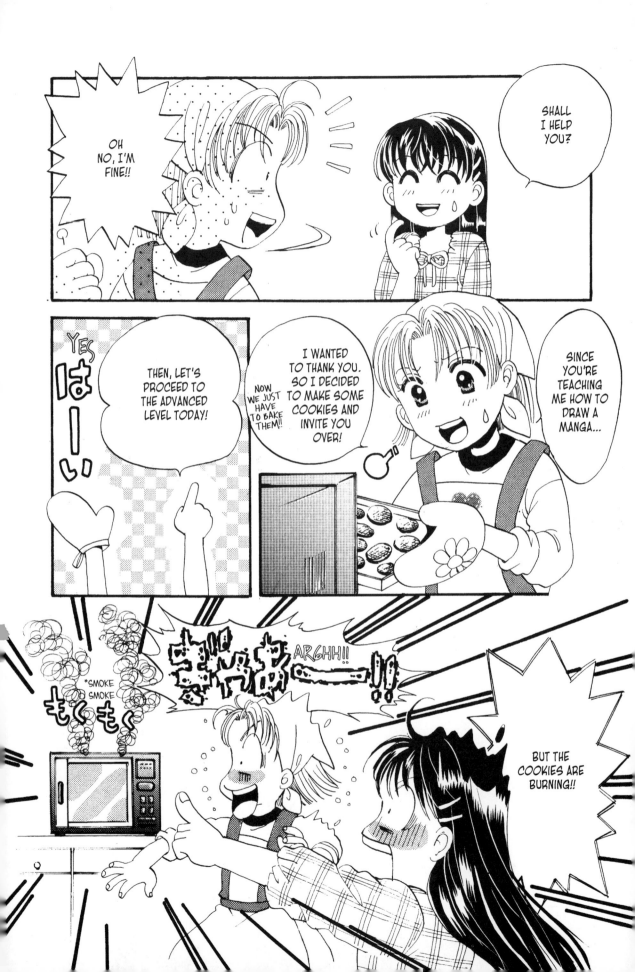

*SOB

UM...

*OH NO

THEY'RE ALL... BLACK...

*CRUNCH CRUNCH

KYOKO, YOU'LL GET SICK...

YOU SHOULDN'T!!

*NO!

IT'S OK. WE CAN STILL EAT THEM!

*POP

WHAT!!?

REALLY!?

THE BURNT PART GIVES IT A COFFEE FLAVOR. IT'S EXCELLENT!!

YUMMY!

NOW, KEEPING THAT IN MIND, WE WILL WRITE STORIES USING "SPECIAL EFFECTS".

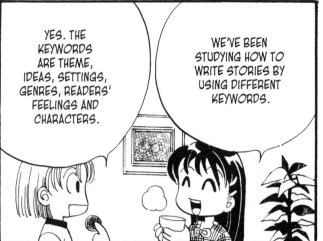

YES. THE KEYWORDS ARE THEME, IDEAS, SETTINGS, GENRES, READERS' FEELINGS AND CHARACTERS.

WE'VE BEEN STUDYING HOW TO WRITE STORIES BY USING DIFFERENT KEYWORDS.

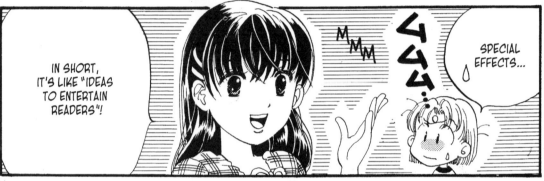

IN SHORT, IT'S LIKE "IDEAS TO ENTERTAIN READERS"!

MMM

SPECIAL EFFECTS...

"FROM "CLASSIFICATION OF POINTS IN STORY-MAKING" ON PAGE 23

ADVANCED TECHNIQUES CATEGORIES FORSTORY-MAKING USING SPECIAL EFFECTS

INTRODUCTION, DEVELOPMENT, TURN AND CONCLUSION	THE ORDER OF EPISODES WHERE THE STORY BEGINS AND MOVES TO THE CLIMAX IN A CLEAR MANNER. YOU CAN USE THIS TO WRITE A STORY.
DEVELOPMENT AND INDUCTIVE METHOD	A METHOD OF STORY-MAKING IN WHICH YOU GET IDEAS FROM THE FLOW OF THE STORY AND LINK TOGETHER THE EPISODES.
PAGE COUNT	THE NUMBER OF PAGES YOU USED TO COMPLETE THE MANGA. THERE ARE SHORT STORIES, MEDIUM-LENGTH STORIES, LONG STORIES AND FOUR-PANEL COMIC STRIPS. YOU CAN USE THIS FACTOR IN STORY-MAKING.

THERE ARE THREE CATEGORIES FOR THE SPECIAL EFFECTS.

IT LOOKS COMPLICATED...

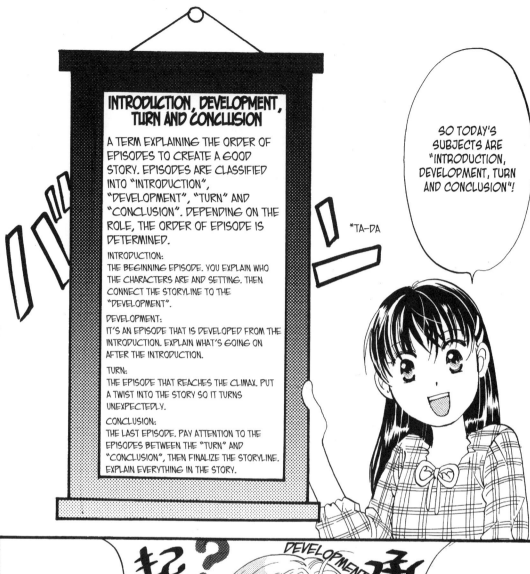

INTRODUCTION, DEVELOPMENT, TURN AND CONCLUSION

A TERM EXPLAINING THE ORDER OF EPISODES TO CREATE A GOOD STORY. EPISODES ARE CLASSIFIED INTO "INTRODUCTION", "DEVELOPMENT", "TURN" AND "CONCLUSION". DEPENDING ON THE ROLE, THE ORDER OF EPISODE IS DETERMINED.

INTRODUCTION:
THE BEGINNING EPISODE. YOU EXPLAIN WHO THE CHARACTERS ARE AND SETTING. THEN CONNECT THE STORYLINE TO THE "DEVELOPMENT".

DEVELOPMENT:
IT'S AN EPISODE THAT IS DEVELOPED FROM THE INTRODUCTION. EXPLAIN WHAT'S GOING ON AFTER THE INTRODUCTION.

TURN:
THE EPISODE THAT REACHES THE CLIMAX. PUT A TWIST INTO THE STORY SO IT TURNS UNEXPECTEDLY.

CONCLUSION:
THE LAST EPISODE. PAY ATTENTION TO THE EPISODES BETWEEN THE "TURN" AND "CONCLUSION", THEN FINALIZE THE STORYLINE. EXPLAIN EVERYTHING IN THE STORY.

*TA-DA

SO TODAY'S SUBJECTS ARE "INTRODUCTION, DEVELOPMENT, TURN AND CONCLUSION"!

起? INTRODUCTION

承 DEVELOPMENT

転 TURN

結 CONCLUSION

I KNOW I NEED TO USE THOSE IN STORY-MAKING, BUT...

I HEAR THOSE TERMS QUITE OFTEN.

*TA-DA

THIS IS YOUR CLUE!

WHAT?

I'LL TEACH YOU IN A SIMPLE WAY!

NO PROBLEM!

AH-HA. LEAVE IT TO ME!

REALLY?

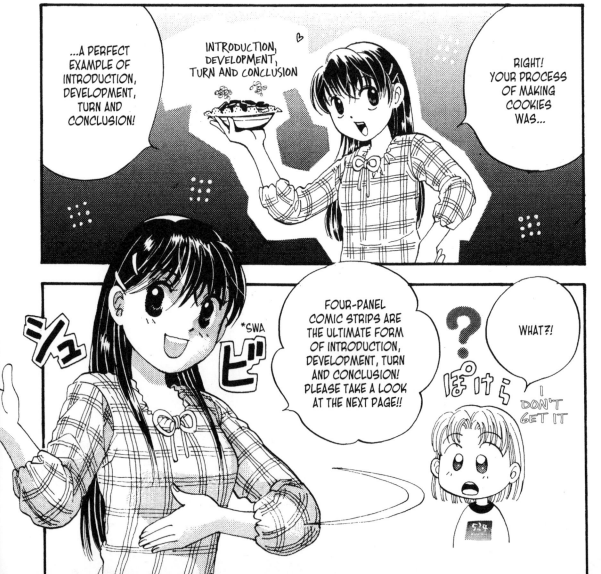

...A PERFECT EXAMPLE OF INTRODUCTION, DEVELOPMENT, TURN AND CONCLUSION!

INTRODUCTION, DEVELOPMENT, TURN AND CONCLUSION

RIGHT! YOUR PROCESS OF MAKING COOKIES WAS...

*SWA

FOUR-PANEL COMIC STRIPS ARE THE ULTIMATE FORM OF INTRODUCTION, DEVELOPMENT, TURN AND CONCLUSION! PLEASE TAKE A LOOK AT THE NEXT PAGE!!

?

WHAT?!

I DON'T GET IT

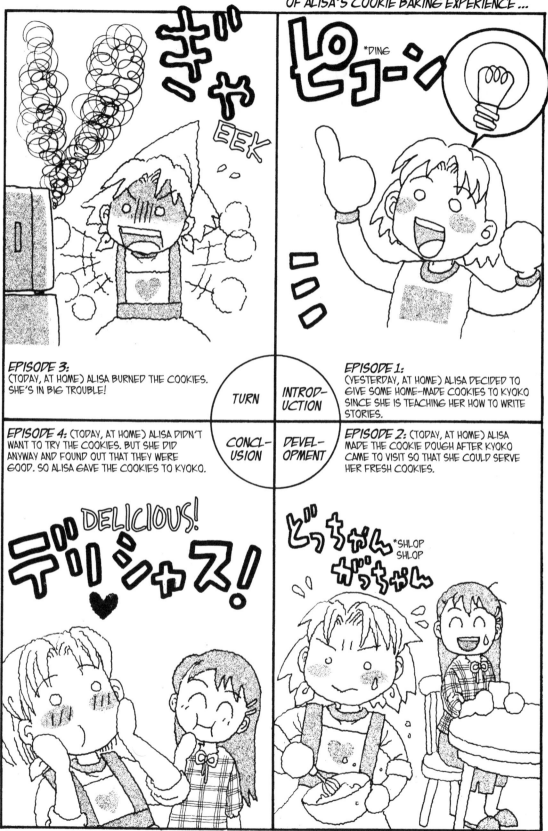

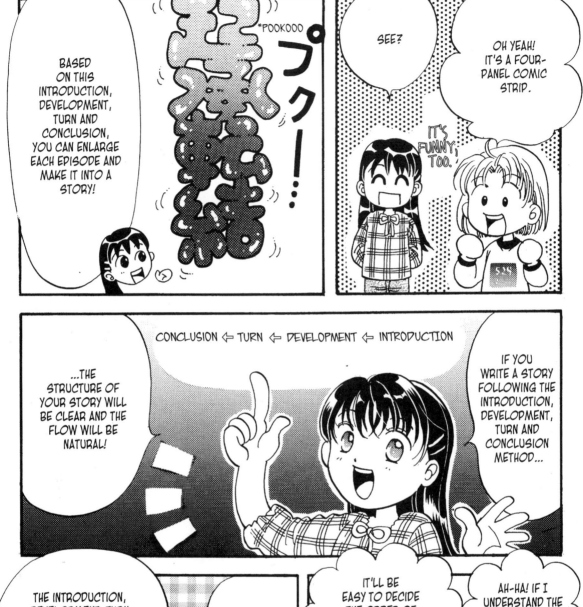

BASED ON THIS INTRODUCTION, DEVELOPMENT, TURN AND CONCLUSION, YOU CAN ENLARGE EACH EPISODE AND MAKE IT INTO A STORY!

*POOKOOO

SEE?

OH YEAH! IT'S A FOUR-PANEL COMIC STRIP.

IT'S FUNNY, TOO.

CONCLUSION ⇐ TURN ⇐ DEVELOPMENT ⇐ INTRODUCTION

...THE STRUCTURE OF YOUR STORY WILL BE CLEAR AND THE FLOW WILL BE NATURAL!

IF YOU WRITE A STORY FOLLOWING THE INTRODUCTION, DEVELOPMENT, TURN AND CONCLUSION METHOD...

THE INTRODUCTION, DEVELOPMENT, TURN AND CONCLUSION METHOD IS LIKE THE NAVIGATOR OF STORY-MAKING!

THAT'S RIGHT!

IT'LL BE EASY TO DECIDE THE ORDER OF EPISODES WHEN I USE THE HAKOGAKI TECHNIQUE!

AH-HA! IF I UNDERSTAND THE INTRODUCTION, DEVELOPMENT, TURN AND CONCLUSION,

*PON

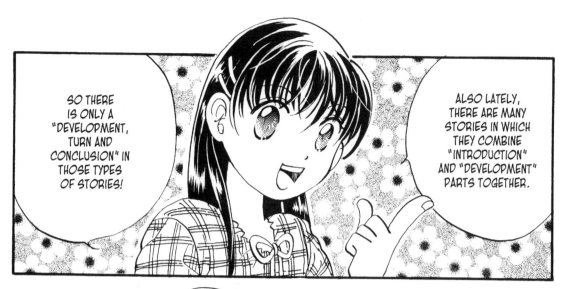

SO THERE IS ONLY A "DEVELOPMENT, TURN AND CONCLUSION" IN THOSE TYPES OF STORIES!

ALSO LATELY, THERE ARE MANY STORIES IN WHICH THEY COMBINE "INTRODUCTION" AND "DEVELOPMENT" PARTS TOGETHER.

BUT YOU STILL NEED TO DESCRIBE YOUR CHARACTERS, SETTINGS AND THE INCIDENT AND THAT REQUIRES THE PROPER MANGA WRITING TECHNIQUES AND SKILLS!

YUP, YUP!

IS THAT A SHOUJO MANGA...?

*FWLP

IT'S A TECHNIQUE TO DRAW THE READER'S ATTENTION BY STARTING THE STORY WITH AN INCIDENT OUT OF NOWHERE!

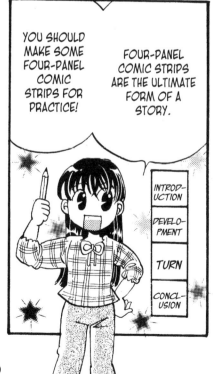

YOU SHOULD MAKE SOME FOUR-PANEL COMIC STRIPS FOR PRACTICE!

FOUR-PANEL COMIC STRIPS ARE THE ULTIMATE FORM OF A STORY.

| INTRODUCTION |
| DEVELOPMENT |
| TURN |
| CONCLUSION |

YES!

APPLIED TECHNIQUES COME LATER.

FIRST, LET'S MASTER THE BASICS OF "INTRODUCTION, DEVELOPMENT, TURN AND CONCLUSION"!

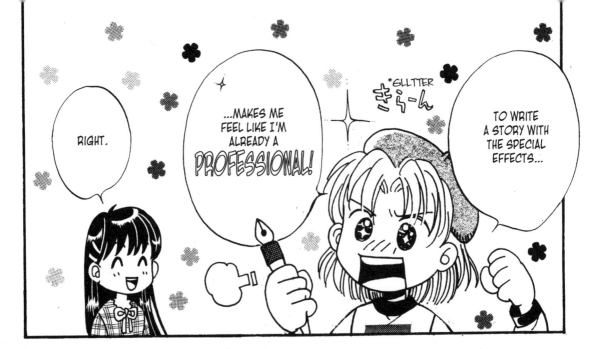

RIGHT.

...MAKES ME FEEL LIKE I'M ALREADY A **PROFESSIONAL!**

*GLITTER

TO WRITE A STORY WITH THE SPECIAL EFFECTS...

...THAT MEANS YOUR LEVEL IN STORY-MAKING HAS GONE UP!

IF YOU PAY ATTENTION TO HOW YOU CAN ENTERTAIN THE READERS....

WOW, ALISA. YOUR EYES ARE BURNING!

ALRIGHT! I'LL MASTER CREATING SPECIAL EFFECTS, TOO!

*FLARLNG

● THE END ●

WHAT IS THE "INTRODUCTION, DEVELOPMENT, TURN AND CONCLUSION" METHOD?

◎ THE ESSENTIAL POINT IS THAT THE CHARACTERS GROW. (1)

WE LEARNED THAT THE "INTRODUCTION, DEVELOPMENT, TURN AND CONCLUSION" METHOD IS LIKE A NAVIGATOR IN STORY-MAKING. IF YOU ADD ONE MORE FACTOR, IT'LL BECOME AN EVEN BE BETTER NAVIGATOR. THAT FACTOR IS "CHARACTER GROWTH" (IN OTHER WORDS, HAVE THE CHARACTER EVOLVE, MENTALLY OR PHYSICALLY). ESPECIALLY, IF YOU MAKE THE MAIN CHARACTER GROW USING THE "INTRODUCTION, DEVELOPMENT, TURN AND CONCLUSION" METHOD, YOU CAN CREATE A FANTASTIC STORY.

SUCH EPISODES AS A SHOCKING INCIDENT, HARDSHIP OR A COMPLICATED HUMAN RELATIONSHIP WILL ATTRACT THE READER'S ATTENTION. AT THE SAME TIME, THE MAIN CHARACTER NEEDS THOSE EPISODES IN ORDER TO GROW. PROFESSIONAL MANGA ARTISTS MAKE ALL THE EPISODES THIS WAY SO THAT THE MAIN CHARACTER CAN EVOLVE.

USING THE CHARACTER'S FACIAL EXPRESSIONS, ACTIONS OR DIALOG, YOU CAN SHOW THAT THE CHARACTER MATURED AT THE END OF THE STORY. YOU CAN CHANGE THE DEGREE OF HOW MUCH THE CHARACTER GROWS UP DEPENDING ON THE DETAILS AND THE PERSONALITY OF THE CHARACTER.

▶ IN THIS MANGA, ALISA IS GROWING THROUGH THE STEPS OF LEARNING HOW TO DRAW A MANGA.

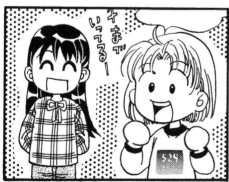

◀ JUST LIKE IN THE REAL WORLD WHERE EVERYBODY HAS A DIFFERENT RATE OF GROWTH, THE CHARACTERS IN THE MANGA DIFFER IN SPEED WHEN LEARNING NEW THINGS. AS FOR KYOKO AND ALISA, ALISA HAS LESS EXPERIENCE COMPARED TO KYOKO. THEREFORE HER IMPROVEMENT SPEED IS FASTER THAN KYOKO'S.

KYOKO'S ONE POINT ADVICE

◎ THE MOST IMPORTANT POINT IS THAT THE CHARACTERS GROW. (2)

IF YOU WANT TO CREATE A STORY IN WHICH YOUR CHARACTERS GROW, WHAT SHOULD YOU PAY ATTENTION TO WHEN YOU CHOOSE EPISODES? THE KEY IS TO MAKE SURE THAT THE CHARACTERS MATURE IN THE "CONCLUSION" PART RATHER THAN THE "INTRODUCTION". FURTHERMORE, THE BEST WAY IS TO RAISE THE CHARACTERS ACCORDING TO THE GENRE OF YOUR STORY.

● **LOVE** ●

MAKE SURE THE CHARACTERS GROW IN HIS/HER LOVE LIFE. FOR EXAMPLE, "THE SELFISHNESS DISAPPEARS AT THE END" OR "STARTS TO UNDERSTAND THE FEELINGS OF THE OPPOSITE SEX".

● **LOVE & COMEDY** ●

MAKE SURE THE CHARACTERS GROW THEMSELVES RATHER THAN IN LOVE. FOR EXAMPLE, "HE/SHE USED TO COMMIT BLUNDERS, BUT DOES NOT ANYMORE." OR "HE/SHE STARTED TO TAKE THE INITIATIVE AND HAVE A POSITIVE OUTLOOK ON LIFE".

● **GAG** ●

MAKE SURE THE CHARACTERS GROW REGARDING HUMOR-MAKING SUCH AS "HE/SHE STARTED TO ACT MORE WEIRD." OR "HE/SHE STARTED TO HAVE A STRANGE ABILITY". IN SOME CASES, THE CHARACTERS DON'T EVEN NEED TO GROW UP.

● **SCHOOL** ●

MAKE SURE THE CHARACTERS GROW MENTALLY OR REGARDING THE SOCIAL STATUS SUCH AS "HE/SHE STARTED TO BE CONSIDERATE TOWARD OTHERS" OR "HE/SHE GOT PROMOTED".

● **MYSTERY** ●

MAKE SURE THE CHARACTERS GROW IN TERMS OF THEIR DETECTIVE SKILLS SUCH AS "HE/SHE IMPROVED HIS/HER INVESTIGATION SKILLS" OR "HIS/HER WAY OF DEALING WITH PEOPLE GOT BETTER".

● **HORROR** ●

MAKE SURE THE CHARACTERS GROW REGARDING THE "THREAT" SUCH AS "HE/SHE OVERCOMES HIS/HER FEAR" OR "HE/SHE SOLVES THE INCIDENTS RELATED TO GHOSTS".

● **FANTASY** ●

MAKE SURE THE CHARACTERS GROW THEMSELVES OR SOME ABILITY RELATED TO THE WORLD SETTINGS SUCH AS "HE/SHE HAS MORE FRIENDS" OR "HE/SHE LEARNS MORE MAGIC".

● **SCIENCE FICTION** ●

MAKE SURE THE CHARACTERS GROW THEMSELVES OR SOME ABILITY RELATED TO THE WORLD SETTINGS SUCH AS "HE/SHE FINDS NEW CHALLENGES" OR "HE/SHE GAINS SPECIAL ABILITY".

● **SPORTS** ●

MAKE SURE THE CHARACTERS GROW IN TERMS OF SPORTS SUCH AS "HE/SHE IMPROVES IN SPORTS ABILITY" OR "HE/SHE LEARNS NEW TECHNIQUE".

● **HISTORICAL DRAMA** ●

MAKE SURE THE CHARACTERS GROW THEMSELVES OR WORLD SETTINGS RELATED SKILL SUCH AS "HE/SHE GREW UP MENTALLY" OR "HE/SHE LEARNS THE KNOCKDOWN TECHNIQUE".

● **PARODY** ●

MAKE SURE THE CHARACTERS GROW ACCORDINGLY TO HIS/HER INDIVIDUALITY.

⑪ WHAT ARE THE DEVELOPMENT AND THE INDUCTIVE METHOD?

THE "DEVELOPMENT METHOD" AND "INDUCTIVE METHOD" ARE THE SUPER TECHNIQUES IN WHICH YOU DEVELOP THE STORY BY CREATING AN EPISODE FROM ANOTHER EPISODE. MORE OVER, LET'S ALSO STUDY THE APPLIED TECHNIQUE IN WHICH GOOD PARTS FROM EACH METHOD ARE COMBINED!

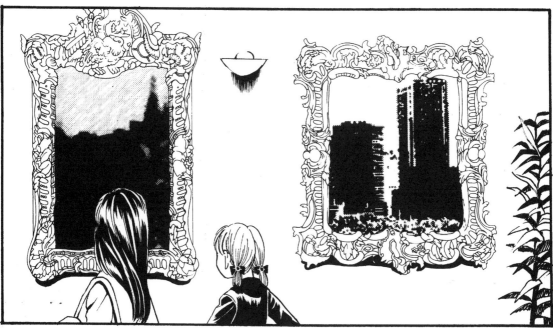

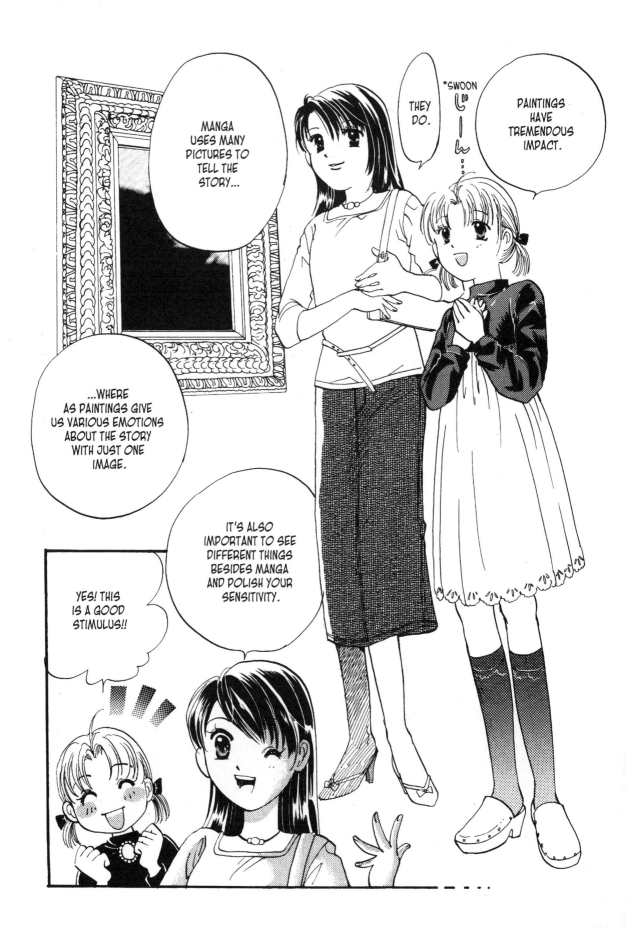

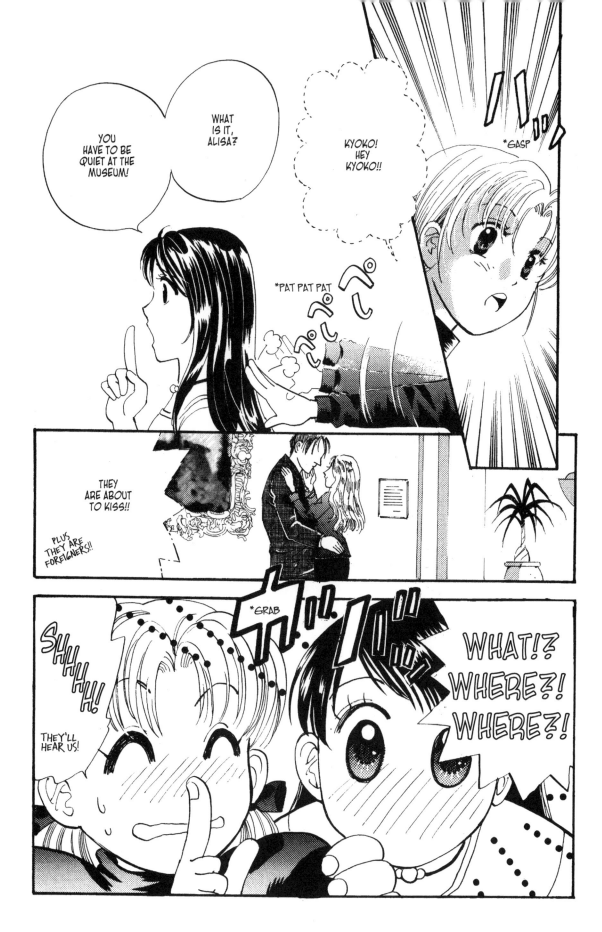

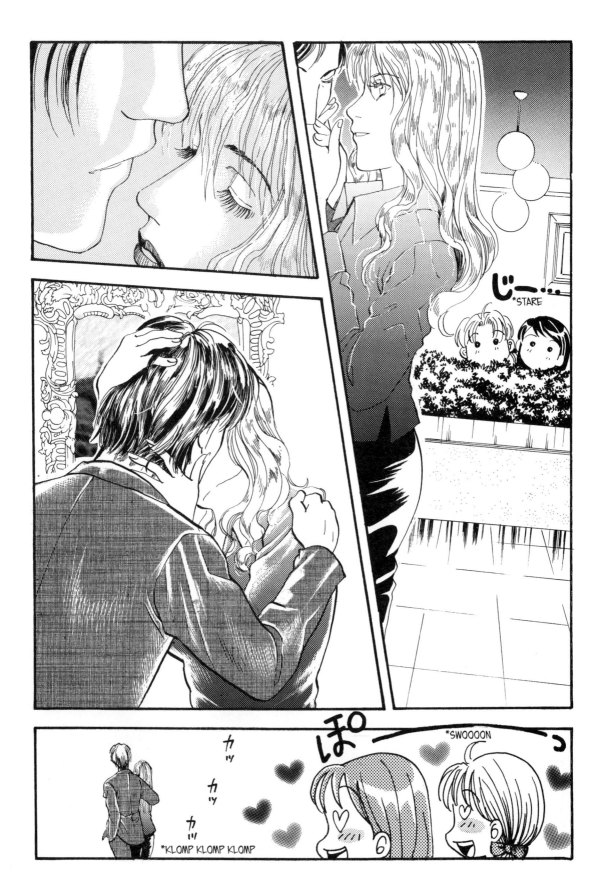

*STARE

*SWOOOON

*KLOMP KLOMP KLOMP

THEY WERE SUCH A BEAUTIFUL COUPLE. IT WAS LIKE THEY WERE A PIECE OF ART.

*SWOOON

KISSING IN A MUSEUM IS SO ROMANTIC ISN'T IT?

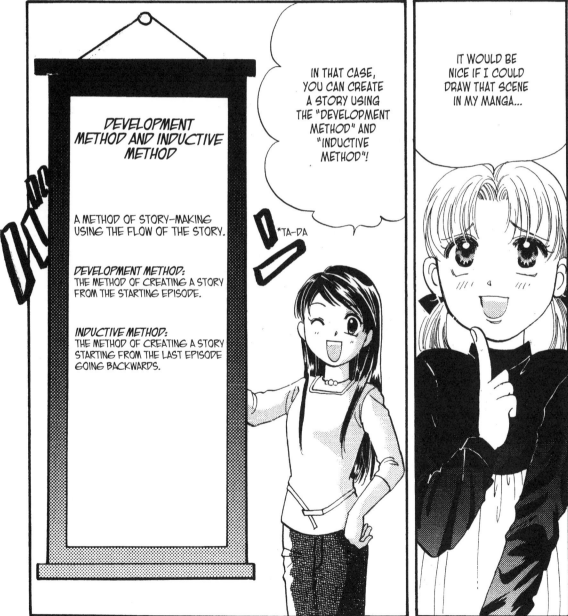

DEVELOPMENT METHOD AND INDUCTIVE METHOD

A METHOD OF STORY-MAKING USING THE FLOW OF THE STORY.

DEVELOPMENT METHOD: THE METHOD OF CREATING A STORY FROM THE STARTING EPISODE.

INDUCTIVE METHOD: THE METHOD OF CREATING A STORY STARTING FROM THE LAST EPISODE GOING BACKWARDS.

IN THAT CASE, YOU CAN CREATE A STORY USING THE "DEVELOPMENT METHOD" AND "INDUCTIVE METHOD"!

*TA-DA

IT WOULD BE NICE IF I COULD DRAW THAT SCENE IN MY MANGA...

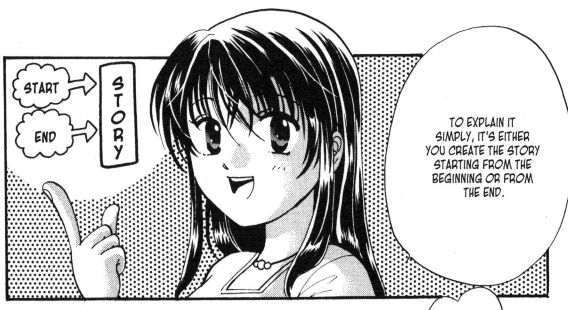

START → END → STORY

TO EXPLAIN IT SIMPLY, IT'S EITHER YOU CREATE THE STORY STARTING FROM THE BEGINNING OR FROM THE END.

THE FLOW OF THE STORY

THE STORY STARTS FROM KISSING IN THE MUSEUM!

DEVELOPMENT METHOD
(GOOD FOR LONG STORIES)

EPISODE	EPISODE	EPISODE	EPISODE
(THE END)			(BEGINNING)
CONCLUSION	TURN	DEVELOPMENT	INTRODUCTION

*IN THE DEVELOPMENT METHOD, YOU ADVANCE THE STORY WITHOUT DECIDING THE ENDING (KEEP MAKING EPISODES), SO YOU CAN ADD VARIOUS KINDS OF EPISODES. HOWEVER, SOMETIMES THE STORY GETS TOO BIG AND YOU CAN LOSE CONTROL OF IT...

THE FLOW OF THE STORY

THE STORY ENDS WITH THE KISSING IN THE MUSEUM!

INDUCTIVE METHOD
(GOOD FOR SHORT STORIES)

EPISODE	EPISODE	EPISODE	EPISODE
(BEGINNING)			(THE END)
INTRODUCTION	DEVELOPMENT	TURN	CONCLUSION

*IN THE INDUCTIVE METHOD, SINCE YOU ALREADY HAVE THE LAST EPISODE, YOU DON'T END UP ADDING UNNECESSARY EPISODES. THEREFORE, THE STORY BECOMES CLEAR TO UNDERSTAND. HOWEVER, IT'S NOT EASY TO EXPAND THE STORY AND SOMETIMES THE READERS CAN TELL WHAT'LL HAPPEN AT THE END...

THAT'S RIGHT. BUT WHEN YOU'RE NOT USED TO DRAWING MANGA, YOU SHOULD AVOID USING THE DEVELOPMENT METHOD!

UH HUH.

I SEE...THE STORY-MAKING PROCESS IS DIFFERENT.

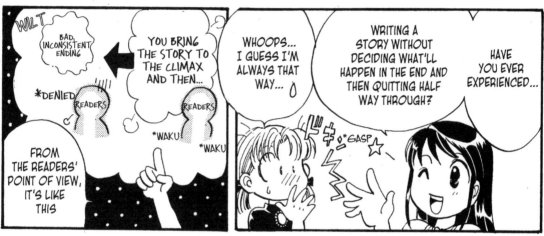

WILT

BAD, INCONSISTENT ENDING

YOU BRING THE STORY TO THE CLIMAX AND THEN...

*DENIED

READERS

READERS

*WAKU!

*WAKU

FROM THE READERS' POINT OF VIEW, IT'S LIKE THIS

WHOOPS... I GUESS I'M ALWAYS THAT WAY... ♪

WRITING A STORY WITHOUT DECIDING WHAT'LL HAPPEN IN THE END AND THEN QUITTING HALF WAY THROUGH?

HAVE YOU EVER EXPERIENCED...

*GASP

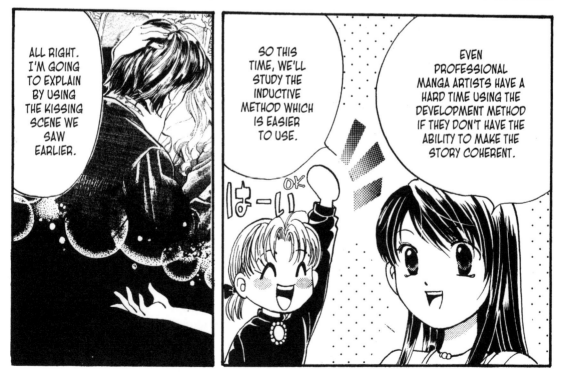

ALL RIGHT. I'M GOING TO EXPLAIN BY USING THE KISSING SCENE WE SAW EARLIER.

SO THIS TIME, WE'LL STUDY THE INDUCTIVE METHOD WHICH IS EASIER TO USE.

EVEN PROFESSIONAL MANGA ARTISTS HAVE A HARD TIME USING THE DEVELOPMENT METHOD IF THEY DON'T HAVE THE ABILITY TO MAKE THE STORY COHERENT.

OK

は一い

✳ APPLIED INDUCTIVE METHOD ✳

THE WAY A STORY DEVELOPS CHANGES DEPENDING ON WHERE YOU PLACE THE SCENE WITH THE BIGGEST IMPACT.

● PLACE THE KISSING SCENE IN THE "DEVELOPMENT" EPISODE AND LINE UP OTHER EPISODES.

CONCLUSION	TURN	DEVELOPMENT	INTRODUCTION

MAKE UP AND KISS IN THE MUSEUM AGAIN ⇐ BREAK UP AFTER FIGHTING ⇐ (THEY START GOING OUT AND) KISS IN THE MUSEUM ⇒ THEY MEET EACH OTHER

EXAMPLE

--

● PLACE THE KISSING SCENE IN THE "TURN" EPISODE AND CHANGE THE ORDER OF EPISODES

CONCLUSION	TURN	DEVELOPMENT	INTRODUCTION

SEE IF THEY FEEL THE SAME WAY AND MAKE UP ⇐ KISS IN THE MUSEUM ⇒ BREAK UP AFTER FIGHTING ⇒ THEY START GOING OUT

EXAMPLE

--

● PLACE THE KISSING SCENE IN THE "INTRODUCTION" EPISODE AND CHANGE THE ORDER OF EPISODES.

CONCLUSION	TURN	DEVELOPMENT	INTRODUCTION

THEY KISS IN THE MUSEUM AGAIN AND MAKE UP THEY FIGHT AND THINGS GET WORSE UNCOMFORTABLE SILENCE BETWEEN THEM ⇒ (ACCIDENTLLY) THEY KISS IN THE MUSEUM

EXAMPLE

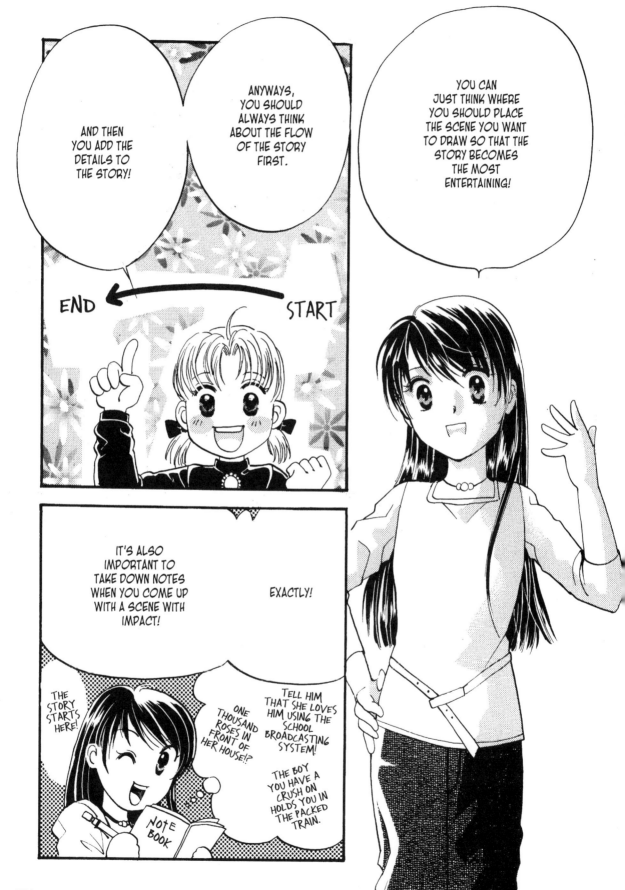

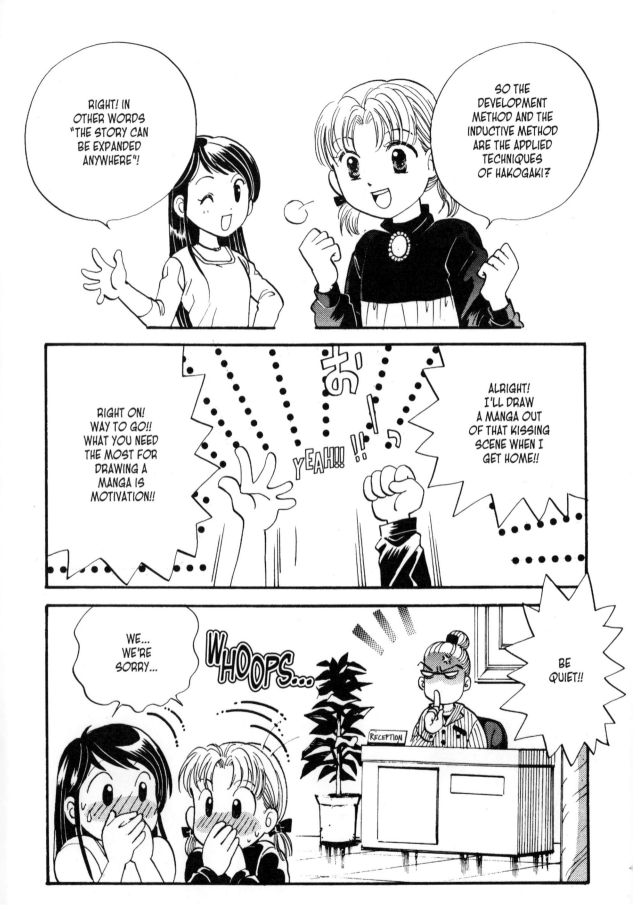

●THE END●

▲ HORIZONTAL: THE ANGLE WHEN YOU LOOK AT THE OBJECT HORIZONTALLY OR STRAIGHT ON. IT'S ALSO CALLED EYE LEVEL.

▲ LOOKING UP: THE ANGLE WHEN YOU LOOK UP AT AN OBJECT FROM BELOW. IT'S ALSO CALLED A LOW ANGLE.

▲ LOOKING DOWN: THE ANGLE WHEN YOU LOOK DOWN AT AN OBJECT FROM ABOVE. IT'S ALSO CALLED A HIGH ANGLE.

■ WHAT ARE THE DEVELOPMENT METHOD AND INDUCTIVE METHOD? ■

◎ THINKING ABOUT THE SCENE YOU WANT TO DRAW AGAIN

WHEN YOU DRAW THE ILLUSTRATION OF THE SCENE YOU WANT TO CREATE, HOW DO YOU USUALLY DO SO? DO YOU JUST DRAW IT FROM A VAGUE IMAGE YOU HAVE IN YOUR MIND? IF YOU PROGRESS THIS WAY, THE EMOTIONS AND IMPRESSIONS FROM THE SCENE COULD BE LOST! IN ORDER TO CREATE A SCENE TO APPEAL TO THE READERS, YOU HAVE TO CONSIDER THE ANGLE AND SHOT, GIVING THE ILLUSTRATION GOOD EFFECTS.

◎ THREE DIFFERENT ANGLES

THE "ANGLE" IS THE POSITION OF YOUR VIEWPOINT WHEN DRAWING AN ILLUSTRATION. IF YOU PUT IT INTO VIDEO OR FILM CAMERA TERMS, IT'S THE POSITION OF THE CAMERA LOOKING AT THE OBJECT.

KYOKO'S

ONE POINT ADVICE

133

● LONG SHOT OR ESTABLISHING SHOT: IT'S A SHOT IN WHICH YOU SEE THE WHOLE BODY OF THE CHARACTER. DEPENDING ON THE CHARACTER, YOU CAN USE THIS WHEN DRAWING WIDE AREAS SUCH AS SCENERY OR INDOOR VIEWS RATHER THAN CHARACTERS.

◎ FIVE SHOTS

A "SHOT" IS CLASSIFIED INTO 5 TYPES DEPENDING ON HOW BIG THE OBJECT, ESPECIALLY THE MAIN CHARACTER, IS DRAWN IN THE PANEL. IT'S EASY, SO PLEASE REMEMBER THESE ANGLES.

● FULL SHOT: IT'S A SHOT IN WHICH YOU SEE THE CHARACTER DRAWN FULLY IN A GOOD SIZE INSIDE THE PANEL. YOU USE THIS FOR SHOWING OUTFITS OR CHARACTER ACTION.

● MIDDLE SHOT OR MEDIUM SHOT: IT'S A SHOT IN WHICH YOU SEE THE CHARACTER DRAWN FROM THE HEAD TO KNEE LEVEL. YOU USE THIS WHEN DRAWING THE CHARACTER'S MOVEMENT AND FACIAL EXPRESSIONS.

● UP SHOT OR CLOSE UP: IT'S A SHOT IN WHICH THE CHARACTER IS DRAWN FROM THE SHOULDER UP. YOU USE THIS WHEN DRAWING THE CHARACTER'S FACIAL EXPRESSIONS.

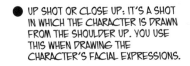

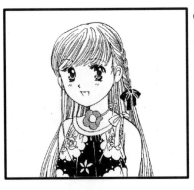

● BUST SHOT OR MEDIUM CLOSE UP: IT'S A SHOT IN WHICH YOU SEE THE CHARACTER DRAWN FROM THE CHEST UP. YOU USE THIS WHEN DRAWING A CONVERSATION BETWEEN CHARACTERS IN CLOSE VICINITY.

⑫ CREATING STORIES BY DETERMINING THE PAGE COUNT

THE PAGE COUNT HAS NOTHING TO DO WITH THE QUALITY OF MANGA. FIRST, YOU MUST KNOW THE NUMBER OF PAGES THAT IS RIGHT FOR YOUR MANGA! THEN, CHOOSE THE EPISODES YOU NEED TO WRITE A STORY.

PLEASE MAKE YOURSELF AT HOME!

WOW... YOU HAVE SO MANY TOOLS FOR DRAWING MANGA...

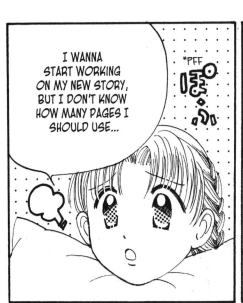

I WANNA START WORKING ON MY NEW STORY, BUT I DON'T KNOW HOW MANY PAGES I SHOULD USE...

*PFF

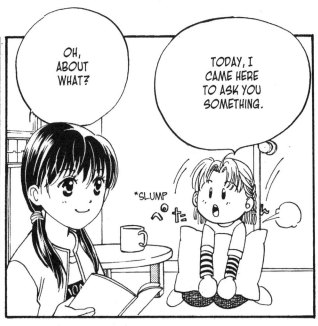

OH, ABOUT WHAT?

TODAY, I CAME HERE TO ASK YOU SOMETHING.

*SLUMP

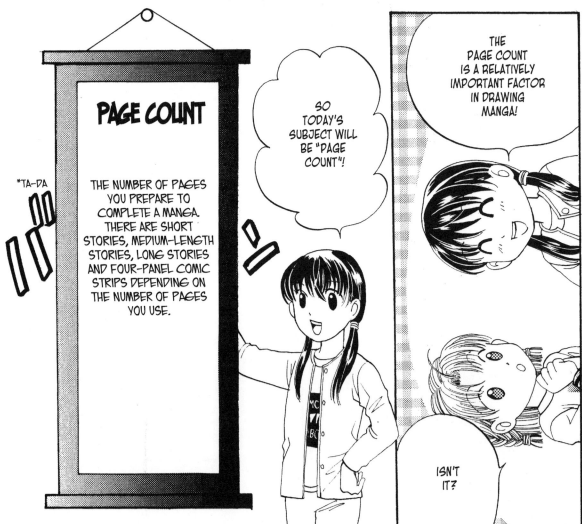

PAGE COUNT

THE NUMBER OF PAGES YOU PREPARE TO COMPLETE A MANGA. THERE ARE SHORT STORIES, MEDIUM-LENGTH STORIES, LONG STORIES AND FOUR-PANEL COMIC STRIPS DEPENDING ON THE NUMBER OF PAGES YOU USE.

*TA-DA

SO TODAY'S SUBJECT WILL BE "PAGE COUNT"!

THE PAGE COUNT IS A RELATIVELY IMPORTANT FACTOR IN DRAWING MANGA!

ISN'T IT?

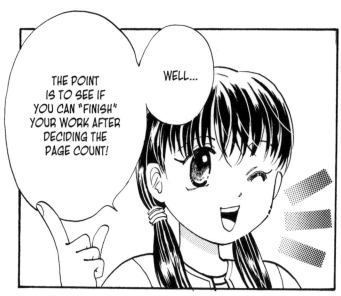

THE POINT IS TO SEE IF YOU CAN "FINISH" YOUR WORK AFTER DECIDING THE PAGE COUNT!

WELL...

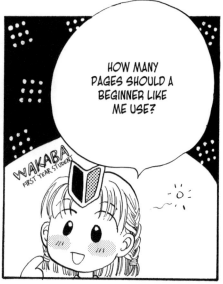

HOW MANY PAGES SHOULD A BEGINNER LIKE ME USE?

WAKABA FIRST YEAR STUDENT

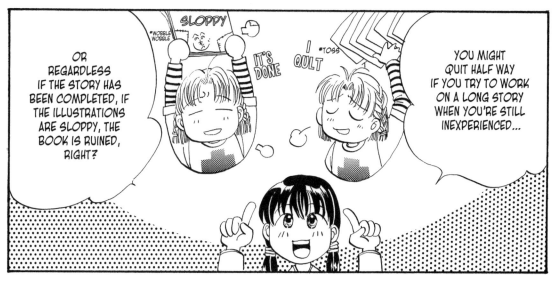

OR REGARDLESS IF THE STORY HAS BEEN COMPLETED, IF THE ILLUSTRATIONS ARE SLOPPY, THE BOOK IS RUINED, RIGHT?

SLOPPY

*WOBBLE WOBBLE

IT'S DONE

I QUIT

*TOSS

YOU MIGHT QUIT HALF WAY IF YOU TRY TO WORK ON A LONG STORY WHEN YOU'RE STILL INEXPERIENCED...

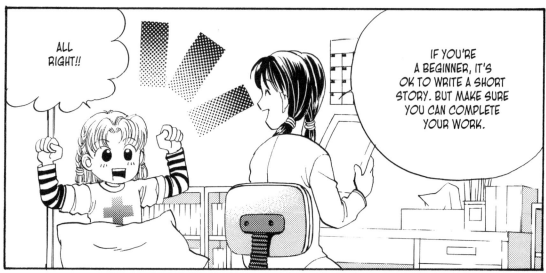

ALL RIGHT!!

IF YOU'RE A BEGINNER, IT'S OK TO WRITE A SHORT STORY. BUT MAKE SURE YOU CAN COMPLETE YOUR WORK.

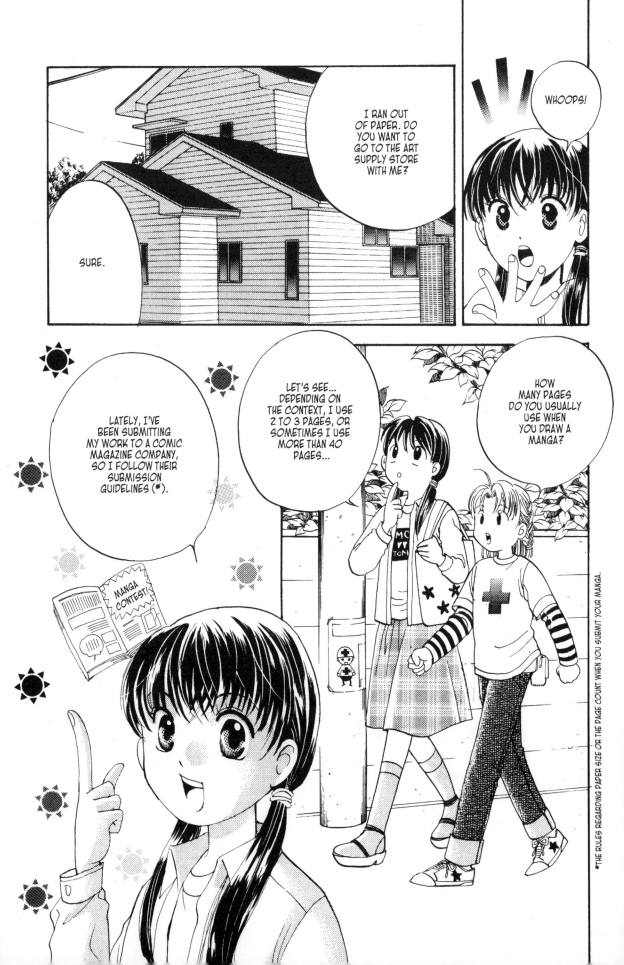

WHOOPS!

I RAN OUT OF PAPER. DO YOU WANT TO GO TO THE ART SUPPLY STORE WITH ME?

SURE.

LATELY, I'VE BEEN SUBMITTING MY WORK TO A COMIC MAGAZINE COMPANY, SO I FOLLOW THEIR SUBMISSION GUIDELINES (*).

MANGA CONTEST!

LET'S SEE... DEPENDING ON THE CONTEXT, I USE 2 TO 3 PAGES, OR SOMETIMES I USE MORE THAN 40 PAGES...

HOW MANY PAGES DO YOU USUALLY USE WHEN YOU DRAW A MANGA?

*THE RULES REGARDING PAPER SIZE OR THE PAGE COUNT WHEN YOU SUBMIT YOUR MANGA.

�֎ CLASSIFICATION BASED ON THE PAGE COUNT �֎

SHORT STORIES	A MANGA THAT IS 16 PAGES OR LESS. THIS LENGTH IS SUITABLE FOR GAG MANGA TO MAKE THE READERS LAUGH, OR A PARODY MANGA IN WHICH YOU USE AN EXISTING MANGA OR ANIME AND REARRANGE IT IN YOUR OWN WAY. USUALLY IT CONSISTS OF ONE TO THREE EPISODES.
MEDIUM-LENGTH STORIES	A MANGA THAT IS 16 PAGES TO 60 PAGES LONG. THIS LENGTH IS SUITABLE FOR YOMIKIRI (A STORY THAT DOESN'T CONTINUE AS A SERIES, BUT ENDS IN ONE EPISODE.). FOR NEW MANGA ARTIST CONTESTS, THE RULES REGARDING PAGE COUNT IS USUALLY THIS LENGTH. IT USUALLY CONSISTS OF 3 TO 8 EPISODES.
LONG STORIES	A MANGA THAT IS 60 PAGES OR LONGER. USUALLY MANGA ON THE WEEKLY OR MONTHLY COMIC MAGAZINES ARE THIS TYPE SINCE THERE ARE MANY EPISODES. THE NUMBER OF EPISODES CAN BE AN INFINITE NUMBER.
FOUR-PANEL CARTOONS, ONE TO TWO PANEL CARTOONS	IN GENERAL, YOU COMPLETE THE STORY WITHIN 4 TO 8 PAGES. AS FOR THE ONE TO TWO PANEL CARTOONS, SOME OF THEM CAN BE COMPLETED WITHIN ONE PAGE.

IF YOU ARE A BEGINNER, 20 PAGES SHOULD BE THE MAX!

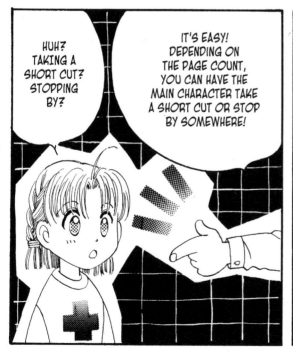

HUH? TAKING A SHORT CUT? STOPPING BY?

IT'S EASY! DEPENDING ON THE PAGE COUNT, YOU CAN HAVE THE MAIN CHARACTER TAKE A SHORT CUT OR STOP BY SOMEWHERE!

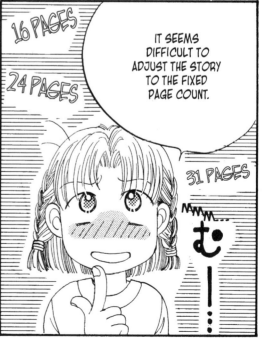

IT SEEMS DIFFICULT TO ADJUST THE STORY TO THE FIXED PAGE COUNT.

16 PAGES

24 PAGES

31 PAGES

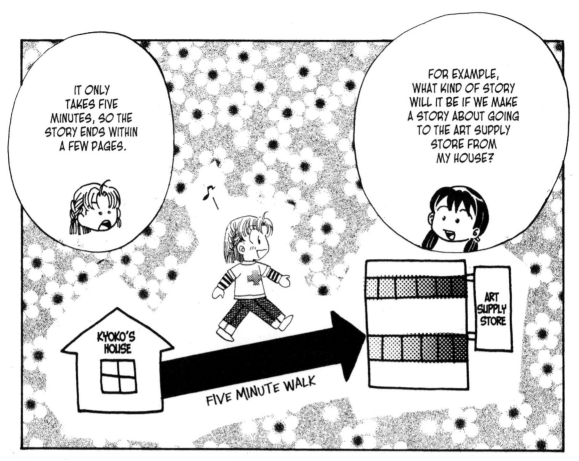

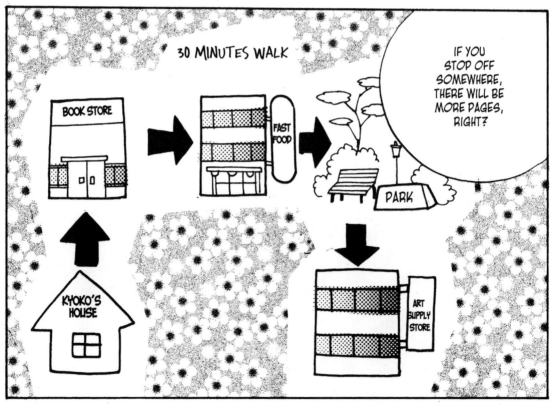

LONG STORIES

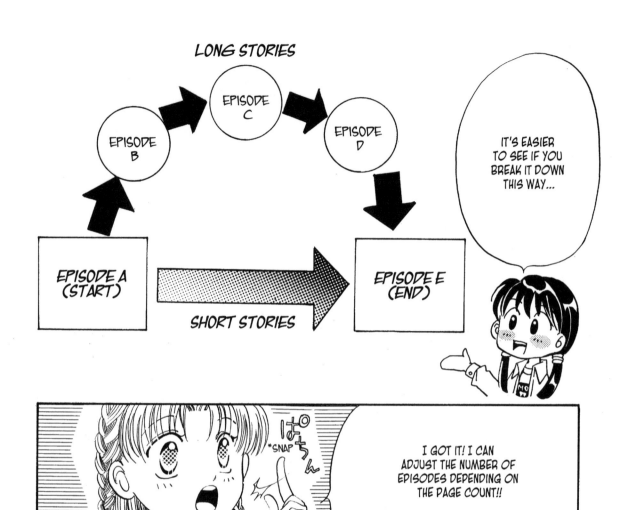

EPISODE B

EPISODE C

EPISODE D

EPISODE A (START)

SHORT STORIES

EPISODE E (END)

IT'S EASIER TO SEE IF YOU BREAK IT DOWN THIS WAY...

*SNAP

I GOT IT! I CAN ADJUST THE NUMBER OF EPISODES DEPENDING ON THE PAGE COUNT!!

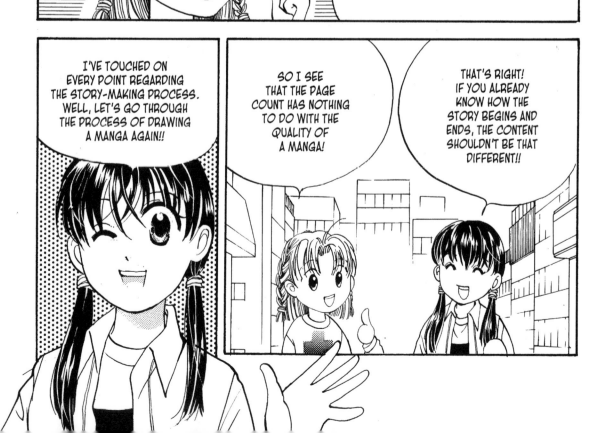

I'VE TOUCHED ON EVERY POINT REGARDING THE STORY-MAKING PROCESS. WELL, LET'S GO THROUGH THE PROCESS OF DRAWING A MANGA AGAIN!!

SO I SEE THAT THE PAGE COUNT HAS NOTHING TO DO WITH THE QUALITY OF A MANGA!

THAT'S RIGHT! IF YOU ALREADY KNOW HOW THE STORY BEGINS AND ENDS, THE CONTENT SHOULDN'T BE THAT DIFFERENT!!

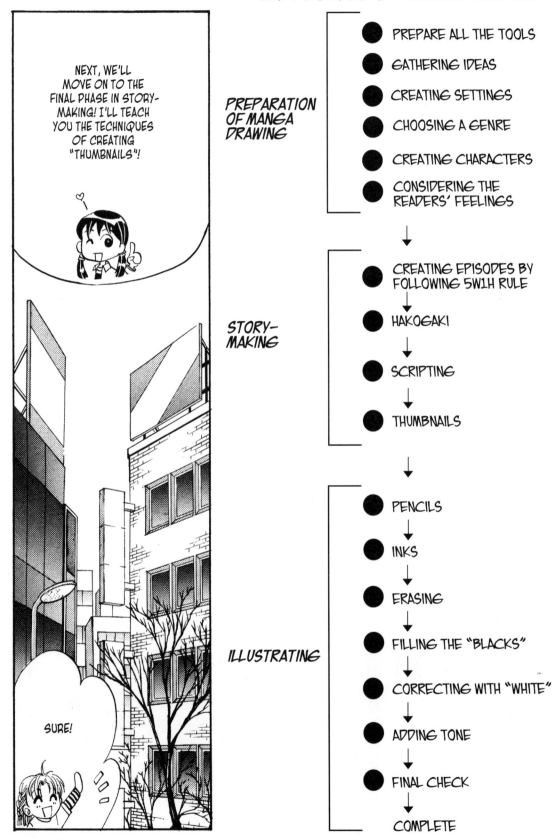

NEXT, WE'LL MOVE ON TO THE FINAL PHASE IN STORY-MAKING! I'LL TEACH YOU THE TECHNIQUES OF CREATING "THUMBNAILS"!

SURE!

THE PROCESS OF DRAWING A MANGA

PREPARATION OF MANGA DRAWING

- PREPARE ALL THE TOOLS
- GATHERING IDEAS
- CREATING SETTINGS
- CHOOSING A GENRE
- CREATING CHARACTERS
- CONSIDERING THE READERS' FEELINGS

STORY-MAKING

- CREATING EPISODES BY FOLLOWING 5W1H RULE
- HAKOGAKI
- SCRIPTING
- THUMBNAILS

ILLUSTRATING

- PENCILS
- INKS
- ERASING
- FILLING THE "BLACKS"
- CORRECTING WITH "WHITE"
- ADDING TONE
- FINAL CHECK
- COMPLETE

HMPH. I'M PERFECT.

I'M LATE!

▲ THE MAIN CHARACTER'S CHARM DIFFERS DEPENDING ON THE PERSONALITY OF THE CHARACTER OR THE GENRE OF THE STORY. WHAT'S CHARMING ABOUT A CHARACTER IS HIS/HER INDIVIDUALITY. USING THE ILLUSTRATIONS, DETERMINE HOW TO SHOW HIS/HER CHARMING POINTS.

■ APPEALING TO THE READERS WITH A LIMITED PAGE COUNT ■

◎ THE TECHNIQUE TO MAKE THE MAIN CHARACTER LOOK ATTRACTIVE

I'LL SHOW YOU HOW TO MAKE THE MAIN CHARACTER ATTRACTIVE BY TAKING ADVANTAGE OF THE PAGE AND PANEL STRUCTURE. HAVE ONE BIG PANEL SOMEWHERE BETWEEN TWO FACING PAGES AND DRAW THE ILLUSTRATION TO MAKE THE MAIN CHARACTER LOOK ATTRACTIVE. THIS PANEL IS CALLED "SHOW-OFF PANEL" AND EVERY PROFESSIONAL MANGA ARTIST USES THIS TECHNIQUE. USING THIS TECHNIQUE CAN BE CRITICAL WHEN THE PAGE COUNT IS LIMITED. PLEASE MAKE A NOTE OF THIS.

KYOKO'S

ONE POINT ADVICE

I CARE ABOUT YOU!! *DOKI DOKI

▲ IF YOU WANT TO DRAW THE ADORABLE SIDE OF A CHARACTER BEING SHY IN FRONT OF THE BOY SHE LIKES, THINK ABOUT THE LINES AND ILLUSTRATIONS TO MAKE HER LOOK ADORABLE.

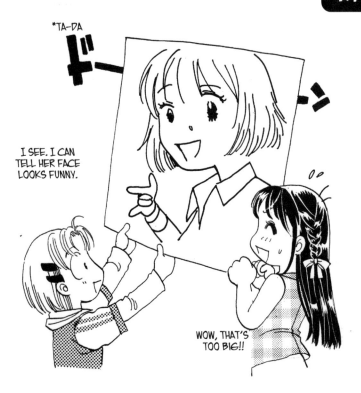

*TA-DA

I SEE. I CAN TELL HER FACE LOOKS FUNNY.

WOW, THAT'S TOO BIG!!

◎ *DRAWING BIG HELPS YOU IMPROVE YOUR ILLUSTRATION SKILLS FASTER.*

ON THE PREVIOUS PAGE, WE LEARNED ABOUT THE "SHOW-OFF PANEL" IN WHICH YOU DRAW THE MAIN CHARACTER TO MAKE HIM/HER LOOK ATTRACTIVE IN A BIG PANEL. CAN YOU DRAW YOUR CHARACTERS LARGE?

TO TEST YOUR SKILLS, DRAW A CHARACTER FULL SIZE ON A B4 SIZED PAPER (14 X 20 IN). IF YOU TAKE A STEP BACK AND LOOK AT THE ILLUSTRATION, DOES IT LOOK CROOKED IN THE FACE OR UNBALANCED IN THE BODY PART? DRAWING A LARGE SIZED ILLUSTRATION IS NOT AS EASY AS YOU THINK.

▲ DRAW IN A SIZE YOU FIND IT EASY TO DRAW AND ENLARGE IT WITH A COPY MACHINE. THEN TRACE THE LINES OVER FOR PRACTICE.

--

DO IT UNTIL YOU COMPLETE IT!

何ごとも最後までシッカリと！

IF YOU CAN DRAW A LARGE SIZED ILLUSTRATION WELL, YOU CAN DRAW ILLUSTRATIONS OF ANY SIZES. WHEN YOU PRACTICE DRAWING CHARACTERS, TRY TO DRAW THEM IN THE LARGEST SIZE POSSIBLE (BUT DON'T GET CARRIED AWAY).

▲ IT'S ALSO IMPORTANT TO COMPLETE THE ILLUSTRATION BY GOING THROUGH THE PROCESS OF PENCILING, INKING, FILLING THE "BLACKS", CORRECTING WITH "WHITE" AND ADDING TONE.

⑬ THUMBNAILS

THUMBNAILS ARE LIKE A BLUE PRINT IN WHICH YOU ROUGHLY "PANEL" BASED ON THE SCRIPT. LET'S LEARN THE BASIC TERMS SUCH AS "PANELING", "BUBBLES", AND "BLEEDING PANELS"!

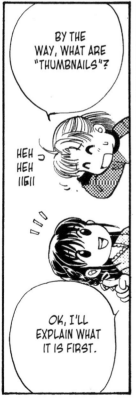

BY THE WAY, WHAT ARE "THUMBNAILS"?

HEH HEH HEH

OK, I'LL EXPLAIN WHAT IT IS FIRST.

YES!

LET'S MOVE ON TO THE FINAL PHASE AND LEARN ABOUT "THUMBNAILS"!

STRAY NINJA

MANGA DRAFTING PAPER

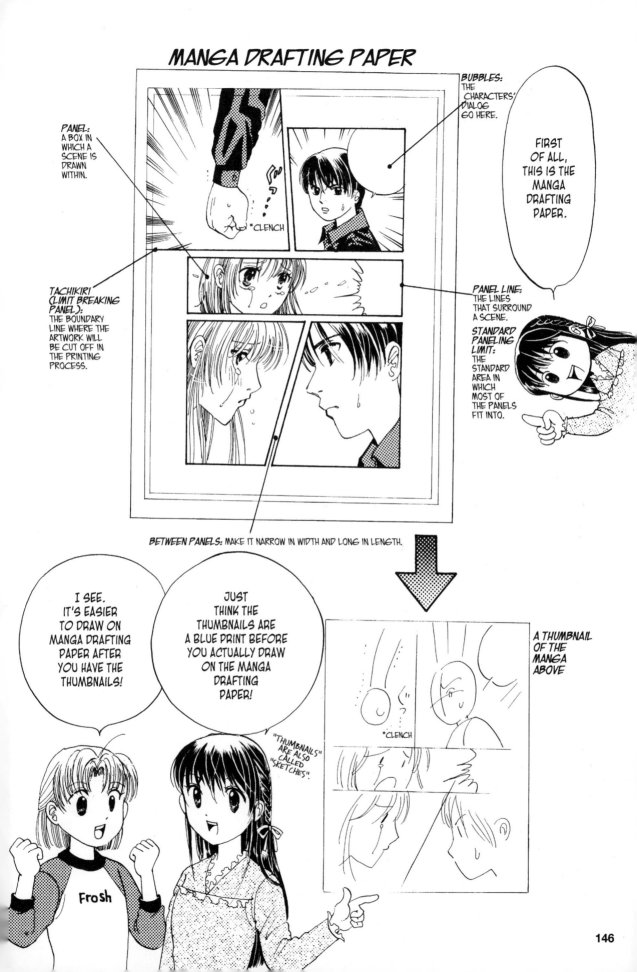

WELL, I DON'T KNOW WHERE TO START...

WHAT'S WRONG?

HEH HEH...

Frosh

SKETCH IT OUT IN YOUR NOTEBOOK OR NOTE PAD USING EITHER PENCILS OR MECHANICAL PENCILS.

WELL NOW, LET'S MAKE THE THUMBNAILS BASED ON YOUR SCRIPT.

......

*UHHHHHH

Frosh

WHAT YOU FIRST MUST CONSIDER WHEN CREATING THUMBNAILS IS TO "MAKE THE ORDER OF PANELS CLEAR"!

PANELING FOR MANGA

IN SHORT, THE PANEL ORDER MUST BE ABLE TO BE CLEARLY READ.

BAD EXAMPLE

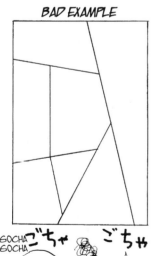

GOOD EXAMPLE

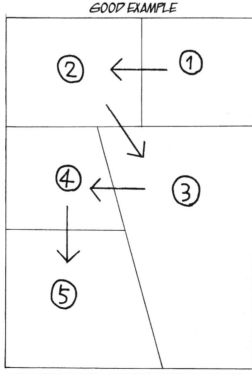

*GOCHA GOCHA

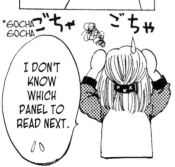

I DON'T KNOW WHICH PANEL TO READ NEXT.

YOU READ PANELS FROM RIGHT TO LEFT, TOP TO BOTTOM (A JAPANESE BOOK IS READ THIS WAY). *PANELING: THE WORK TO DECIDE ON THE SIZE AND THE POSITION OF THE PANELS.

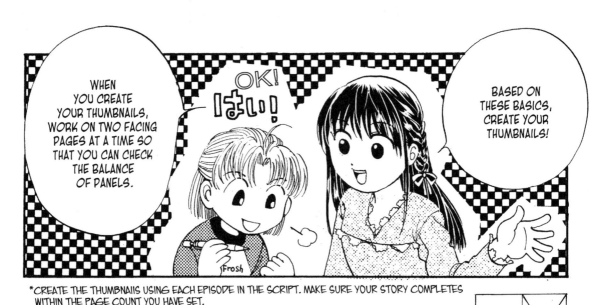

*CREATE THE THUMBNAILS USING EACH EPISODE IN THE SCRIPT. MAKE SURE YOUR STORY COMPLETES WITHIN THE PAGE COUNT YOU HAVE SET.

*IN JAPANESE MANGA, MANGA USUALLY STARTS FROM A FRONT COVER PAGE WHICH IS LOCATED ON THE LEFT SIDE OF TWO FACING PAGES. (SEE THE RIGHT PAGING EXAMPLE) THERE IS AN ILLUSTRATION OF THE FRONT COVER PAGE.

WOULD YOU GO WITH ME?

NOT AT ALL.

EVER SINCE WE WERE IN THE ELEMENTARY SCHOOL! COULDN'T YOU TELL?!

WHAT'S UP, SUZUKI-SAN?

*HUFF HUFF

SCHOOL

YAMADA-KUN!

WHAT?

IT'LL BE BORING TO GO OUT WITH ME.

YOU...

ME?!

I LOVE YOU!

......

JERK!!

*TATATATA

HEY...

IS THAT TRUE?

*NOD NOD

......

⑨

⑧

SO, THIS IS THE PAGE WHERE THE STORY REACHES THE CLIMAX!

I MADE MY STORY IN 12 PAGES. HOW'S THIS?

① ✕

③ ②

⑤ ④

⑦ ⑥

UP

⑨ ⑧

⑪ ⑩

✕ ⑫

*IT'S HANDY IF YOU DIVIDE PAPERS IN HALF.

HERE ARE SOME TIPS IN PANELING TO MAKE YOUR MANGA BETTER.

REALLY...?

OK! IT'S PRETTY GOOD FOR YOUR FIRST WORK, BUT YOUR PANELING COULD BE A BIT BETTER...

LET'S FIX YOUR WORK FOLLOWING THESE TIPS...

(1) MAKE THE PANEL THAT CONTAINS THE SCENE YOU WANT TO DRAW THE READER'S ATTENTION, LARGER! APPLY DIFFERENT SIZES FOR THE PANELS.

(2) DRAW CHARACTERS FACING THE CENTER OF THE BOOK AS MUCH AS POSSIBLE.

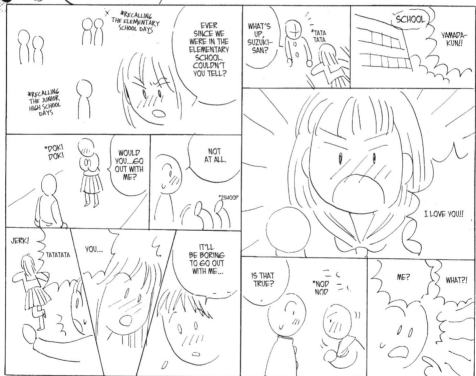

(3) IN THE LAST PANEL, DRAW A SCENE THAT LEADS TO THE NEXT PAGE.

(4) USE THE ANGLE AND SHOT TECHNIQUE FOR THE CHARACTERS AND ADJUST THE ILLUSTRATIONS.

(5) DON'T CHANGE THE CHARACTER'S POSITION FROM THE THUMBNAILS.

(6) MAKE THE ORDER OF THE BUBBLES CLEAR. BASICALLY, IT'S FROM RIGHT TO LEFT, TOP TO BOTTOM.

OF COURSE ONCE YOU GET THE HANG OF IT, YOU CAN DRAW DIRECTLY ON THE MANGA DRAFTING PAPER. BUT FIRST, YOU HAVE TO LEARN HOW TO CREATE GOOD THUMBNAILS.

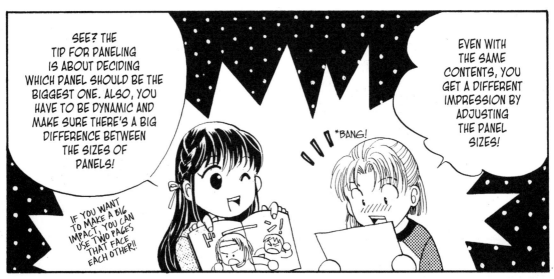

SEE? THE TIP FOR PANELING IS ABOUT DECIDING WHICH PANEL SHOULD BE THE BIGGEST ONE. ALSO, YOU HAVE TO BE DYNAMIC AND MAKE SURE THERE'S A BIG DIFFERENCE BETWEEN THE SIZES OF PANELS!

IF YOU WANT TO MAKE A BIG IMPACT, YOU CAN USE TWO PAGES THAT FACE EACH OTHER!!

*BANG!

EVEN WITH THE SAME CONTENTS, YOU GET A DIFFERENT IMPRESSION BY ADJUSTING THE PANEL SIZES!

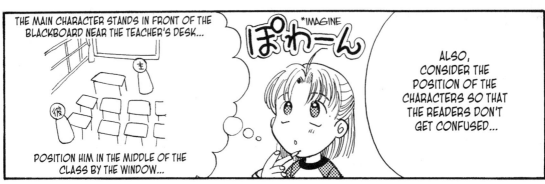

THE MAIN CHARACTER STANDS IN FRONT OF THE BLACKBOARD NEAR THE TEACHER'S DESK...

POSITION HIM IN THE MIDDLE OF THE CLASS BY THE WINDOW...

*IMAGINE
ぽわーん

ALSO, CONSIDER THE POSITION OF THE CHARACTERS SO THAT THE READERS DON'T GET CONFUSED...

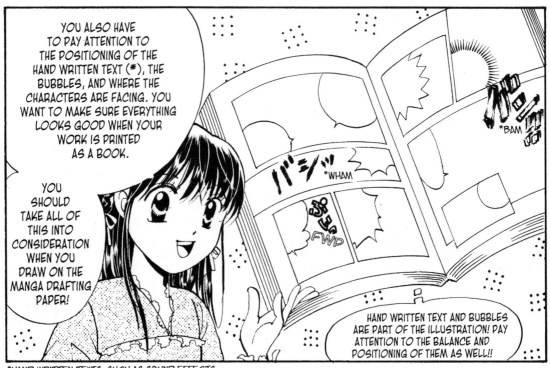

YOU ALSO HAVE TO PAY ATTENTION TO THE POSITIONING OF THE HAND WRITTEN TEXT (*), THE BUBBLES, AND WHERE THE CHARACTERS ARE FACING. YOU WANT TO MAKE SURE EVERYTHING LOOKS GOOD WHEN YOUR WORK IS PRINTED AS A BOOK.

YOU SHOULD TAKE ALL OF THIS INTO CONSIDERATION WHEN YOU DRAW ON THE MANGA DRAFTING PAPER!

*BAM

バシッ *WHAM

FWP

HAND WRITTEN TEXT AND BUBBLES ARE PART OF THE ILLUSTRATION! PAY ATTENTION TO THE BALANCE AND POSITIONING OF THEM AS WELL!!

*HAND WRITTEN TEXTS: SUCH AS SOUND EFFECTS.

150

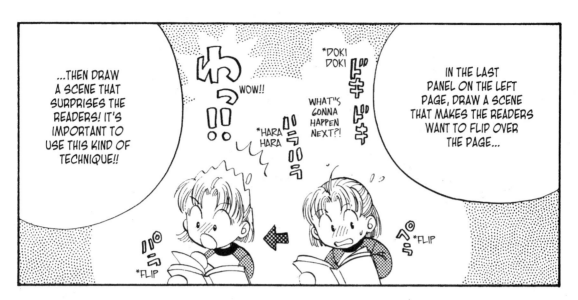

...THEN DRAW A SCENE THAT SURPRISES THE READERS! IT'S IMPORTANT TO USE THIS KIND OF TECHNIQUE!!

IN THE LAST PANEL ON THE LEFT PAGE, DRAW A SCENE THAT MAKES THE READERS WANT TO FLIP OVER THE PAGE...

*DOKI DOKI

WOW!!

WHAT'S GONNA HAPPEN NEXT?!

*HARA HARA

*FLIP

*FLIP

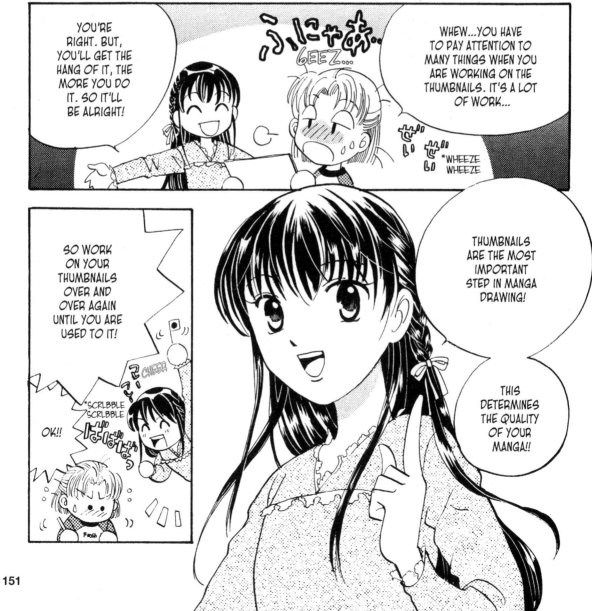

YOU'RE RIGHT. BUT, YOU'LL GET THE HANG OF IT, THE MORE YOU DO IT. SO IT'LL BE ALRIGHT!

WHEW...YOU HAVE TO PAY ATTENTION TO MANY THINGS WHEN YOU ARE WORKING ON THE THUMBNAILS. IT'S A LOT OF WORK...

GEEZ...

*WHEEZE WHEEZE

SO WORK ON YOUR THUMBNAILS OVER AND OVER AGAIN UNTIL YOU ARE USED TO IT!

THUMBNAILS ARE THE MOST IMPORTANT STEP IN MANGA DRAWING!

THIS DETERMINES THE QUALITY OF YOUR MANGA!!

CHEER

*SCRLBBLE SCRLBBLE

OK!!

FRESH

YEAH!!

PLEASE REFER TO "SHOUJO MANGA TECHNIQUES: DRAWING BASICS", VOLUME ONE OF THIS SERIES FOR THE TECHNIQUES OF ILLUSTRATION!

THE STORY WILL BE COMPLETE ONCE YOU FINISH YOUR THUMBNAILS!

GRATUITOUS PLUG!

*SHAKE SHAKE

YOU'RE NOT SCARED OF WRITING STORIES ANYMORE, ARE YOU?!

COOL! THANKS TO YOU, I HAVE CONFIDENCE IN STORY-MAKING!!

I HOPE YOU WILL WRITE A LOT OF GOOD STORIES, TOO!

I'LL WRITE LOTS OF STORIES!!

● THE END ●

⑭TACKLING PLAGIARISM

EVERYTHING STARTS FROM "I WANT TO DRAW MY ORIGINAL MANGA BECAUSE I HAVE A MESSAGE I WANT TO CONVEY". SO YOU HAVE TO CREATE SOMETHING ORIGINAL. GOOD LUCK!

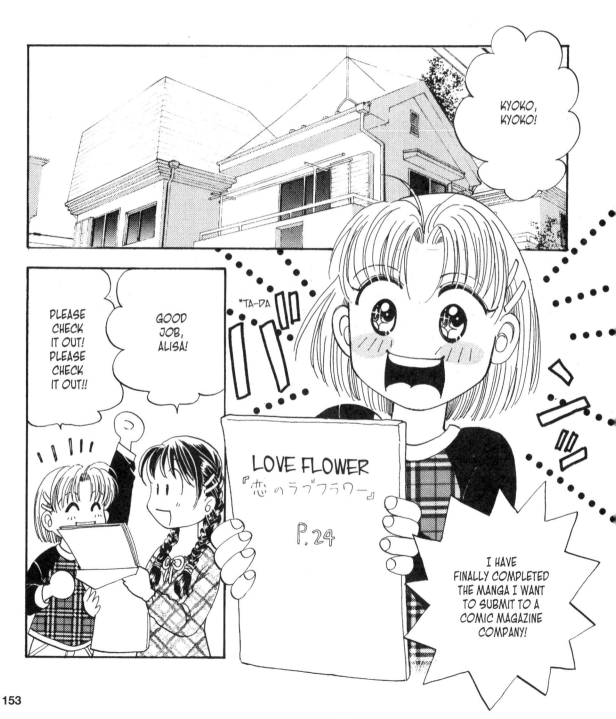

KYOKO, KYOKO!

*TA-DA

GOOD JOB, ALISA!

PLEASE CHECK IT OUT! PLEASE CHECK IT OUT!!

LOVE FLOWER
『恋 のラブフラワー』
P.24

I HAVE FINALLY COMPLETED THE MANGA I WANT TO SUBMIT TO A COMIC MAGAZINE COMPANY!

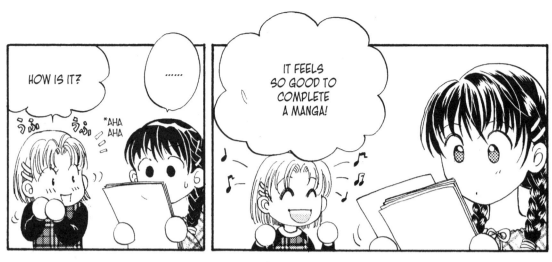

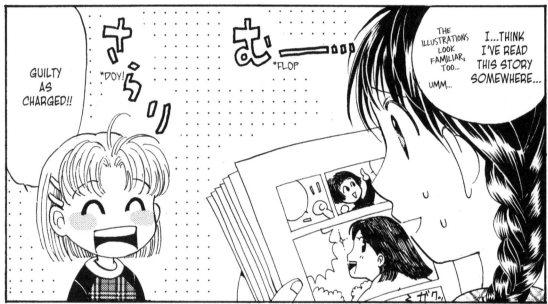

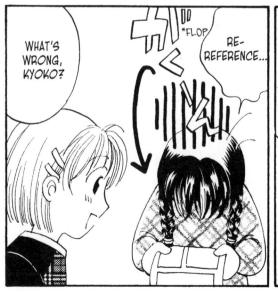

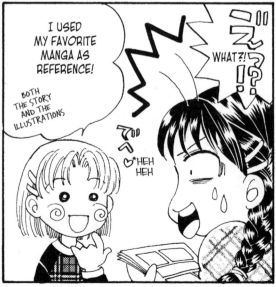

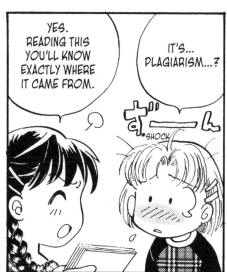

YES. READING THIS YOU'LL KNOW EXACTLY WHERE IT CAME FROM.

IT'S... PLAGIARISM...?

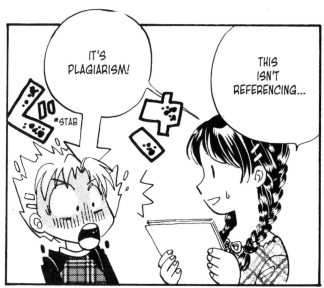

IT'S PLAGIARISM!

*STAB

THIS ISN'T REFERENCING...

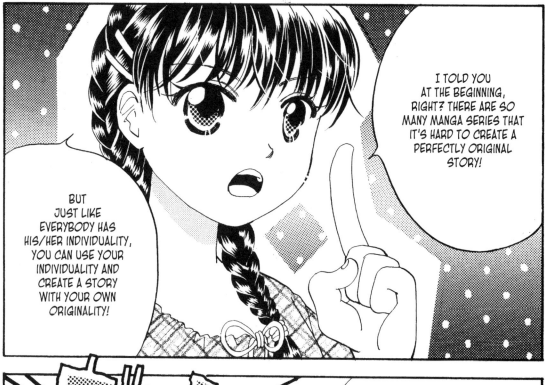

I TOLD YOU AT THE BEGINNING, RIGHT? THERE ARE SO MANY MANGA SERIES THAT IT'S HARD TO CREATE A PERFECTLY ORIGINAL STORY!

BUT JUST LIKE EVERYBODY HAS HIS/HER INDIVIDUALITY, YOU CAN USE YOUR INDIVIDUALITY AND CREATE A STORY WITH YOUR OWN ORIGINALITY!

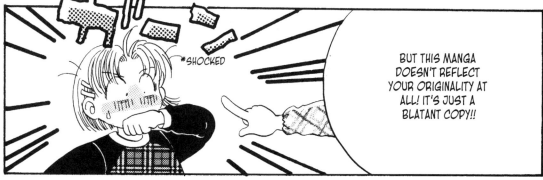

*SHOCKED

BUT THIS MANGA DOESN'T REFLECT YOUR ORIGINALITY AT ALL! IT'S JUST A BLATANT COPY!!

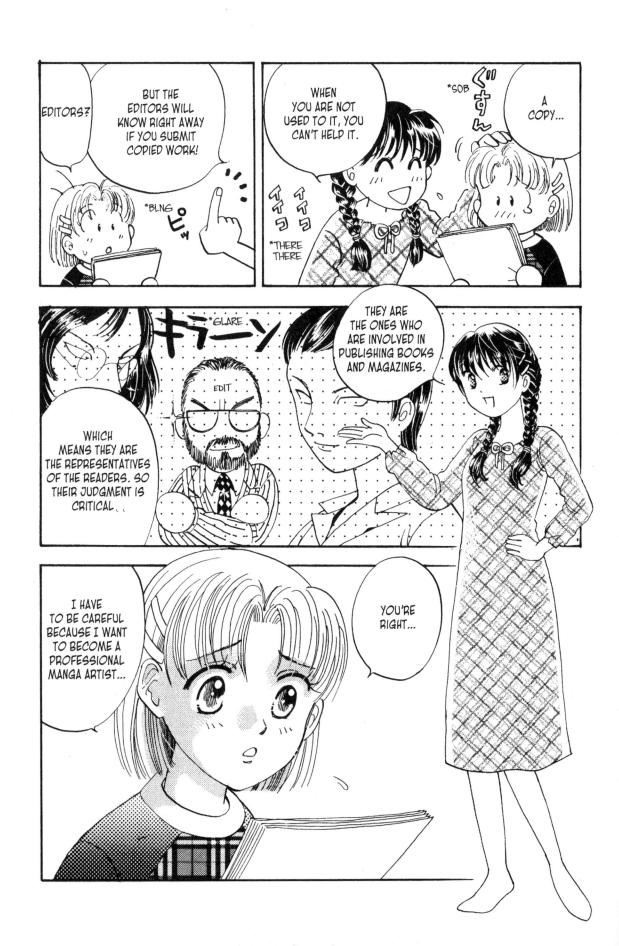

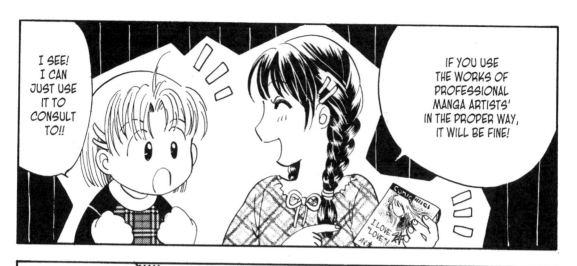

IF YOU USE THE WORKS OF PROFESSIONAL MANGA ARTISTS' IN THE PROPER WAY, IT WILL BE FINE!

I SEE! I CAN JUST USE IT TO CONSULT TO!!

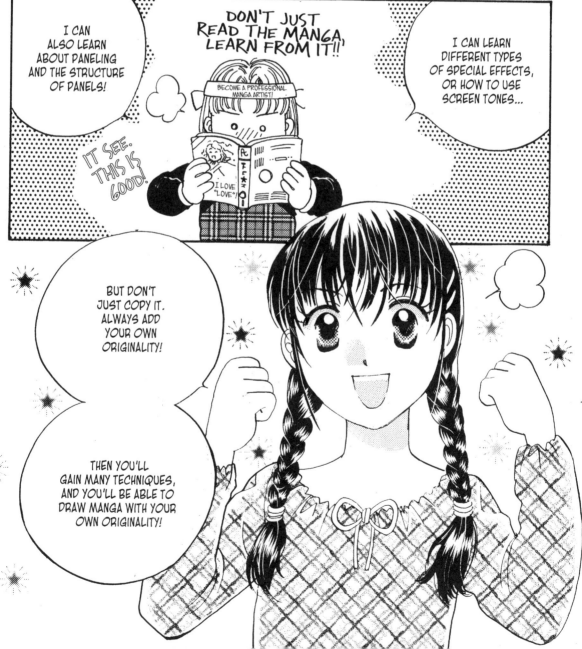

I CAN LEARN DIFFERENT TYPES OF SPECIAL EFFECTS, OR HOW TO USE SCREEN TONES...

DON'T JUST READ THE MANGA, LEARN FROM IT!!'

I CAN ALSO LEARN ABOUT PANELING AND THE STRUCTURE OF PANELS!

IT SEE. THIS IS GOOD!

BECOME A PROFESSIONAL MANGA ARTIST!

I LOVE "LOVE"!

BUT DON'T JUST COPY IT. ALWAYS ADD YOUR OWN ORIGINALITY!

THEN YOU'LL GAIN MANY TECHNIQUES, AND YOU'LL BE ABLE TO DRAW MANGA WITH YOUR OWN ORIGINALITY!

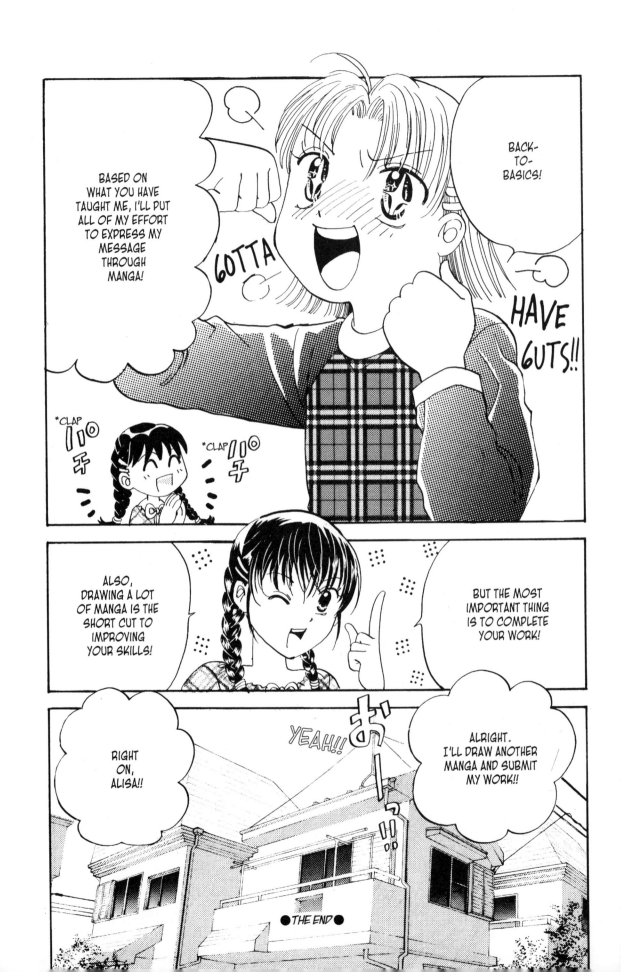

Let's Draw MANGA 漫画
Shoujo Characters

Draw shoujo manga the way you like it!

"HEE HEE"

TEE HEE

Let's Draw MANGA 漫画
Shoujo Characters

ISBN# 1-56970-966-1 SRP $19.95

Both beginner and intermediate artists can now learn to draw "shoujo" characters in the highly recognizable styles established by celebrated Japanese manga artists. With detailed coverage of classic characteristics and basic features, including signature costumes, hairstyles and accessories, this book is a dream come true for the aspiring "shoujo" manga artist.

Distributed Exclusively by:
Watson-Guptill Publications
770 Broadway
New York, NY 10003
www.watsonguptill.com

DMP
Digital Manga Publishing

www.dmpbooks.com

Let's Draw MANGA 漫画

TOKYO URBAN-HIP HOP CULTURE

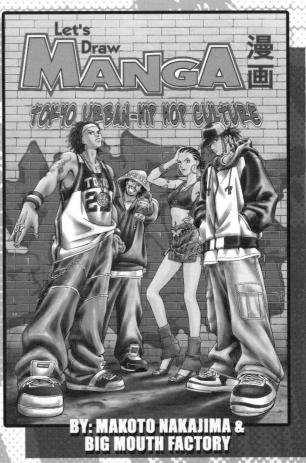

BY: MAKOTO NAKAJIMA & BIG MOUTH FACTORY

ISBN# 1-56970-969-6
$19.95

Distributed Exclusively by:
WATSON-GUPTILL PUBLICATIONS
770 Broadway
New York, NY 10003
www.watsonguptill.com

DMP
Digital Manga
Publishing

DIGITAL MANGA PUBLISHING
www.dmpbooks.com

Manga Academy

Learn how to create manga from the ground up!

Interactive critiques

Student forums

Let the pros teach you the tricks of the trade!

Drawing, inking, and coloring tips

 enroll at: mangaacademy.com

ポップ

pop culture sightseeing

exclusive anime studio tours

a one-of-a-kind adventure

For reservations or inquiries, please contact:

Pop Japan Travel at:
Toll Free: (888) 447-6204 Fax: (714) 668-1740
Email: travel@popjapantravel.com

Visit us on the web at:
http://www.popjapantravel.com

Let's Draw Manga

Astro Boy
1-56970-992-0 $19.95

All About Fighting
1-56970-987-4 $19.95

Hip hop
1-56970-969-6 $19.95

Monsters
1-56970-967-X $19.95

Ninja & Samurai
1-56970-990-4 $19.95

Sexy Gals
1-56970-989-0 $19.95

Transforming Robots
1-56970-991-2 $19.95

Tezuka School of Animation

Vol 1 Learning the Basics
1-56970-995-5 $13.95

Vol 2 Animals in Motion
1-56970-994-7 $13.95

Berserk *

Vol 1
1-59307-020-9 $13.95

Vol 2
1-59307-021-7 $13.95

Vol 3
1-59307-022-5 $13.95

Desire

Vol 1
1-56970-979-3 $12.95

Hellsing *

Vol 1
1-59307-056-X $13.95

Vol 2
1-59307-057-8 $13.95

Vol 3
1-59307-202-3 $13.95

IWGP
Ikebukuro West Gate Park

Vol 1
1-56970-986-6 $12.95

Vol 2
1-56970-985-8 $12.95

Vol 3
1-56970-984-X $12.95

Only the Ring Finger Knows

Vol 1
1-56970-980-7 $12.95

Passion

Vol 1
1-56970-978-5 $12.95

Vol 2
1-56970-977-7 $12.95

Ring *

Vol 1
1-59307-054-3 $12.95

Vol 2
1-59307-055-1 $12.95

Trigun *

Vol 1
1-59307-052-7 $14.95

Vol 2
1-59307-053-5 $14.95

Trigun Maximum *

Vol 1
1-59307-196-5 $12.95

Worst

Vol 1
1-56970-983-1 $12.95

Vol 2
1-56970-982-3 $12.95

Vol 3
1-56970-981-5 $12.95

Let's Draw Manga *Sexy Gals* is distributed by Digital Manga and can be found online at www.dmd-sales.com.

All titles with an asterisk (*) are co-published titles with Dark Horse Comics.

To find a comic book store in your neighborhood please call the toll free Comic shop locator. (1-888-266-4226)

STOP!

THIS IS THE END OF THE BOOK.

THIS BOOK READS IN ITS ORIGINAL RIGHT TO LEFT MANGA READING FORMAT.
PLEASE START FROM THE OTHER SIDE OF THE BOOK.

THANK YOU.

I SEE... NOW I GET IT!

FINISH ←

START

THE READING ORDER: READ RIGHT TO LEFT. TOP TO BOTTOM.

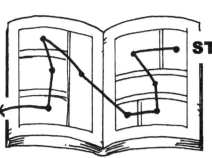

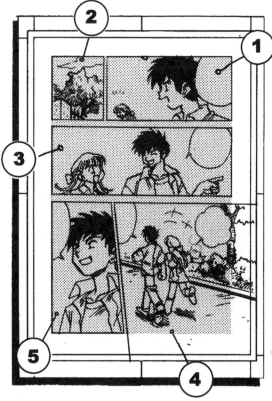